pastel
school

READER'S DIGEST
Learn-As-You-Go-Guide

pastel
school

Hazel Harrison

Reader's Digest

THE READER'S DIGEST ASSOCIATION, INC.
Pleasantville, New York/Montreal

First printing in paperback 2006

A READER'S DIGEST BOOK

Designed and edited by Quarto Inc.

Senior Art Editor *Penny Cobb*
Senior Editor *Kate Kirby*
Text Editor *Mary Senechal*
Designer *Hugh Schermuly*
Picture Researcher *Jo Carhill*
Picture Manager *Giulia Hetherington*
Photographers *Colin Bowling, Paul Forrester, Les Weiss, Laura Wickenden*
Editorial Director *Mark Dartford*
Art Director *Moira Clinch*

The credits that appear on page 176 are hereby made a part of this copyright page.

Library of Congress Cataloging in Publication Data

Harrison, Hazel.
 Pastel school: a practical guide to drawing with pastels/
Hazel Harrison.
 p. cm. — (Reader's Digest learn-as-you-go guide)
 Includes index.
 ISBN 0-89577-849-1 (hardcover)
 ISBN 0-7621-0698-0 (paperback)
 1. Pastel drawing—Technique. I. Title. II. Series.
NC880.H355 1996
741.2'35—dc20 95-33556

Reader's Digest and the Pegasus logo are registered
trademarks of The Reader's Digest Association, Inc.

Printed in Singapore

 3 5 7 9 10 8 6 4 (hardcover)
 1 3 5 7 9 10 8 6 4 2 (paperback)

Foreword

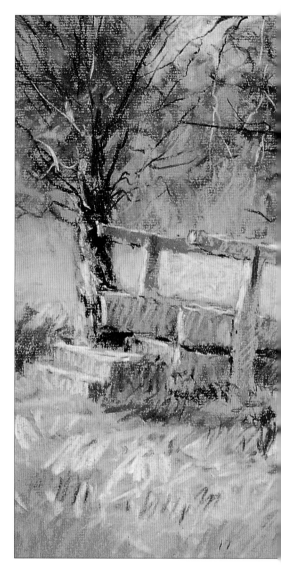

If you are new to pastel, you may feel apprehensive – perhaps you have heard that this is a difficult medium to use. It is true that it takes practice to produce an excellent pastel painting, but the basic skills are easy to acquire. Pastel is an immensely satisfying medium, and in many ways ideal for beginners. A child takes the first steps in art with chalks or crayons rather than paints and brushes, relishing the ease of spreading color on paper. And so it is for the inexperienced artist. With any of the other painting media, you

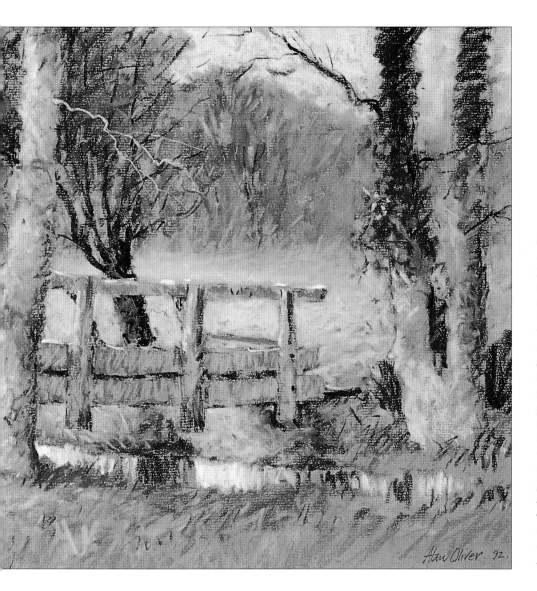

Alan Oliver '92.

A VERSATILE MEDIUM

In some pastel paintings, colors are blended so that no lines are visible, but this work exploits the medium's capacity to draw and paint simultaneously. Each area contains a delicate network of strokes, following varied directions, which gives the picture a wonderfully lively quality. Notice the foreground squiggles suggesting rough grass – some fine and light, others more heavily applied. (Old Bridge – Alan Oliver)

must premix your colors on a palette, learn how to handle brushes, and spend time drawing before you can apply color. Pastel needs none of these intermediary stages, because it is both a drawing and a painting medium. The stick of color becomes virtually an extension of your hand: just as the child does, you can pick it up and start painting.

Although there are no "difficult" techniques associated with pastel, there are many ways of using the medium, and all artists have their distinctive styles. This book is designed to help you discover your personal style, through practice and the example of others. A flip through the pages will show you some of the exciting possibilities that are open to you.

Hazel Harrison

Contents

8
INTRODUCTION

1
WHAT YOU WILL NEED

18
ABOUT PASTELS

22
PASTEL CARE

24
PAPER TEXTURE

26
PAPER COLOR

28
THE STUDIO AND THE PORTABLE KIT

2
FIRST MARKS

32
WORKING WITH PASTELS

34
LINE STROKES

36
SIDE STROKES

38
COMBINING STROKES

40
GESTURAL DRAWING

3
BUILDING UP YOUR SKILLS

44
COLOR MIXING

48
BLENDING LARGE AREAS

52
BLENDING SMALL AREAS

56
USING LINE STROKES

58
BROKEN COLOR

60
OVERLAYING COLORS

62
UNDERDRAWING

64
BUILDING UP A PAINTING

66
EDGES, OUTLINES, AND DETAILS

68
WET BRUSHING

70
CHARCOAL AND PASTEL

72
UNDERPAINTING

74
USING THICK COLOR

76
LAYING A TEXTURED GROUND

78
MAKING CORRECTIONS

80
COMPARING METHODS

BASICS OF PICTURE MAKING

86
COMPOSING THE PICTURE

90
BASIC COLOR PRINCIPLES

94
WORKING FROM LIFE

96
USING VISUAL REFERENCES

98
MAKING YOUR SKETCHES WORK

100
EXPLORING THE OPTIONS

PICTURE MAKING

106
STILL LIFE

112
Project 1
Painting fruit

114
Project 2
Painting patterns

116
Gallery

118
FLOWERS

124
Project 3
Violet and white flowers

126
Gallery

130
LANDSCAPE

138
Project 4
Skies and seascapes

140
Project 5
Hilly landscapes

142
Gallery

146
PORTRAITS AND FIGURES

152
Project 6
Head-and-shoulders portrait

154
Project 7
Figures in landscape

156
Gallery

160
BUILDINGS

166
Project 8
Mediterranean village

168
Gallery

170
LOOKING AFTER YOUR WORK

172
MANUFACTURERS' EQUIVALENT CHART

173
INDEX

176
CREDITS

Introduction

INTRODUCTION

Pastel is becoming one of the most popular painting media, prized by both amateurs and professionals for its rich color, its versatility, and its easy handling. If you open a drawer of pastels in an art supply store, the glow of color that greets your eye seems to offer a direct invitation to try your hand.

PASTEL TECHNIQUES

Pastel is the most direct of all the media, but that does not mean it is problem-free. Any good painting is the product of thought, planning, and the thorough knowledge of the medium that comes from practice and experimentation.

This book contains a series of exercises and projects designed to help you gain this knowledge. You will learn how to exploit the different marks you can make with a pastel stick, using sweeping side strokes for broad impressions, and line strokes for more precise portrayals. You will discover how to blend colors into rich mixtures on the paper surface, and how to create the hazy effects for which the medium is so well suited.

Colors can be thoroughly mixed by blending, which is useful if you have a limited selection of

Continued on page 10 ▷

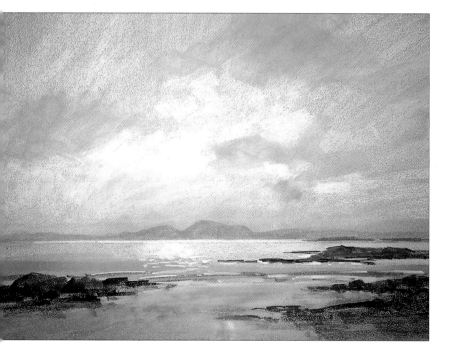

Short lengths of pastel make side strokes following direction of clouds; one color applied lightly over another.

Light side strokes for larger rocks; crisp edges of smaller rocks achieved by heavier pressure with a shorter piece of pastel.

SIDE STROKES

This painting, direct from the subject, demonstrates the value of pastel as an outdoor sketching medium. The choice of a relatively large scale and sweeping side strokes enabled the artist to work quickly, before the light changed. There is little detail, yet the forms and surfaces are perfectly delineated by variations in the size, shape, and direction of the strokes. (Sunset Over Jura – Aubrey Phillips)

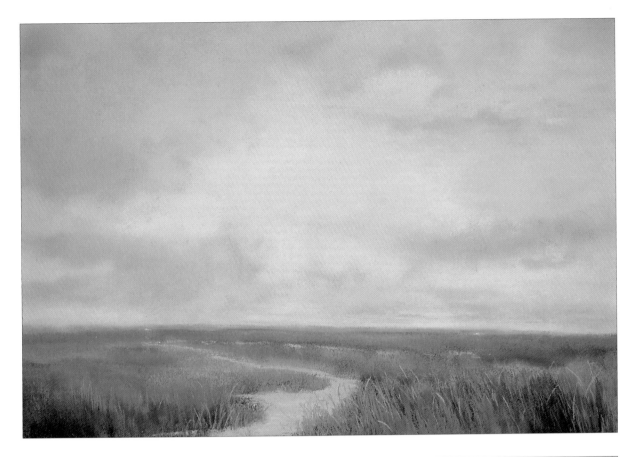

BLENDED COLOR

*Pastel can achieve the look of an oil painting, and with less trouble. The soft effects and glowing colors result from applying the pastels in successive layers and blending them, often using the whole hand. No line is visible, except in the foreground, where crisply drawn lines achieved with pastel pencils provide a contrast for the blended color. (*Golden Fields *– Lois Gold)*

Several applications of color are blended with the hand to give gentle gradations and remove hard edges.

Pale color placed in thick layers to resemble opaque paint.

Blades of grass drawn over underlying color with pastel pencils; background grasses lightly blended with a tortillon.

pastel sticks. However, because it is so easy, blending can be overdone, resulting in a bland picture. Most artists combine blended color with line or side strokes, and sometimes use blends only in the early stages, drawing over the soft color as the work progresses.

Some pastelists prefer the related method of applying one color thickly over another to achieve blended effects. Others build up entire pictures with a network of lines or small strokes made with the point of the pastel stick. This "cross-hatching" technique can produce subtle effects.

The pioneers of pastel painting, such as the 18th-century French portraitist Maurice-Quentin de la Tour, valued pastel's capacity for soft effects and velvety finishes, but today's artists rate its mark-making qualities more highly. Such painters have brought new techniques into the pastelist's repertoire. You will be introduced to methods

Continued on page 12 ▷

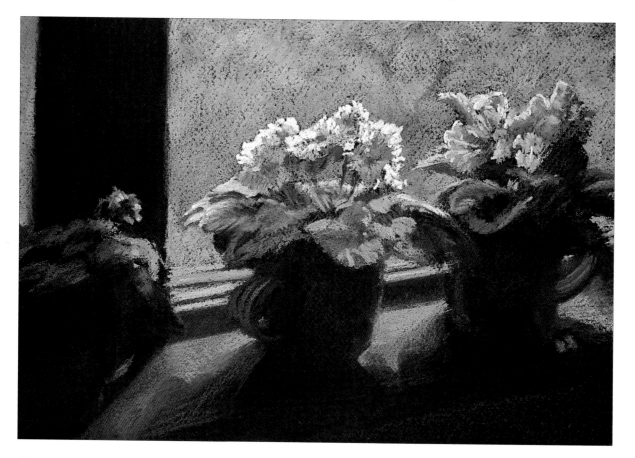

OVERLAYING COLORS

Blended color effects are possible without using fingers or a rag. This artist applied one color over another so that they merged and were pushed well into the grain of the paper. The texture of the thick paper, known as pastel board, has a texture which grips the powdery pigment. (Winter Garden – Rosalie Nadeau)

Result of overlaying clear: one color shows through another to convey an effect of light.

Color pushed so thoroughly into surface that no flecks of paper are visible.

Heavily applied pastel in varied colors builds up leaf forms.

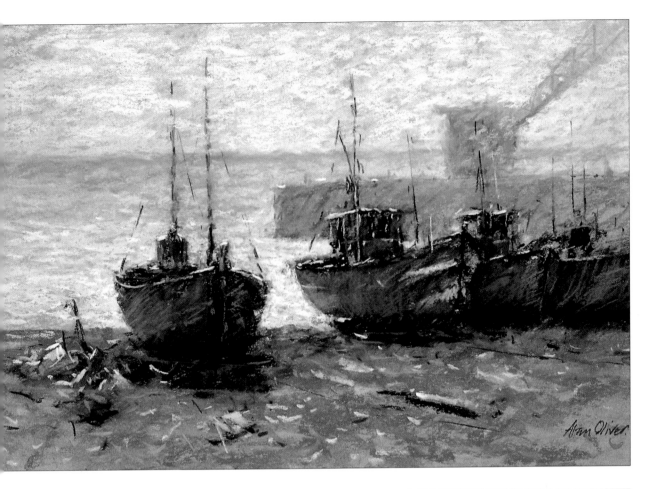

VARIED MARKS

The color effects in this atmospheric seascape are subtle, yet no blending has been used. Instead, each area is built up with a web of lines and small side strokes made with short lengths of pastel. Fine lines, such as the masts and the highlights on the edges of the boats, were drawn in the final stages with a sharp edge of pastel. (Hastings Beach – Alan Oliver)

Short strokes slightly varied in direction express shimmering light and movement of sea.

Foreground treated lightly, with different shapes and sizes of marks suggesting pebbles and fragments of driftwood.

Light diagonal hatching over darker color of boats prevents over-solid, static appearance; same method used on quay and crane.

such as wet-brushing (spreading pastel color with water or turpentine), working over an underpainting, painting on sandpaper, and applying a textured ground — all of which can give your work an extra dimension as well as being fun to try. You may even work out new techniques of your own, or find an unaccustomed or unusual surface that you enjoy using.

STYLES AND WORKING METHODS

Unlike watercolor techniques, some of which are complex, pastel methods are easy to master. What is a little trickier is evolving your own style. One of pastel's most exciting features is its versatility, but this can create its own problems. As you can see from the pictures in this book, each artist uses the medium in a different way. A pastel can resemble an oil painting, its colors built up thickly and pushed into the paper surface; it can be fused and delicate, or taut and linear, with no blending. So how do you decide which path to follow for your first attempts?

To some extent it is a matter of following your own inclinations. If you enjoy drawing but find it hard to handle color, you will probably use the

Continued on page 14 ▷

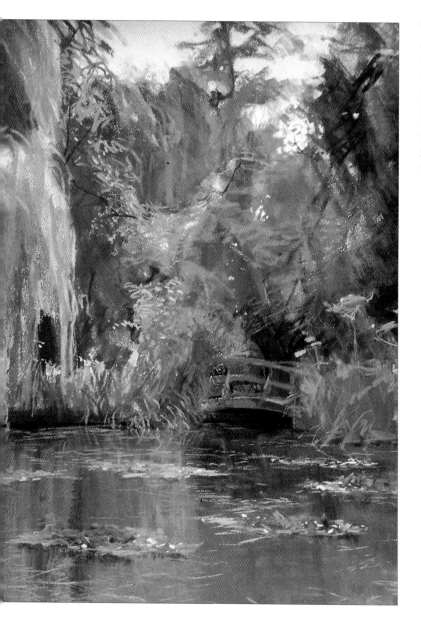

WORKING OVER AN UNDERPAINTING

Done on location, this work began with a watercolor underpainting. Varied strokes and colors were added in layers to create an impression of shimmering light. No green has been used, yet the trees are completely convincing. This artist makes her own surface by spraying white paper with resin and pumice powder. This gives a sanded texture that holds the pigment. (Morning Blue – Kitty Wallis)

Deep turquoise-blue over deeper blues and warm browns gives the impression of green. Pastel marks suggest leaves.

Watercolor underpainting provides basis for pastel colors; acrylic is sometimes used instead.

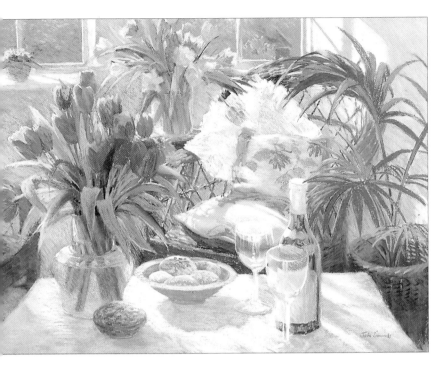

APPLYING COLOR

This artist's work is characterized by delicacy of color and technique. She uses blending in the early stages of a picture, but continues with light line strokes, mixing by overlaying. (Spring Light in the Sitting Room – Jackie Simmonds)

Touches of pale pink are worked over gray to prevent shadows from becoming too cold and dull.

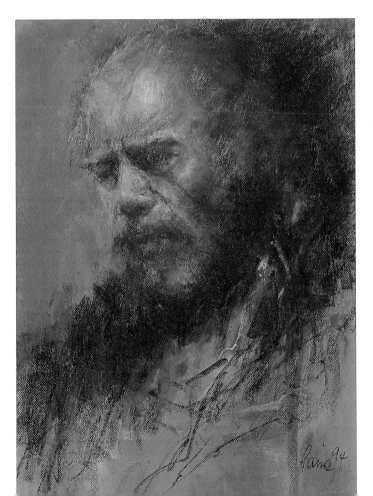

PAINTING BY DRAWING

The fact that pastel is both a drawing and a painting medium is evidenced by this powerful portrait, which combines line with a painterly use of tone and color. It began with a wash of acrylic, visible in the lower half of the picture. (The Journeyman – Ken Paine)

Pastel built up thickly over acrylic on face with firm side strokes worked from dark to light.

Acrylic used on white paper to provide medium-toned ground color. Left uncovered except for lines suggesting clothes.

tip of the pastel stick to give your work a linear emphasis. If your main interest is color, you may want to keep line to a minimum.

The development of your personal style will largely determine your working methods. If you like soft effects, you will use blending techniques or try wet-brushing. But some beginners, while knowing exactly the effect they want to create, are unable to achieve it. This can be due to lack of practice, but often results from choosing the wrong paper. Thick overlays of color, for example, work best on a textured surface, such as pastel board, sandpaper, or watercolor paper; on standard pastel paper the top layer of color tends to fall off, no matter how carefully you apply it.

When you see paintings you admire, either in this book or in a gallery, try to analyze the artist's methods. Unless you are one of the lucky few with a strong natural gift, it is difficult to develop your art in isolation. You can sometimes learn more by looking at other people's work than through hours of practice.

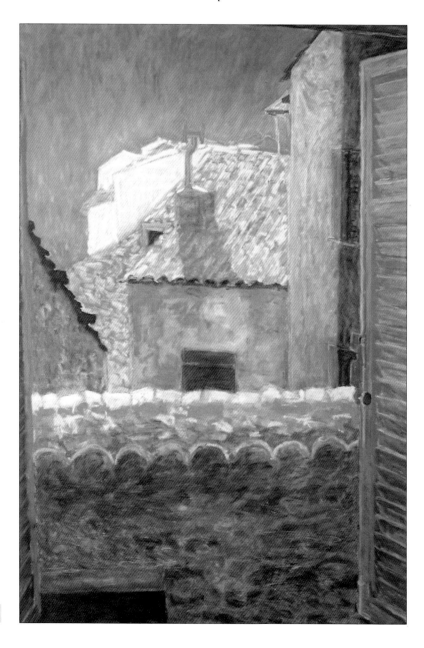

BROKEN COLOR
Like the painting of flowers on page 10, this is worked on pastel board, but the artist's technique is entirely different. He built up the picture in short strokes of varied sizes and directions, so that each area of color is "broken" – that is, not completely flat. Alan Oliver used a similar method for the sea and sky in his seascape on page 11. The effect is more vibrant than solid or blended color. (Window, Valensole – *Patrick Cullen*)

Broken color in sky gives more convincing effect of light than flat color.

Size and shape of pastel marks suggests texture of wall; colors are varied and exciting.

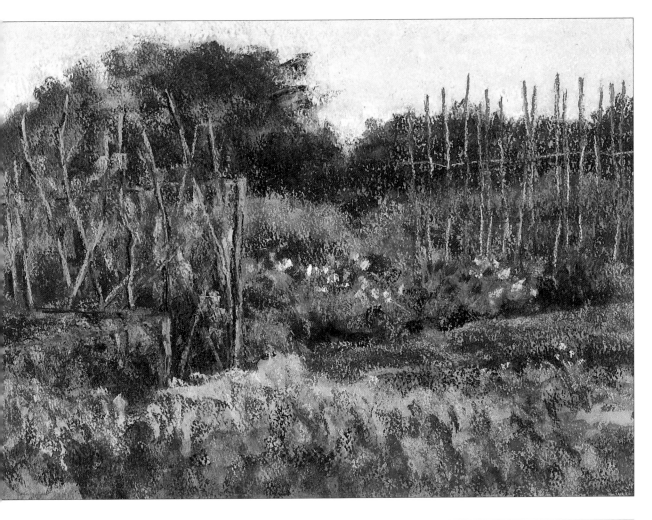

WORKING ON WATERCOLOR PAPER

Pastel painters who like a definite texture often work on watercolor paper, whose irregular surface breaks up the pastel marks in interesting ways. The paper is usually tinted first, because it is difficult to work on white. Here the artist applied an underpainting of acrylic washes. She then swept in the pastel color using side strokes, and gradually built up forms, textures, and details. (Rottingdean Allotments – Judy Martin)

Linear details and vivid color accents added in final stages with tip of pastel stick.

Heavy texture breaks up pastel strokes, allowing each layer of color to show through the next.

1

What You Will Need

About Pastels

WHAT YOU
WILL NEED

All painting media – oil paints, watercolors, acrylics, and pastels – have the same basic component: pigment. Pigment is a colored powder, once obtained from natural sources, such as plants and minerals, but now mainly synthesized in laboratories. What gives each medium its own characteristic is the binder and other substances used to form the tubes or pans of paint or sticks of pastel. In the case of pastel, a tiny amount of gum is sufficient to prevent the sticks from falling apart. Thus pastel is almost pure pigment, possessing a brilliance of color unrivaled by any other medium.

PASTEL TYPES

There are four basic kinds of pastel: soft (sometimes known as chalk pastels), hard, pastel pencils, and oil pastels. The last are outside the scope of this book, because their consistency and method of manufacture is different from that used for "dry" pastels, and the two are not compatible.

The emphasis here is on soft pastels, since these are favored by the majority of pastel painters. Both hard pastels and pastel pencils can be useful on occasions – either on their own or in conjunction with soft pastels – and these are mentioned where relevant.

Soft pastels are made in cylindrical sticks, the diameter varying with the brand. Hard pastels, usually square-sectioned, are less crumbly than soft pastels and therefore effective for sharp lines, details, and linear techniques. They also provide a good way of blocking in the picture (see p.64). Pastel pencils – softer than hard pastels but harder than soft ones – are often used for making a preliminary drawing (see p.62) as well as for adding touches of detail and definition.

Pastels, particularly soft ones, vary considerably according to the manufacturer, with some brands classified as soft being harder than others.

Continued on page 20 ▷

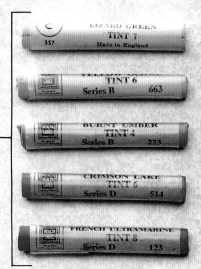

SOFT PASTEL STICKS
Soft pastels are made in a variety of shapes. These sticks are light and easy to handle. The paper wrappers protect your hands from dust as well as making the sticks less likely to break. As you wear down the point, tear off a little of the paper at the tip.

HALF-LENGTH STICKS
These short sticks cost less than the full-length ones and are made especially for beginners. They are less prone to breakage, so they are sold without wrappers.

CHUNKY PASTELS
For those who like to work on a large scale and prefer broad effects to fine detail, these cigar-shaped pastels are ideal.

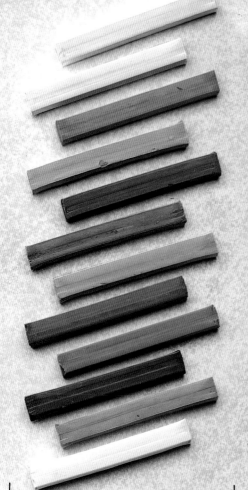

Something you need to know is that nearly all pastel colors come in different "values"—that is, darker or lighter gradations of each individual hue. These values, called "tints" by some manufacturers, are denoted in different ways. Some number them from 1 to 10, the lowest number denoting the lightest and the highest one the darkest. Tints are made by adding white, and shades by adding black, to the pigment; so if you want the color in its purest form, look for a middle number. Again, you will quickly get used to choosing by eye.

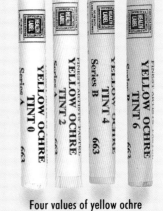

Four values of cobalt blue Four values of yellow ochre

HARD PASTELS

Not all pastel painters include hard pastels in their equipment, but hard pastels are useful for blocking in at early stages and for finishing touches.

PASTEL PENCILS

Pastel pencils are also good for fine detail, and for sharpening edges that have blurred. Their primary use, however, is for making the preliminary drawings. Never draw with an ordinary graphite pencil, because you can't easily cover the marks with pastel.

Some are so crumbly that you almost have to spread the color with your fingers. With experience you will discover which type you like best. This may involve trial and error, but you need not waste pastels if you switch brands, since they are all compatible with one another.

COLORS

Color ranges also differ from one brand to another, and so do the names of the colors, which can be confusing. Some pastels are straightforwardly named according to the pigment – for example, "ultramarine blue" or "cadmium red." Others have more fanciful names, such as "glowing ruby red." If you are selecting colors from a wide range, or combining colors from several manufacturers, you may have to choose by eye, which you will find easy once you have made a start. It is also fun – there is nothing more enticing than a drawer full of richly colored pastel sticks.

THE STARTER PALETTE

Pastels are made in a huge range of colors – some manufacturers produce over 200 – but you can start with 20 to 30, adding more as you need them. But how do you know which colors to buy? A good rule of thumb is that you will need at least two versions of each of the primary hues (red, yellow, and blue), three or four greens and browns, two different grays, a white, and a black. Our recommended palette, with 26 colors, also has an orange, a mauve, and a purple.

Many beginning artists start with one of the small boxed sets produced especially for newcomers to the medium. Some of these are fine, but check whether the set conforms to the guidelines above. If it does not include black, for example, or has only one red, you may need to buy those colors separately.

BOXED SETS
(above) Most pastel manufacturers produce starter sets of between 12 and 20 colors. These are adequate for early experiments, and you can buy more colors as single sticks once you begin to work seriously.

MAKING A COLOR CHART

Sooner or later you will have to replace some of your colors, and by the time the pastel stick is worn down to a stub, you will almost certainly have lost its wrapper. So how will you know which color to take from the drawer in the art supply store? It is no good trying to guess; instead, be methodical and compile a color chart as soon as you have made your initial purchase. Put down a sample of each color, with the name and value number underneath, and pin the chart up on the wall or keep it in a ring binder or a small spiral-bound sketchbook.

A recommended starter palette

The 26 colors shown here provide a range of values suitable for most subjects. Our artists used this palette for all the demonstrations in this book except those in the final chapter. Additional colors can be produced by mixing, as shown on pages 44–47, and variations of tone (light and dark) made by using a light or heavy pressure, or by adding white.

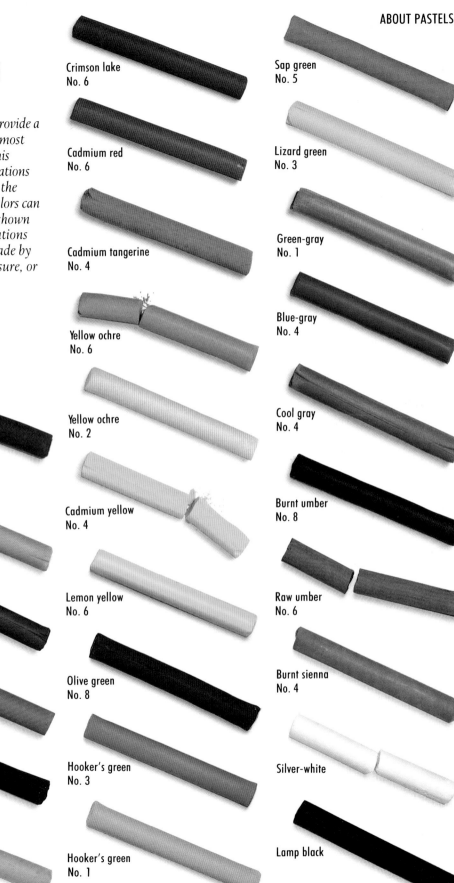

Crimson lake
No. 6

Cadmium red
No. 6

Cadmium tangerine
No. 4

Yellow ochre
No. 6

Yellow ochre
No. 2

Cadmium yellow
No. 4

Lemon yellow
No. 6

Olive green
No. 8

Hooker's green
No. 3

Hooker's green
No. 1

Sap green
No. 5

Lizard green
No. 3

Green-gray
No. 1

Blue-gray
No. 4

Cool gray
No. 4

Burnt umber
No. 8

Raw umber
No. 6

Burnt sienna
No. 4

Silver-white

Lamp black

Ultramarine blue
No. 6

Ultramarine blue
No. 1

Prussian blue
No. 3

Cerulean blue
No. 4

Purple
No. 6

Mauve
No. 2

21

Pastel Care

A boxed set of pastels contains a tray of preformed slots to which you can return your sticks after each working session. But if you choose a starter palette of loose pastels, you will need to consider ways of organizing the pastels neatly and keeping them separated so that they remain clean.

You can buy grooved boxes to fill with your own selection of colors, or you can save money by using your ingenuity. For example, corrugated cardboard is ideal for separating pastels, and you can utilize it to line the small oblong cardboard boxes in which manufacturers package their pastels and tubes of paint.

As you build up your collection of sticks, you will need a larger container — so keep your eyes open for a long, flat box with a well-fitting lid. If you haven't any corrugated cardboard, you could line the box with ground rice. This not only cushions the pastels but helps to keep them clean, because the rice absorbs the dust that always collects on the surface of the sticks.

KEEPING CLEAN
Line a box or dish with ground rice and make it your palette for the pastels you use during a working session. Replace each stick before you pick up a new color; this will keep the sticks clean and avoid breakage.

However carefully you store your pastels, you can't always keep them clean when you are working. Eventually, they will become dirty, because pastel dust on your hands will be transferred to a previously clean stick. They can be cleaned easily with ground rice or a similar grain, such as semolina.

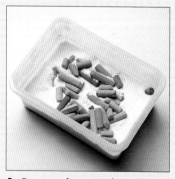

1 *Put your dirty pastels into a container full of ground rice and shake them until the muddy-colored dust is absorbed by the grain.*

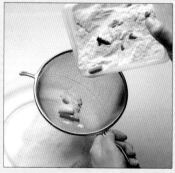

2 *Empty the contents of the container into a sieve or a colander to strain off the rice. Your pastels are now clean.*

This all-in-one easel and storage tray is ideal for the outdoor painter. The box hooks onto the easel, and can be detached and carried separately. However, such items are expensive and are not really necessary for painting indoors, where you can keep your pastel box on a tabletop.

SAFE STORAGE
Corrugated cardboard holds the sticks firmly in individual grooves, so that they remain clean and are less likely to break.

The sliding lid keeps pastels well cushioned for carrying.

IMPROVISED STORAGE BOXES
If you can't find satisfactory custom-made pastel boxes, look for suitable containers, such as this cutlery tray. If you have a lot of colors, you cannot keep each one separate; but try to arrange them in recognizable groups, so that you can quickly pick out the ones you need.

Paper Texture

Because pastel is such a soft, crumbly medium, it does not adhere well to a smooth surface. Because of this, pastel papers are manufactured with a slight "tooth," or texture, which "bites" the powdery pigment and holds it in place. There are several types of paper made especially for pastel work. The two best-known and most readily available are charcoal paper and Mi-Teintes. The first has a pattern of straight lines, while the texture of the second resembles fine chicken wire. But Mi-Teintes is effectively two papers in one, as you can use the smoother side if you prefer — it has a less obtrusive texture but it still holds the pastel.

If you like to work thickly, you may want to experiment with three other kinds of paper: sandpaper, pastel board, and velour paper. Sandpaper, made for carpentry work and available in different grades from very coarse to very fine, is popular with pastel painters — usually the finer ones are chosen. Some art suppliers produce a version specifically for pastels, called sanded paper, which comes in much larger sheets. Buying pastel board can be confusing, because it is also known under a variety of brand names, including Sansfix paper and Rembrandt paper; but all pastel board is made from tiny particles of cork pressed together to give a surface a little like sandpaper but less scratchy. Velour paper has a lovely velvety feel, and gives a soft line.

You can also work on papers not specifically designed for pastel work, such as watercolor paper, a popular choice among many pastel painters. This paper has a relatively heavy texture that holds the pigment well, but because it is white, you may want to color it (more about this on page 72). As you will see on the following pages, pastel papers are nearly always colored.

TEXTURE RANGES

This photograph shows the two standard pastel papers and some more specialized ones. The chart opposite demonstrates how the pastel behaves on the different textures.

Charcoal paper

Mi-Teintes paper

Sanded paper

Pastel board

Watercolor paper medium surface (cold-pressed)

ENSURING A SMOOTH SURFACE

If you work on one of the thinner papers, you may find that blemishes can be caused by the slightest scratches or bumps in the drawing board. Cushion your painting surface by putting a sheet of paper beneath it. This can be any regular white paper or another sheet of your chosen pastel paper.

Finding the best surface

It often takes time to discover which paper best suits your way of working. This at-a-glance chart offers some suggestions, but it's a good idea to experiment, starting with the less expensive papers made especially for pastel work.

CHARCOAL PAPER

Lines show through the pastel unless very heavily applied.

MI-TEINTES PAPER

Regular texture is always visible but can add interest to your work.

MI-TEINTES, "WRONG" SIDE

Smoother but with enough texture to hold the pastel.

SANDED PAPER

Grips color well; is suitable for detail, as it does not break up the strokes.

MEDIUM SANDPAPER

Breaks up strokes; not suitable for fine lines or detail.

VELOUR PAPER

Pastel sinks into the surface, so that the edges of strokes are softened.

PASTEL BOARD

Grips pastel well, allowing one color to be laid thickly over another.

WATERCOLOR PAPER

Heavy texture; pastel "sits" on top of grain unless pushed in.

Paper Color

Pastels can be done on white paper, but this is the exception. Colored papers are usually chosen, and paper manufacturers produce a large range, from neutral grays and beiges to vivid primary hues.

The reason for working on colored papers is simple and practical. As we have seen, pastel papers have a surface texture, so unless you apply the color very heavily, it is virtually impossible to cover the paper completely. The color sits on top of the raised texture, and there are always flecks and patches of naked paper showing between and around strokes. If the paper is white, this creates a disturbing, jumpy effect in the finished picture.

Moreover, it is difficult to work on a white surface, because it is hard to assess the first colors you put on. Since everything looks dark against white, you may find that you begin with colors that are much too pale, setting a wrong "color key" for the picture. A gray or beige paper allows you to judge both the light and the dark colors, because it provides a middle tone.

Pastel is a partnership between pigment and paper, and if the color of the paper is chosen with care, it enhances the work. In many pictures, large areas of paper are deliberately left uncovered. Landscapes are often done on blue or blue-gray paper, with the sky left as the paper color. In portraits the face and figure are worked in pastel, while the background consists entirely or almost entirely of the paper color, perhaps with a few light strokes to suggest furniture or a window frame to give a context to the figure.

Although exciting results can be achieved with dark or brightly colored papers, these are difficult to manage and are not recommended for early attempts. Initially it is best to go for a gray, gray-blue, or beige, any of which will give you a neutral background that won't interfere with your perception of the pastel colors.

COLOR CHOICES

Pastel papers are made in a wide range of colors, but beware of the more vivid ones, as they can influence your paintings in a negative way. For example, it would be difficult to achieve a gentle color effect on a bright red paper.

The two standard pastel papers, charcoal and Mi-Teintes, can be bought as individual sheets or in pads, usually spiral bound. Some pads contain a variety of colors. Look through these before you buy them – some of the colors may be too bright or dark for normal use, and could be wasted. Avoid buying a small pad that may inhibit you from working freely; soft pastel is best used as a broad medium.

Large sheets can be bought individually.

Pad sizes range from pocket size to portfolio size.

The effect of paper color

These charts show six colors (pale yellow ochre, pale ultramarine blue, crimson lake, Hooker's green, lizard green, and raw umber) on three different paper colors. Even these neutral papers affect the appearance of the *first colors applied; the yellow virtually disappears on the cream paper, so you would need to begin with the darker colors, leaving the pale ones until you have hues to judge them against.*

GRAY PAPER	BLUE-GRAY PAPER	CREAM PAPER

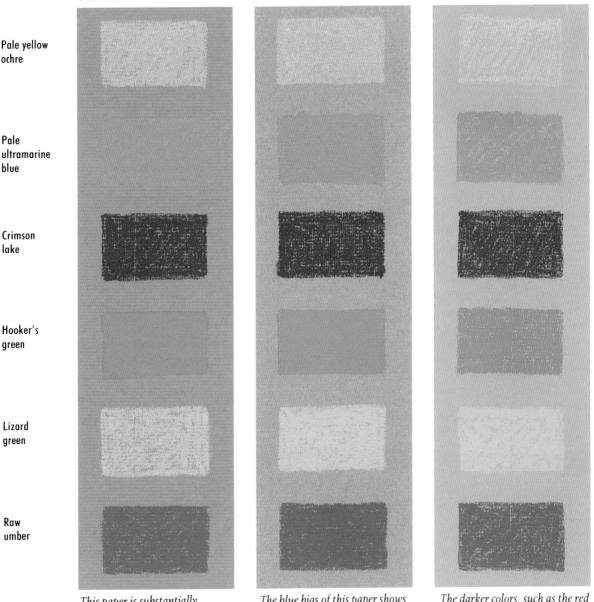

Pale yellow ochre

Pale ultramarine blue

Crimson lake

Hooker's green

Lizard green

Raw umber

This paper is substantially darker than the others, showing the yellow well. The three mid-toned colors – blue, light green, and raw umber – look much paler than they do on the second paper.

The blue bias of this paper shows the yellow and greens to advantage. It is a popular choice for landscapes, because areas can be reserved for sky and for highlights on foliage.

The darker colors, such as the red and deep green, show up well on the light paper, while the raw umber looks darker than on the other papers.

The Studio and the Portable Kit

**WHAT YOU
WILL NEED**

One of the many attractions of pastel work is that you don't need much equipment; the basic requirements are pastels and paper. However, there are a few items useful to have on hand before you begin painting.

The first is something to support the paper. You don't have to go to the expense of buying a ready-made drawing board; most of the boards sold as building material are usable — plywood, masonite, or smooth-surfaced particleboard.

If you work on a large scale, consider buying an easel. And since you won't want to dirty the floor, you will need some kind of ground cover, such as a dropcloth or even an old sheet.

Rags for cleaning your hands periodically are essential — pastel is a messy medium. Rags are also useful for blending (see p.48). You should have a tortillon and some cotton swabs handy for blending in small areas, and a kneaded eraser for correcting errors. The final item is fixative. There is nothing worse than smudging a completed painting with your hand, and fixative will help to prevent this. Take it on location, and fix your work before carrying it home.

BULLDOG CLIPS
Bulldog clips can be used for holding paper on a thin drawing board, such as plywood or masonite.

SINGLE-EDGE RAZOR BLADE
A razor blade with a cover is an alternative to a craft knife.

KNEADABLE PUTTY ERASER
Have an eraser handy for correcting preliminary drawings.

PLASTIC STORAGE CONTAINER
For transporting pastels, a plastic storage container is ideal.

CRAFT KNIFE
A craft knife is useful for sharpening pastel pencils and for cutting paper.

OUTDOOR SKETCHING EQUIPMENT CHECKLIST

It is frustrating to find that you have forgotten something vital when you are out sketching. Make a list of everything you normally use, and any extra clothing you might need, and check off each item as you gather them together.

- ✓ Box of pastels
- ✓ Pastel paper – take several sheets
- ✓ Pastel pencils or charcoal, for drawing
- ✓ Drawing board
- ✓ Masking tape or thumbtacks
- ✓ Easel
- ✓ Folding stool or chair
- ✓ Kneaded eraser

- ✓ Tortillons or cotton swabs
- ✓ Rags or baby wipes
- ✓ Fixative
- ✓ Tracing or tissue paper to protect work
- ✓ Plastic bag large enough to contain board, in case of rain
- ✓ Rainwear, sweater, sun hat, depending on climate

BRUSHES
Brushes are not essential, but are useful for blending and for flicking off excess pastel.

MASKING TAPE
For fastening large sheets of paper to the drawing board, masking tape is better than bulldog clips.

TORTILLONS
Tortillons are used to blend small areas.

COTTON SWABS
Cotton swabs are an inexpensive alternative to tortillons.

COTTON
Cotton is good for larger-scale blending.

RAGS
Rags or paper towels help keep your hands clean as you work.

WOODEN BOARD
A specially made board is a luxury; there are many cheaper alternatives.

PROTECTING THE FLOOR
Even an uncarpeted floor needs protection while you work, because pastel dust flies around if you try to sweep it up. Put an old sheet, a drop cloth, or a sheet of plastic under your easel. Shake it outside gently when you have finished working.

USING SPRAY FIXATIVE
Fixative comes in aerosol cans or in jars for use with mouth-operated atomizers. The aerosols (now free of CFCs) are recommended, because they are easy to use and produce a reliably even spray. Read the instructions on the can before you proceed; do not stand too close, and avoid overwetting the paper, which can cause blotches and color runs. Don't use fixative in a heated room with the windows closed, as the fumes are unpleasant. A kindlier alternative to fixative is odorless hairspray, which has the same effect with less smell.

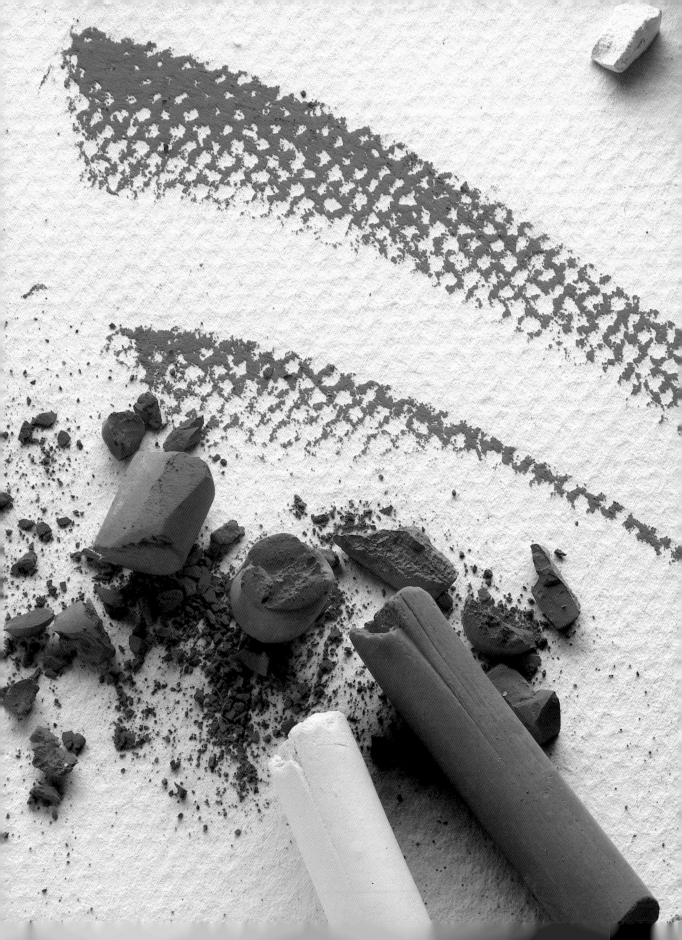

2

First Marks

Working with Pastels

Don't keep a bunch of pastels in your nonworking hand. They will quickly dirty through contact with one another, and you may also drop and break them.

FIRST MARKS

As soon as you start to use your pastel sticks, you will discover that pastel is a messy medium. Colored dust falls onto any nearby surface, your hands become covered with it, and perfect new pastel sticks acquire a muddy coating from jostling with other colors on your worktable.

As explained on page 22, you can occasionally clean your pastels with ground rice, but you should try to keep the sticks as neat as possible while you are working. This means training yourself to be methodical.

When you are in a hurry to get something down on paper, it is natural to pick up a new color before putting the previous one back in the container; after a while you may find yourself with a handful of colors. But however natural the habit, it is not wise. A better practice is to make an improvised palette to hold the colors you are using at any one time and to which you can return the pastels systematically. A length of corrugated cardboard is ideal for the purpose, and so is a tin dish with ground rice in it.

Your hands will become soiled from the pastel sticks, so keep a damp rag on hand for cleanup between color changes. Apart from the risk of dirtying your work, you may have to answer the doorbell or the telephone. And it's a good idea to wear an apron, smock, or an old shirt to protect your clothing.

AVOID SMEARING

It is easy to smear completed areas of a painting with your hand. If you are working at the top of the picture, cover the lower parts with clean paper.

USING A MAHLSTICK

An alternative is to use a mahlstick, which you can make by padding one end of a piece of cane or dowel. This keeps your hand away from the paper and gives better control for details.

TRYING OUT COLORS

Leave a margin around the edges of your picture for testing colors. Alternatively, keep a spare piece of paper nearby as a test sheet. This is useful when trying to match a color you have already used.

WORKING POSITION

It is best to work at an easel with the board upright. This allows you to step back and assess your work from a distance; you cannot judge it properly if you are too close. If you have no easel, lean the board against a wall.

WORK AREA

You will need a surface of convenient height to set out your materials within easy reach. This could be a small table or a board on top of a stool. Keep a damp rag there so that you can clean your hands when necessary.

SHARPENING PASTELS

BREAKING PASTELS

Pastels can be sharpened with a knife, but the point will quickly wear down. Fine lines can be achieved by using the edge of the pastel stick, or making a new edge by breaking one of the sticks in half.

USING SANDPAPER

An alternative is to rub the end of the stick over a piece of sandpaper. This is more wasteful, since you will lose a good deal of the color, whereas broken sticks can still be used.

33

Line Strokes

FIRST MARKS

The marks you make with your sticks of color are the bricks and mortar of your pastel paintings. They can describe form and volume, convey texture, and create outline and detail. And, more than this, they are your personal handwriting, making your work different from that of any other artist.

The more you can practice, the better. You will gain experience in handling pastels as well as building up a repertoire of marks. After a while you will know instinctively which ones to use in your paintings, just as the process of handwriting becomes so automatic that you no longer consider how each letter and word are formed.

The strokes made with the tip or edge of the pastel stick can be infinitely varied, so begin by doodling to see how many different ones you can achieve. Try long, light strokes; short, jabbing ones; curves and dots. Try making strokes that change from light to heavy, or from fine to thick, depending upon the pressure you apply and the angle of the pastel stick to the paper.

Experiment with ways of holding the pastel: for light strokes you can guide it loosely with your fingers near the top end, while for short, dense marks requiring greater pressure, you will need to grip the stick near the drawing end. If pastels break, as they will under pressure, don't worry, because you will need smaller lengths to try out the side strokes discussed on page 36.

Try a range of squiggling marks made with a blunted point.

Vary the stroke from thin to thick, starting with a sharp edge which becomes progressively worn down.

Make short strokes with the sharp tip of the pastel.

Make short, straight, jabbing strokes, holding the pastel near the end.

HEAVY PRESSURE

Heavy pressure, with the pastel pushed into the paper grain, gives stronger color.

LIGHT PRESSURE

The lighter the pressure, the paler the color will look, as the pastel only partially covers the paper.

Use the edge of the stick to draw fine lines and long, sweeping strokes.

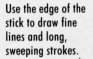

Try several colors, making strokes that follow different directions and overlap one another.

PUTTING LINE STROKES INTO PERSPECTIVE

Now that you have practiced your line strokes, try using them for a real subject. Choose something simple, like the leaf shown here, or a single still life object, such as a mug or piece of fruit. Vary your lines, making some sharper than others, some heavy, and others light. When you come to try out the side strokes shown on the next page, use the same subject so that you have a direct comparison and can see how the kind of strokes you make affects the quality of the image.

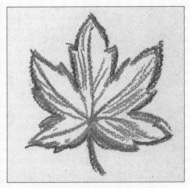

Here simple lines were used, with medium pressure. The orange strokes in the center follow the directions of the forms, giving the impression of the gentle curves and swells without the need for heavy shading.

For the background, diagonal hatching lines (see p.56) have been used, in different colors and pressures. The orange lines on the leaf were drawn with a blunt point, and the veins with a sharp one.

Side Strokes

Line strokes give excitement to a pastel painting because they are immediately noticeable, but side strokes can be equally expressive in a quieter way. Although these are the strokes to choose for covering large areas, this is not their only application. Side strokes can be nearly as varied as line strokes, depending upon the pressure, the direction of the stroke, and the size of the piece of pastel used.

This last point is important, because to make side strokes you have to sacrifice some of your sticks of color and break them into pieces of a suitable length to create the effect you want.

Take a piece of pastel half an inch to two inches long, and rub it over the paper once or twice until a flat side is created. Then try different directions of strokes — from long, straight, even ones to short curves — and different pressures. You will see that a heavy pressure forces the pigment into the grain of the paper, while light pressure creates a veil of color on the surface of the paper. Pressure can be varied in a single stroke, creating a gradation from light to dark.

Make broad strokes with a one-inch length of pastel and medium pressure.

Then make shorter strokes with a half-inch piece and heavier pressure.

Make long strokes, varying the pressure from heavy to light and twisting the stick slightly.

HEAVY PRESSURE

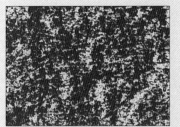

Heavy side strokes produce solid areas of color, with little of the paper showing through.

LIGHT PRESSURE

Light side strokes give a veillike effect of pale, hazy color.

When you use side strokes for a subject that you have previously described with line strokes, you will immediately see the difference. Side strokes are lovely for covering large areas, but you can't achieve detail with them. These two renderings give a broad impression of the leaf. Further definition could be achieved by combining side strokes and line strokes (see overleaf).

Angle the pastel stick in different ways so that the marks change from thick to thin.

Try a series of curves, following different directions, and again varying the pressure.

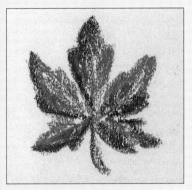

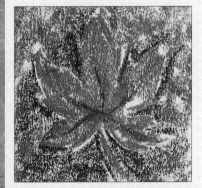

Several different colors have been used, with medium pressure. Notice that where one color has been applied over another color, a mixture is created. The orange laid over the blue results in a brownish hue.

Both the pressure and the direction of the strokes have been varied. In the background, small, short strokes of orange overlay light and heavy applications of blues. A single tapering stroke has been used for the stem.

Combining Strokes

Some artists use only line strokes, and others only side strokes – blended or unblended – but most often the two are combined. Sometimes you won't see the side strokes in a finished picture, because they are utilized mainly to block in the colors (see p.64) and then are overlaid with lines to create a more interesting surface.

If you keep the side strokes fairly light, you can work over them with lines of the same or a different color, and similarly you can work over lines with side strokes. Try out both these options, varying the pressure of your strokes as before, and see how the results differ.

Then try putting line and side strokes side by side in any way you choose. Don't think too much about what you are doing, just let your hand roam over the paper, and if you see an effect you like, remember it or make a note of it, because it may come in handy later for a picture. This type of practice may seem aimless, but it is never wasted, because the more you handle your pastels the better they will respond.

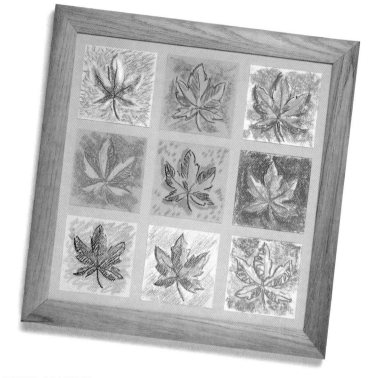

MAKING A SAMPLER

In the past, children who were learning embroidery used to make samplers, combining a variety of different stitches in one piece of work, and you can do the same thing with your pastel marks. Using the same subject you chose before (see pp.35 and 37), and the colors in the starter palette, try combining strokes, as shown opposite. Use both the "wrong" (smooth) side and the textured side of Mi-Teintes paper for further variety. When you have several samples you are pleased with, stick them all together (see below) and pin up the finished piece on your wall. It will make a pleasing decoration as well as serving as a reminder of how to achieve certain effects.

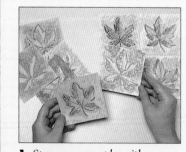

1 *Spray your samples with fixative to avoid smudging, then spread them out on a tabletop and shuffle them gently around to see which ones look best next to one another. Try different arrangements until you find one you like.*

2 *Cut out a piece of background paper 14 inches square, and use a ruler to draw 4-inch squares, leaving ½ inch between each one. Then carefully apply paper glue to each square and stick on the samples one by one.*

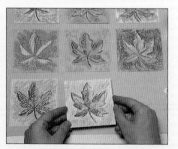

3 *The sampler almost completed. As in a patchwork quilt, aim for a good balance of colors and tones. Here the dark brown and green on either side of the central leaf show it up well.*

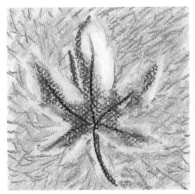

Background: side strokes of ultramarine blue with cadmium red. Leaf: side strokes of ultramarine blue and white; lines of black.

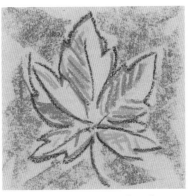

Background: side strokes of cerulean blue. Leaf: line strokes of tangerine, ultramarine blue, and yellow ochre; lines of lizard green.

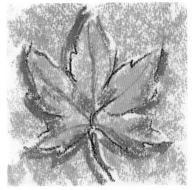

Background: side strokes of burnt sienna and raw umber. Leaf: side strokes of mauve overlaid with shorter side strokes of burnt sienna.

Background: crisscrossing side strokes of cerulean blue and lizard green. Leaf: side strokes of lizard green; outlines and hatching lines of sap green.

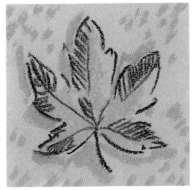

Background: short, blunt side strokes of yellow ochre. Leaf: side strokes of mauve, overlaid with line strokes and hatching in purple.

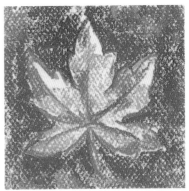

Background: burnt sienna side strokes overlaid with yellow ochre side strokes. Leaf: side and line strokes of Hooker's green, yellow ochre, and burnt sienna.

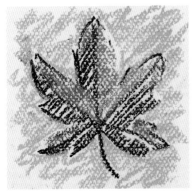

Background: squiggly strokes of light ultramarine blue. Leaf: side strokes of burnt sienna; line strokes of black.

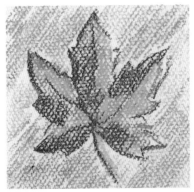

Background: long line strokes of lizard green and Hooker's green. Leaf: side strokes of lizard green; side strokes and medium to heavy lines of Prussian blue.

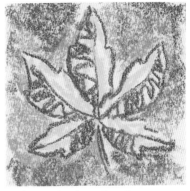

Background: side strokes of mauve overlaid with side strokes of burnt sienna. Leaf: very blunt line strokes of cadmium yellow; varying-thickness line strokes and squiggles of burnt sienna.

Gestural Drawing

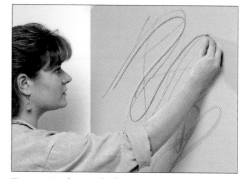

To practice this method, you need to work freely, without fear of unsteadying the easel; so pin a large sheet of paper to the wall. Make bold, sweeping strokes over the surface.

FIRST MARKS

Artists sometimes use the word "gesture" or the term "gestural mark" to refer to a mark that is more exploratory than exact. You often see this in drawings of people or animals in motion — one line is drawn over another in free and rapid movements of the hand and wrist. The effect gives the impression of movement, and the network of lines rather than one line alone creates the image.

Because the essence of this method is to work broad and free, you should not be too close to your picture. It is best either to stand at an easel or to have your paper pinned to the wall, and to hold the pastel at arm's length so that you can work "from the elbow."

Choose a subject in which movement is important, such as a galloping horse, a running figure, or a group of dancers, and try to let your use of the pastel describe this quality. You can tackle landscape subjects in a similar way, using both line and side strokes. You might, for example, build up the impression of wind-tossed trees by means of scribbled line and loose hatching, and employ short, bold side strokes for scudding clouds.

This method of working is good practice for anyone who tends to be timid or whose approach is overly tight and fussy. Removing the possibility of achieving fine detail can free you to focus on the key qualities of the subject.

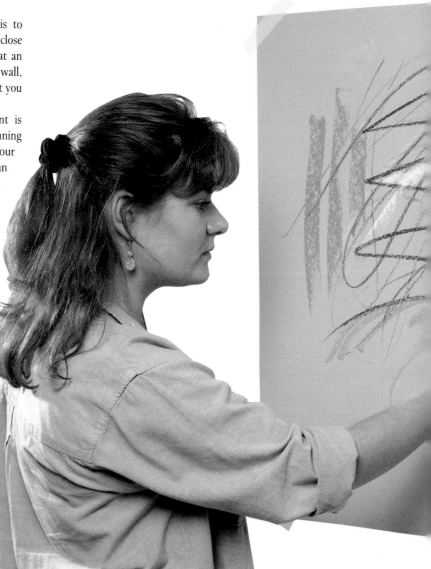

VARYING THE STROKES

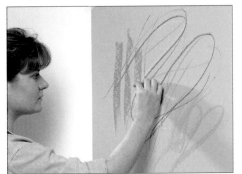

Now try to vary the strokes, using the side of a short length of pastel to add broad, straight lines over and through the curves.

BUILDING UP THE PICTURE

Continue to build up the effect, filling some areas and leaving others open. Don't think too hard about what you are doing; just get the feeling of working "from the elbow."

LINE AND MOVEMENT

As you can see from these sketches, rapidly drawn and varied lines are ideal for describing movement. The artist worked on large sheets of paper to give scope for bold, sweeping lines and side strokes, and the speed at which she made the drawings conveys a sense of urgency. The landscape is particularly interesting, showing that a powerful impression can be given with almost no color – just the color of the paper plus black and white.

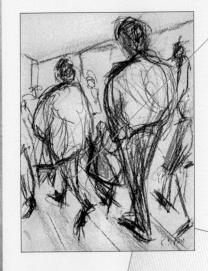

The series of curving and straight lines on a diagonal used for the leg seem to propel the figure forward in space.

Light side strokes, which describe the rounded forms, are overlaid with line strokes following the direction of movement.

Line strokes softened by rubbing with a finger follow the direction of the windblown path.

3
Building Up
Your Skills

Color Mixing

One of the most appealing things about pastels is that the process of mixing colors takes place on the paper itself. Instead of colors being mixed on a palette beforehand, they develop as you work.

What often happens with pastels is that as soon as you put a mark on the paper, you see that it's either too light or too dark. You can lighten any color by laying white on top, either blending it in (see pp. 48–51) or leaving it as is.

Black is effective for darkening blues, greens, and browns but of little use for yellows and reds because it changes the nature of the colors. Black and yellow produces green, and black and red makes brown. To darken yellow, try mixing it with light brown. Red can be darkened either with deep brown or with purple.

CHANGING THE HUES

When you are working with a small selection of colors, you may have to mix them in a more dramatic way – combining two colors to make a third (see pp.46–47). To do this successfully, it helps to know a few basic facts about color.

There are three colors that can't be produced from mixtures of other colors. These are red, yellow, and blue, which are known as the primary colors. Mixtures of any pair of these produces what is known as a secondary color. Blue and yellow make green; blue and red make purple; and yellow and red make orange. A mixture of all three primary colors, or of one primary and one secondary color (three colors, in effect) makes what is called a tertiary color. Some of these tertiaries are the browns and grays, which are described as neutral, but they can also be quite vivid. For example, if you mix two colors that are next to one another on a color wheel, such as blue (primary) and green (secondary), you will have blue-green, which is not a neutral color.

Continued on page 46 ▷

White Black

Crimson lake

French ultramarine blue

Cadmium yellow

Cadmium tangerine

Hooker's green

Purple

MIXING WITH WHITE AND BLACK

This chart shows some interesting variations in the effects of white and black. The purple, green, and yellow retain their character when white is added, but the red and orange turn pink. The black works with the blue, green, and purple, but turns the yellow into green and the red into brown.

SECONDARY MIXES

The secondary colors – oranges, greens, and violets – are a combination of two primary colors: red + yellow, blue + yellow, and red + blue. Secondaries are achieved by applying one primary over another but are not always worthwhile. Although red and blue make purple, it is less vibrant than a ready-made purple.

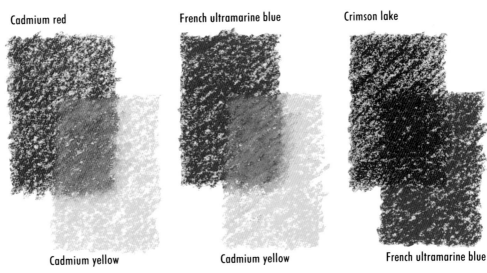

Cadmium red

French ultramarine blue

Crimson lake

Cadmium yellow

Cadmium yellow

French ultramarine blue

ALTERING COLORS

Colors can be lightened, darkened, or modified in any number of ways by applying one over another. The yellow over green produces a pale but vivid yellow-green, the green over cerulean blue a subtle blue-green, and the same green over ultramarine blue a stronger blue-green. Lemon yellow over burnt sienna makes a subtle orange; red mixed with burnt umber produces a rich color more interesting than the umber alone, and ultramarine blue deepens and enriches the green-gray. Conduct some experiments of your own – it is the best way to learn about color mixing.

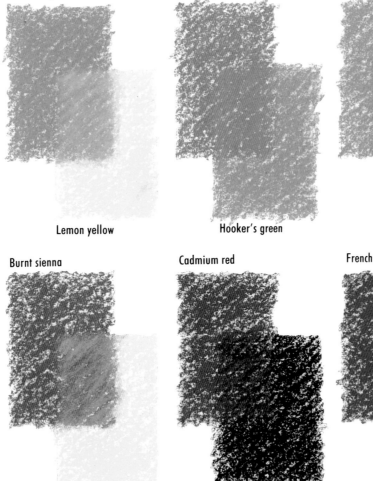

Hooker's green

Cerulean blue

Hooker's green

Lemon yellow

Hooker's green

French ultramarine blue

Burnt sienna

Cadmium red

French ultramarine blue

Lemon yellow

Burnt umber

Green-gray

Wherever possible you should avoid mixing three primary colors, as the paper can become clogged and the mixture muddy. It is best to restrict yourself to two-color mixes. An effective way of producing a neutral tertiary color is to use opposites on the color wheel or complementary colors. Three common pairs of complements are red and green, blue and orange, and yellow and violet – each pair consisting of one primary and one secondary color. They are so different, they neutralize one another when used in mixtures.

Because pastel colors can't be premixed as paints can, manufacturers produce a good many secondary and tertiary colors. Even so, you will often have to modify existing colors. No pastel box, however extensive, contains enough greens to match the diversity of nature, so you may find you have to add yellow, blue, or even its complement, red, to alter an existing green. And once you become familiar with your colors, you may discover that you can make a better green by mixing yellow and blue, or a subtle purplish-brown by combining red, blue, and yellow.

MIXING COMPLEMENTARY COLORS

Mixtures made by applying one color over its complement, or opposite on the color wheel, are especially useful for shadows, which often lack sparkle. The mixtures here are half-and-half, but you can also use touches of a complementary color to gray a hue. If a green in the middle distance of a landscape looks too bright, for example, lay a very light veil of red over it.

TWO-COLOR MIXTURES

This chart shows all the starter-palette colors mixed by being overlaid in equal proportions. This gives you an idea of the range you can achieve, and you can create many additional colors by varying the proportions of the mixtures, or by adding white.

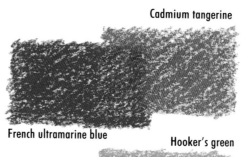
Cadmium tangerine

French ultramarine blue

Hooker's green

Cadmium red

Mauve

Cadmium yellow

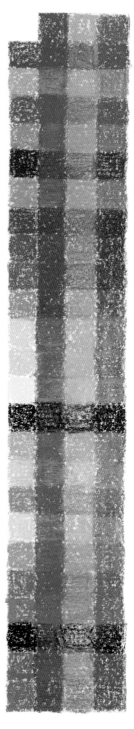

Ultramarine blue No. 6

Ultramarine blue No. 1

Prussian blue No. 3

Cerulean blue No. 4

Purple No. 6

Mauve No. 2

Crimson lake No. 6

Cadmium red No. 6

Cadmium tangerine No. 4

Yellow ochre No. 6

Yellow ochre No. 2

Cadmium yellow No. 4

Lemon yellow No. 6

Olive green No. 8

Hooker's green No. 3

Hooker's green No. 1

Sap green No. 5

Lizard green No. 3

Green-gray No. 1

Blue-gray No. 4

Cool gray No. 4

Burnt umber No. 8

Raw umber No. 6

Burnt sienna No. 4

Cerulean blue No. 4

Purple No. 6

Mauve No. 2

Crimson lake No. 6

Cadmium red No. 6

Cadmium tangerine No. 4

Yellow ochre No. 6

Yellow ochre No. 2

Cadmium yellow No. 4

Lemon yellow No. 6

Olive green No. 8

Hooker's green No. 3

Hooker's green No. 1

Sap green No. 5

Lizard green No. 3

Green-gray No. 1

Blue-gray No. 4

Cool gray No. 4

Burnt umber No. 8

Raw umber No. 6

Burnt sienna No. 4

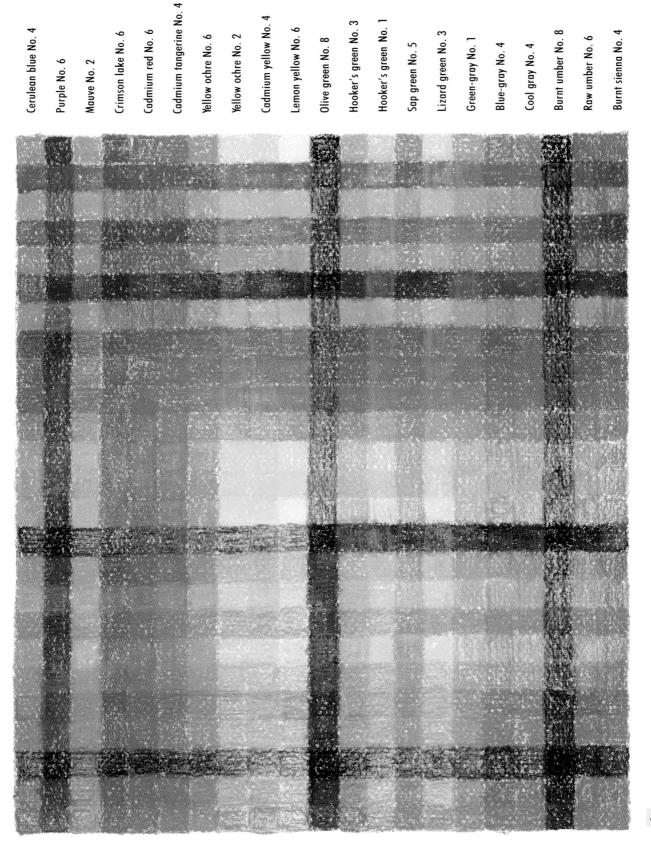

Blending Large Areas

One of the properties of pastel that can make it hard to handle – its powdery texture – can also be turned to advantage. If you have ever rested your hand on a work in progress, you are familiar with how easily crisp lines can become smudged. And you accidentally discovered a primary technique of working in pastel: blending.

Blending simply means rubbing one color into another and into the paper so that any lines are softened, and colors and tones merge with no perceptible boundaries. The technique is excellent for creating diffused effects – misty skies, for example – and for any areas of a painting that are intended to recede, such as the background of a portrait or still life.

For large areas, such as skies, it is best to lay on the color with the broad side of the pastel stick and then to blend with a rag, paper towel, large brush, or the flat of your hand. The last way is often preferable, since both rags and brushes remove a good deal of color – making a lot of dust in the process – whereas the small amount of oil in your skin mixes with the pastel and makes it adhere to the paper, so that it is more easily pushed into the surface of the paper.

Blending can also be a remedial measure. If you are building an image mainly with linear strokes and find that in one area the marks look too harsh or the colors too bright, simply rub gently over them for a softened effect.

Because it is so easy to create soft effects and mixed colors by blending, the method tends to be overused by beginners, and this can result in a bland picture. If you find this happening, use your blended areas as a base, spray the piece with fixative, and work over it with more energetic strokes, using soft or hard pastels.

HAND BLENDING

1 *For a windswept sky, place several bands of light and dark color one above the other. Then soften the boundaries between colors with the side of your hand.*

LINES OVER BLENDS

There is extensive blending in this atmospheric landscape, but the artist has contrasted the soft areas achieved in this way with fine lines made with hard pastels. These pull the scene into focus; if blending is used throughout a picture, the effect is too vague and fuzzy to make an impact. (Meadows in Windley – Jane Stanton)

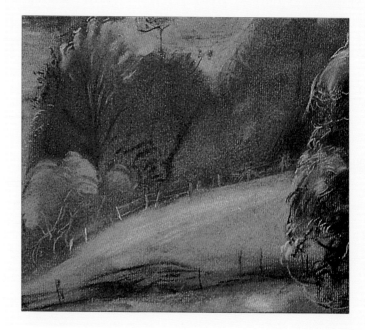

2 *You can alter the colors, or introduce others, as you progress. Add brown to suggest the warmer hues of sunset. Apply it lightly with the point of the pastel or the side of a short stick.*

3 *Use your finger or thumb to rub the colors into one another and blend the edges of the strokes.*

4 *Hand blending is particularly effective, because it creates less dust than merging the pastel with brushes.*

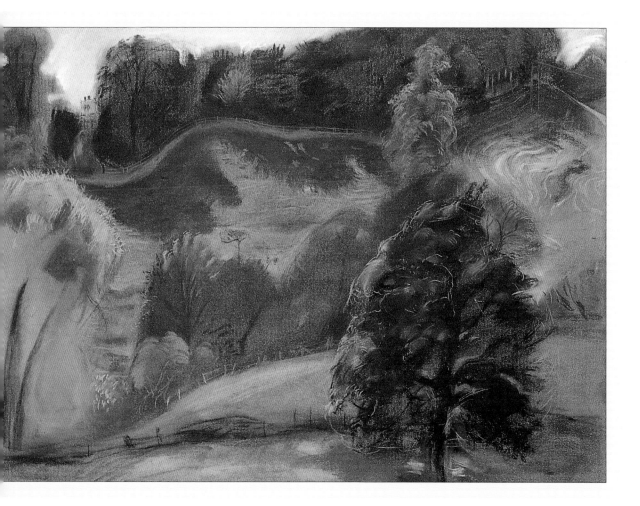

BLENDING WITH A PAINTBRUSH

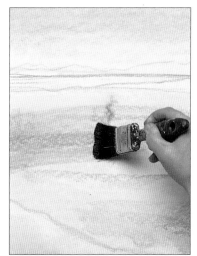 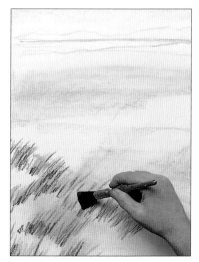

1 A paintbrush is good for conveying a diffused effect over an extensive area. Use broad side strokes and brush along, not across, them to blend.

2 Beginning with broad, light strokes is the key to successful blending. The brush will remove a good deal of the color, leaving the strokes blurred but still visible.

3 Foreground areas need to be more definite, so use point strokes for the grasses and brush gently over them to soften the edges.

BLENDING WITH A RAG

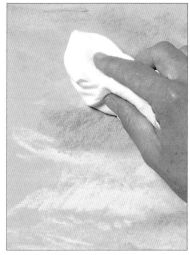 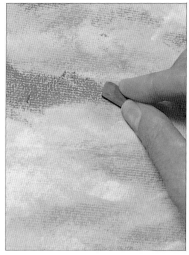 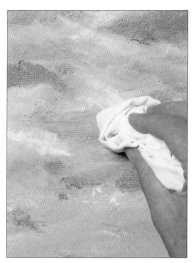

1 Apply the first colors lightly, without pressing the pigment into the paper. Then brush over them with a rag. This removes some of the color, but you will add more as the work progresses.

2 Use the side of the pastel stick to lay darker color over the first blended ones. Again, avoid pressing too heavily. You should be able to see the grain of the paper through the marks.

3 Continue adding pastel and blending until you have the right depth of color. To enhance shapes, blend each one separately, drawing the rag along the shape rather than across it. Use the rag like a paintbrush or pastel stick to help you build up forms.

MIXED BLENDING METHODS

The rich colors of this sky were achieved by applying one color over another and blending them with sweeping motions of the hand. Smaller areas were blended with the fingertips, and for the grasses shown in the detail, the artist used hard pastels over a layer of yellow-brown, blending them with a tortillon. (Beach Grasses – Lois Gold)

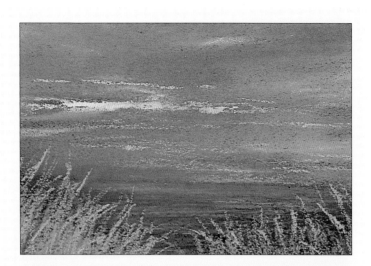

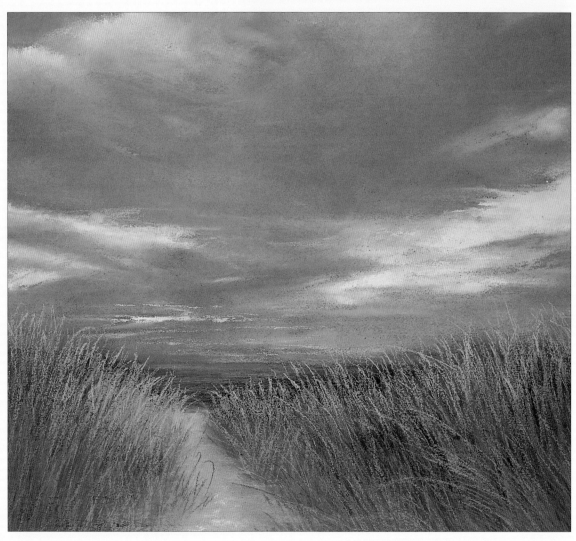

Blending Small Areas

BUILDING UP YOUR SKILLS

The loose blending described on the previous pages is fine for skies and backgrounds, but not good when it comes to small areas that you need to control precisely. If you are painting a still life or flower and want a gentle gradation of color and tone to build up form, perhaps on petals or on the curve of a vase, blend with a finger or a tortillon.

A tortillon, or rolled paper stump, is perfect for small areas such as eyes, lips, or flower stems but must be used with caution, since a new tortillon has a sharp point and can dig into the paper and damage it. Cotton swabs are tailor-made for working in small areas. The firm buds of cotton, with their rounded ends, give excellent control and don't damage the paper, in addition to being inexpensive and readily available.

As we have seen, blending removes some of the color, which can create a problem when you are dealing with a dark area. In such cases you may have to build up several layers of color, blending each in turn, and perhaps spraying with fixative (see p.28) between layers.

A tortillon, or stump, is a tight roll of paper. You can easily make your own. Begin by cutting a piece of light paper, such as drawing or typing paper, into a tall triangle or a triangle with its top cut off. Turn over the bottom edge and roll up the paper as tightly as possible. Seal the loose end with a touch of glue or a piece of tape. Tortillons can also be made from paper towels, but you will need a stiffener; try rolling the paper around a cocktail stick.

USING A TORTILLON

1 *Choose the two shades that most closely match the overall color of the fruit, and apply them lightly.*

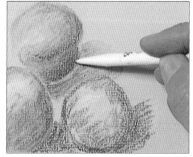

2 *Begin building up the forms with darker colors, using the tortillon to blend the shadow areas only.*

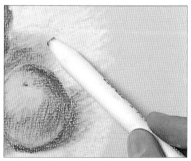

3 *To avoid overblending, decide where subtle effects are most important. The edge of the shadow needs softening, so use the tortillon here, and also for the halo of reflected light at the bottom of each piece of fruit.*

FINGERS AND COTTON SWAB

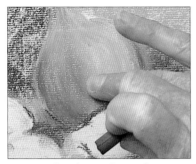 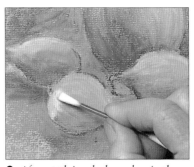 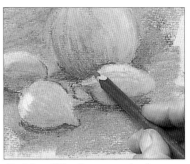

1 Merge the colors with your fingers first, reserving the cotton swab for precise blending in the later stages.

2 After applying darker colors in the shadowed areas, use the cotton swab to soften the transition from dark to light and to define the edges. You can "draw" with it as you do with a pastel stick.

3 A lot of blending can make the picture too hazy, so add final details and crisp up some of the edges with a pastel pencil.

BLENDING BY OVERLAYING

In this painting, blended effects were achieved by applying successive layers of color with the sides of the pastel sticks. This is an excellent method for the dark, rich colors of the apples and shadows, shown in the detail. Overlaying colors does not remove pigment; instead, each new color holds the earlier ones in place. (Fiesta Bouquet – Rosalie Nadeau)

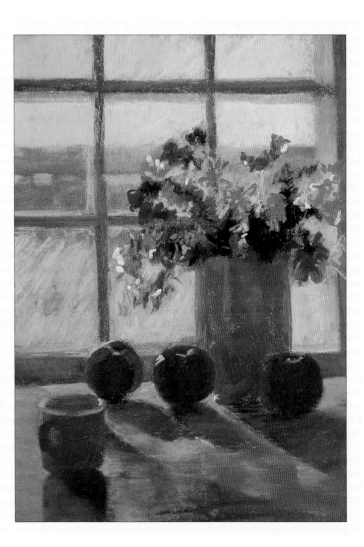

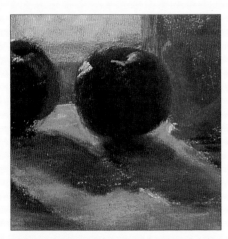

BLENDING WITH A SOFT BRUSH

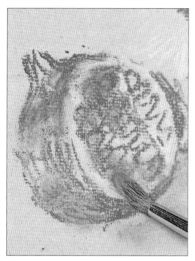

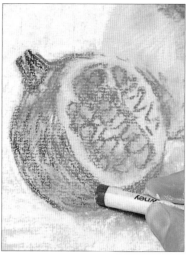

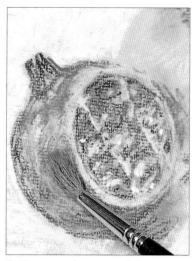

1 *When you only want to fade the line strokes and spread the color a little, work with a soft paintbrush, which fills in the paper between strokes.*

2 *Build up the shadowed side of the fruit with darker colors, applying curved lines that follow the rounded form of the pomegranate.*

3 *To suggest the texture of the cut pomegranate, make small point strokes and leave them unblended. The side of the fruit is smoother, so use the brush to soften the dark strokes and mix the colors slightly.*

FINGER BLENDING

1 *Flowers call for rich colors but a soft effect, so finger blending is ideal. Use your fingers from the beginning, pushing the color well into the paper.*

2 *Place a darker color on top, rubbing with a finger to create soft edges and to mix the colors together. Do not cover the lighter color completely, as the gradation from dark to light describes the forms of the petals.*

3 *Follow the same method for the leaf, applying green and then blending in some red. This is an effective combination of colors, producing a rich brown.*

SELECTIVE BLENDING

Combined methods work well here. Smoothly blended pastel on the glass objects emulates the actual surfaces, as you can see in the detail of the decanter. In contrast, the white flowers were built up with stabbing strokes of the pastel tip. A more linear approach was adopted for the tablecloth and background, with strokes overlaid but unblended.
(Wisteria and Roses – Urania Christy Tarbet)

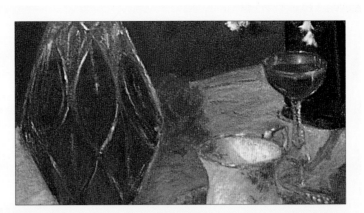

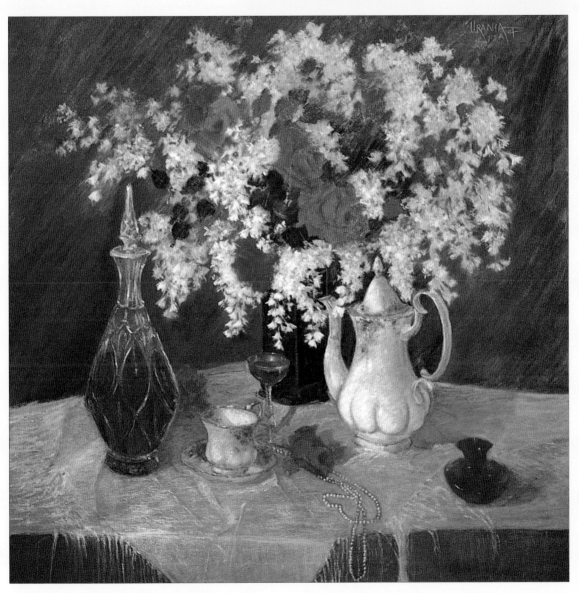

Using Line Strokes

Some artists build up entire pictures with a network of lines, each one distinct and un-blended, but interweaving to create vibrant color mixtures and to convey a feeling of energy.

A technique often used in this context is hatching. This consists of a series of closely spaced lines, which can be straight, diagonal, or curved but must be roughly parallel. For denser effects, another set of lines is sometimes drawn on top at right angles to the first, and this is known as cross-hatching.

These techniques were first developed for the purpose of building up areas of tone in monochrome drawings (the closer the lines, the darker the tone), but they are now used by both colored-pencil artists and pastelists to achieve mixed-color effects. The method is particularly suitable for hard pastels and pastel pencils, because they retain the crispness of the line. Hatching and cross-hatching with soft (regular) pastels creates a gentler effect, since some smudging is inevitable, but the method can still work well.

It is not the only way of using lines to create effects, however. Pablo Picasso, who rebelled against traditional drawing techniques, developed a method of his own known as scribble line. He used this mainly for monochrome pen-and-ink work, but it can be adapted to color. The idea is to build up the forms almost randomly, as though you were doodling. It takes a little practice but can produce exciting results.

SCRIBBLE LINE DRAWING

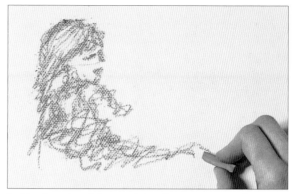

1 *Use the point of the pastel, but do not attempt to draw outlines of the subject. Instead let the pastel stick roam over the paper, with the strokes crossing over one another.*

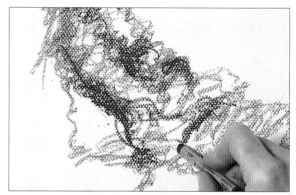

2 *Restrict yourself to one color initially. When the drawing begins to look convincing, introduce other colors as needed. This dark blue gives weight and solidity to the figure.*

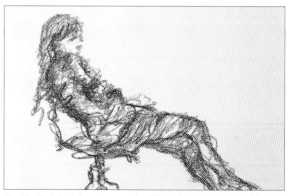

3 *The finished drawing exudes life and movement, and is a convincing portrayal of a figure despite the lack of detail.*

HATCHING AND CROSS-HATCHING

1 *Draw diagonal strokes on the pitcher with the points of the pastel sticks, building up a linear network of blue, red, black, and gray.*

2 *To avoid smudging the colors on the pitcher, complete step one before beginning the lemons with a flat area of yellow. Then add curving line strokes that follow the forms.*

3 *Use the same method of hatching and cross-hatching for the background and tabletop, taking care not to rest your hand on the finished area.*

HATCHED SKIN TONES

*The artist made skillful use of linear hatching to render a range of skin tones. The colors you can see in the detail of the head are relatively strong – deep blue-greens, reds, and tiny strokes of blue. But look at the whole painting, where the skin is seen in the context of background and clothing, and you will notice the way the colors mix optically, giving an effect that is both subtle and rich. (*Model in the Studio *– Dorothy Barta)*

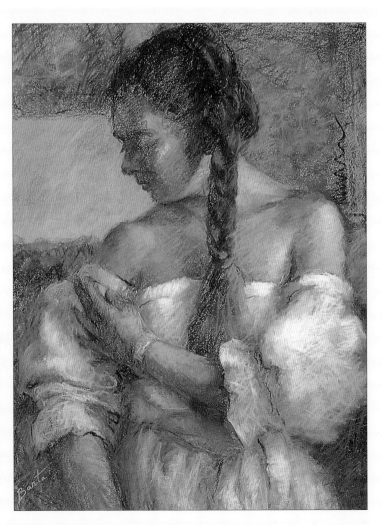

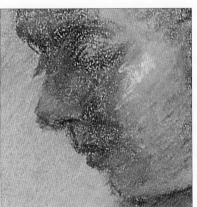

Broken Color

Another way of mixing colors without blending is by using broken-color methods – that is, building up each area with short strokes of different colors. For a sky you might choose two blues and a mauve, or two grays and two blues, while for grass you could utilize a range of greens and include small touches of yellow and blue. These will all mix visually from a distance, and be perceived as an area of green.

This is also known as optical mixing, and its charm lies in the lively shimmering quality of each area of color, which can't be achieved by smooth blends. Optical mixing is excellent for foliage, grass, skies, or any subject where you want to express the quality of light on a surface.

Although you can build up broken colors to some extent on any pastel paper, the more heavily textured ones that grip the pastel pigment firmly are best, as you want each stroke to remain separate. Try sanded paper or pastel board (see p.74), or watercolor paper given a wash of watercolor as a base. We show you how to do this on page 72.

EFFECTS OF LIGHT

Broken-color methods are often used for landscapes, and are particularly effective for snow scenes and skies, because they convey the shimmering effect of reflected light much better than a flat area of color does. As you can see in the detail, the snow is composed of many short strokes of blue interspersed with white, pale orange, and gray-green, while the trees are built up with deeper colors in the same way. The painting is on sanded paper. (Toward Cambridge, Winter – Geoff Marsters)

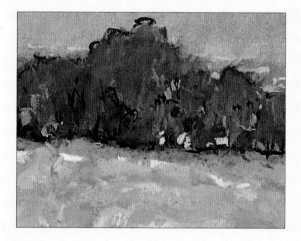

POINTILLIST METHOD

1 *Pick a color of paper that tones in with the subject so that you can leave areas uncovered. Start by blocking in the main shape in black, then add small dabs of blue, green, and yellow close together.*

2 *For the sky, make short, separate strokes that allow the paper to show through. Because of your limited palette, the surface is an important provider of extra color.*

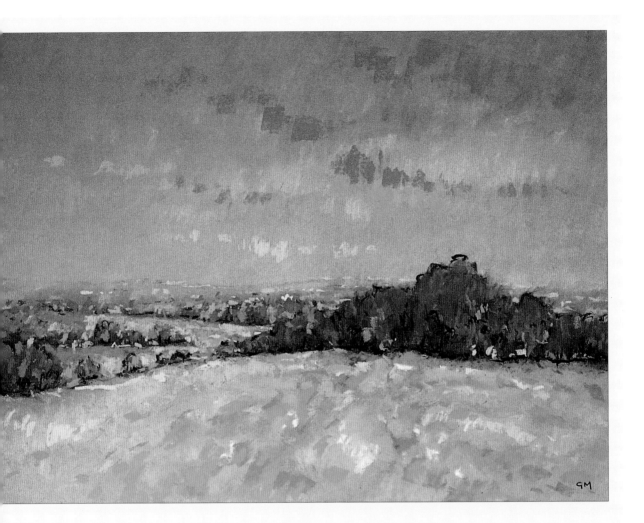

3 *Continue building up the color in dots and dabs. The degree of pressure you apply affects the tone of the color, so use a gentler touch for the darker colors than for the lighter ones, such as yellow. Push these well into the paper grain to give them maximum strength.*

4 *Bring in some hints of the pale blue sky color around the branches. Without these "sky holes" – patches where the light comes through because there is little foliage – the tree will look unrealistic. Finally, redefine the branches with dark brown.*

Overlaying Colors

So far, we have looked at mixing colors by blending and at mixing them by juxta-positions. But there are other ways of combining colors that can add an exciting surface quality to your work. The ability to build up a picture in successive layers, each one revealing some of the underlying color, is one of the great attractions of pastel work.

One of these layering techniques is feathering, which involves making a series of very light strokes with the point of the pastel over an area of previously laid, fixed flat color. You can feather with a contrasting color or with one related to the first color, and you can make several layers of feathered strokes.

Another method is to use the side of the pastel stick to drift a veil of color over an area of the picture. This can be a good way of modifying a color that is too bright or too dark, or of produc-ing subtle mixtures. A variation of this method is scumbling, in which the overlaid strokes are roughly circular. You can use the tip of a blunted pastel or make side strokes with a short length.

REVIVING DULL COLORS

Feathering is an excellent method for giving new life to colors that have become dull through overblending – something that can easily happen in pastel work. If you have done too much blending, there will be a good deal of pigment on the paper; so spray it with fixative first and then lay some feathered strokes on top in a color that is slightly more vivid than the blended one. The painting will immediately begin to sparkle.

SCUMBLING

1 *This method is suitable for large-scale pictures or for backgrounds, where you do not need to control shapes precisely. Scribble lightly over an area of paper, using the side of the pastel stick in a circular motion.*

2 *After blending the first color with your fingers, apply a paler layer of scribbled marks in open strokes that will enable the underlying color to show through.*

3 *Scumble a pale gray in gentle strokes over the first two colors. Scumbling generally works best with light over dark, but it can be useful for subduing an over-bright color.*

FEATHERING COLORS

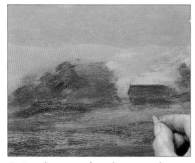
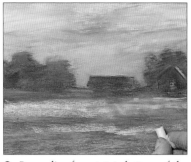

1 *Work on a surface that grips the pastel well, such as pastel board. Block in the sky, hills, and dark foreground with light side strokes; then gently lay down lighter colors over dark, using the side of a short length of pastel.*

2 *Proceeding from top to bottom of the picture, continue to lay one color over another, and then begin to lighten the foreground. The grain of the paper breaks up the pastel strokes to create a veillike effect.*

3 *If your fingers are covered in pastel dust, use them to bring in further touches of a color applied earlier. Paintings look more unified if colors are repeated from one area to another.*

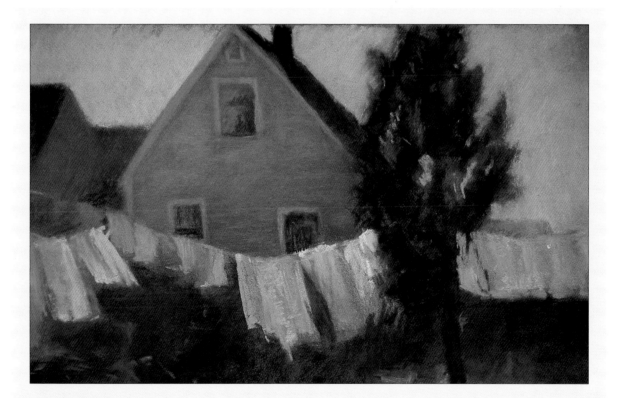

LAYERING COLORS

The luminous colors and painterly effect were achieved by using the sides of the pastel sticks in a series of layers. One color shines through another even on the dark house, and the sky is made lustrous by mingling pale greens and blues with delicate pinks. The very soft, absorbent paper has a fibrous surface that gives it an uneven "tooth." (Laundry Lights – Rosalie Nadeau)

61

Underdrawing

Because pastel is both a drawing and a painting medium, it is not always necessary to make a preliminary underdrawing. You can start off in color and draw as you work. However, for any subject involving a variety of shapes that need to be carefully related, such as a still life or figure painting, it is advisable to establish a good foundation.

Pencil should never be used for a preliminary drawing. The graphite from which pencils are made is greasy and repels the soft pastel color. Pastel pencils, hard pastel sticks, and charcoal are all suitable for preliminary work.

Charcoal has an advantage over both pastel pencil and hard pastel, which are difficult to erase if the drawing goes wrong. You can brush down any incorrect charcoal lines with a rag or your hand and draw over them. This way you can be confident of getting the shapes and composition right before you lay on the color. To avoid sullying the pastel colors, fix the charcoal drawing when you have finished it, or brush it down with a broad brush to remove the excess dust.

If you have an existing drawing or photograph that you want to use as the basis for a pastel, you might like to try a method called pouncing. The original picture is traced, holes are pierced along the traced-in lines, and charcoal or pastel dust is applied with a pounce bag through the holes onto the paper. To make the holes, you can either use a pounce wheel or a pointed implement, such as a large needle – the former is quicker. This technique is used for painting murals and by embroiderers for marking designs onto fabric.

PASTEL PENCIL

1 *Choose a color of pastel pencil that shows up clearly on your paper and that will blend with the colors of the subject. Draw the lines lightly at first.*

2 *Concentrate on outlines, but put in any strong contour lines, such as those on the onions, because they help you to understand the forms.*

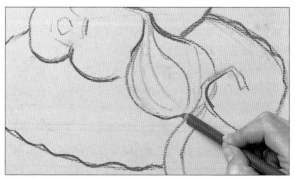

3 *When you are confident that the drawing is right, strengthen any lines that will be dark in the painting. If your pencil strokes are too faint, you will lose them as soon as you begin to apply color.*

CHARCOAL

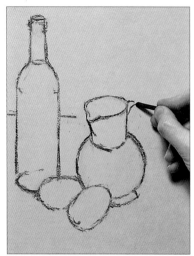

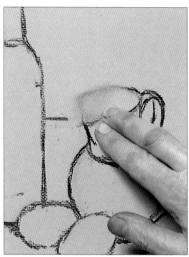

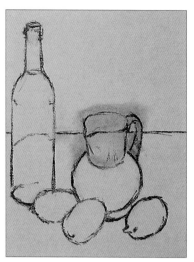

1 Medium-thickness vine charcoal is best for underdrawing; thinner sticks break easily. Hold the stick loosely near the top end and begin sketching the main lines of the underdrawing.

2 Errors can quickly be erased. Rub the charcoal off immediately with your finger before redrawing.

3 Correct the drawing, erasing again if necessary. The rubbed-down charcoal leaves a gray smear, but this will not affect the pastel color.

USING A POUNCE WHEEL

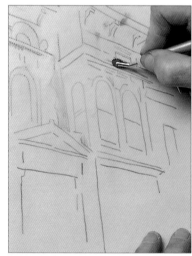

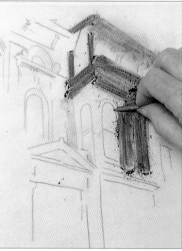

1 Trace the image onto thin tracing paper and draw the pounce wheel along all the lines to produce a series of tiny holes. Press hard to ensure that the wheel punctures the paper evenly.

2 Secure the tracing to the top of the working paper with masking tape. Then scribble heavily with charcoal over the entire tracing to push the dust through the holes.

3 Lift the tracing paper off carefully, holding it by one corner. Any surplus dust on the drawing can be gently blown away.

Building up a Painting

When you begin a pastel painting, the first thing you need to do is establish the basic tonal structure and the main shapes and colors. This process is known as blocking in, and it is often done with hard pastels. The reason for this is that hard pastels, being less crumbly and prone to fall off the paper, provide a solid foundation on which to build up the picture with soft pastels. You can block in with soft pastels, but there is more danger of muddying the colors, since the later layers will tend to mix into the first. Blocking in can also be done with paint, as explained on page 72.

When blocking in, bear in mind that you are not concerned with detail; you are simply laying a base, so look for the main colors and for areas of light and dark. Light side strokes are normally used, since these cover the area quickly and don't fill up the grain of the paper. However, you can use point strokes if that's the way you intend to develop the picture. In either case, keep the strokes light so that the subsequent colors remain clean. Once you have established the "skeleton" of your picture, you must consider how to go about building up the colors, forms, and details. No single prescription can be given for this process, because it is a matter of personal choice. Every artist develops his or her own way of beginning and building up a picture.

But there is one general rule about developing a painting, which is that you should never bring one area to an advanced stage of completion before you begin the next. Painting is a process of constant evaluation. You need to keep the entire image fluid so that you can make changes as you work. If one area is highly finished, you will not be able to work over it in this way.

BLOCKING IN WITH HARD PASTEL

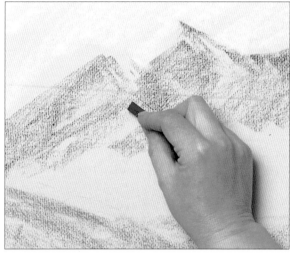

1 *Identify the main shapes and colors in your subject. Begin to block them in with the side of the pastel stick. Use light strokes that do not fill the grain of the paper.*

BUILDING UP WITH SOFT PASTEL

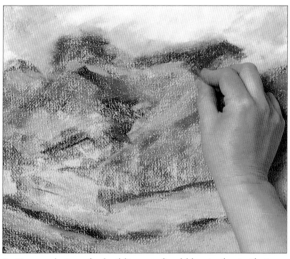

1 *Your technique for building up should be similar to that used for blocking in, so continue to use side strokes throughout.*

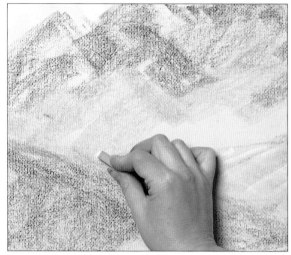

2 *To guide the later work, identify any areas of dark tone, but do not attempt to describe the shapes precisely. Continue to keep the strokes light.*

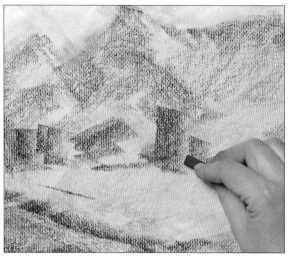

3 *Do not take the blocking in process too far; remember that it is only a foundation. There should be no detail, and the pastel must be subtle enough to let the paper show through.*

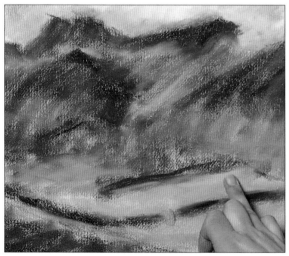

2 *Still keeping the treatment broad and avoiding details, build up color effects by blending and overlaying. When you are working on the middle area, take care not to rest your hand on the paper.*

3 *Assess the picture from time to time to decide how much more work it needs. A little detail – a mountain stream, some middleground trees – would bring this landscape into focus. You will learn how to achieve this on the following pages.*

Edges, Outlines, and Details

BUILDING UP YOUR SKILLS

A complaint against pastels is that you can't get good sharp lines. But you can, with a little basic planning. If the edges form an important part of the initial drawing, use hard pastel or pastel pencil for the boundaries of shapes. This could be a suitable treatment for flowers where you need to define the shapes of certain petals from the outset. Because of the way light strikes forms, some edges are crisp (known as "found edges"), while others are blurred (known as "lost edges").

A useful soft-pastel method for edges and outlines is masking. Suppose you want a straight edge for the side of a wall, or a clean edge for a bottle, but you don't want a hard drawn line. Cut a piece of paper to the shape and hold it in place on the working surface while you lay on the pastel. When the masking paper is removed you will have a perfect edge. Often you will need lines and edges only as a finishing touch of definition; so when your painting is nearing completion, decide whether it needs any finishing touches, such as crisp outlines, linear accents, or highlights.

HIGHLIGHTING

Highlights give your work sparkle and help to define shape. Apply the edge of a white pastel stick firmly over the existing color. It will mix slightly with the color beneath to create a natural effect.

DETAILS

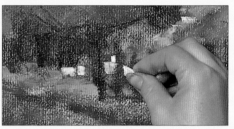

Adding white houses and a river sharpened the picture shown on the previous page, but the foreground still needs definition. Draw a broad but firm line suggesting a path. This leads the eye toward the houses in the center of the picture.

HARD PASTEL OUTLINES

1 *Draw the outlines carefully with hard pastel colors that match those of the subject. Use the corner of the pastel stick for a fine line.*

2 *Fill in the shapes with soft pastel, blending colors lightly, then draw firm, straight strokes of tangerine for the stamens. Give form to the petals by blending some tangerine into the white.*

3 *Fill in the remaining petal in the same way. If you leave a little of the gray paper showing in the center, it will suggest shadow.*

MASKING EDGES

1 *Trace the outline of your chosen object – in this case, a bottle – cut it out, and discard the shape. The remaining paper will serve as a mask.*

2 *Hold the mask firmly in place around the bottle while you apply thick pastel color.*

3 *Carefully remove the tracing paper to reveal a sharp edge. Do not work any further on the background because you might spoil the line.*

USING THE PAPER COLOR

The edges of objects often become blurred because background color slips over them. One way to avoid this is to work on a dark or vividly colored paper and leave the background bare, as in this painting. (Snapdragons – Lois Gold)

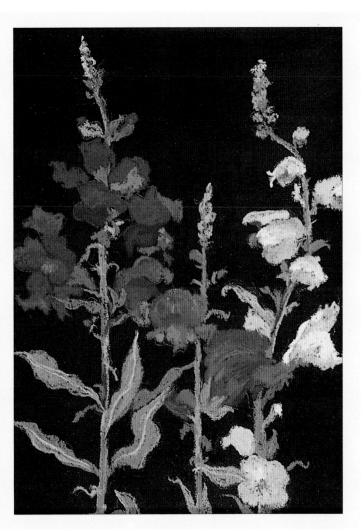

Wet Brushing

Pastels are normally used dry, but they can be mixed with a variety of binders or with water and spread with a brush. Wet brushing is an excellent way of covering the paper quickly. By laying down broad side strokes and washing over them with a brush, you can produce a rapid underpainting (see p.72).

But this is not the only application of the technique. You can also use it as an integral part of the picture, so that brushstrokes of spread color complement the marks of the pastel. A bristle brush is best for this because it creates more distinct marks.

WET BRUSH UNDERPAINTING

This work on sanded paper was built up in layers of rich color over a turpentine-brushed underpainting. The pastel color was dissolved with turpentine and scrubbed onto the paper. In the detail showing the left-hand foreground, you can see marks made by the fluid color running down the paper. (Taos Fall – Bob Rohm)

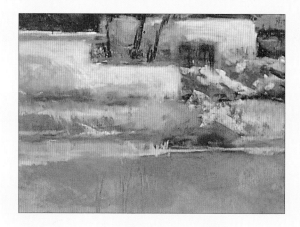

USING WATER

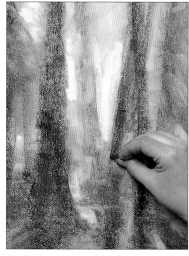

1 *Thin paper may buckle when water is applied, so choose Mi-Teintes or watercolor paper. Block in the composition and establish the principal shapes and colors. Use light side strokes for this work.*

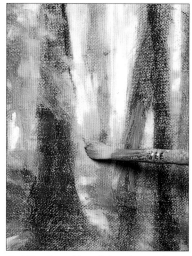

2 *Dip a broad bristle brush into clean water and begin to spread the pastel. Once wet, pastel takes on the consistency of paint and fills the grain of the paper with solid color.*

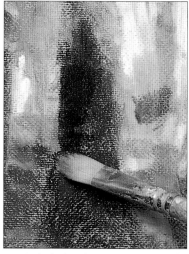

3 *Wash the brush to remove traces of the paler color, and spread black pastel on one side of the tree trunk only. This produces a gradation of tone that describes the form; specks of the paper still show through the areas of dry pastel, making it appear lighter.*

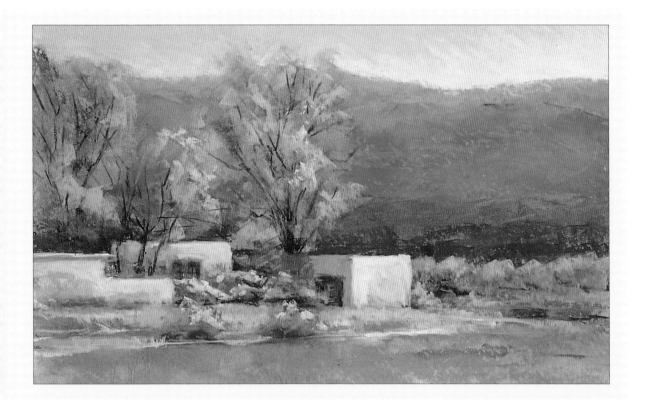

USING TURPENTINE

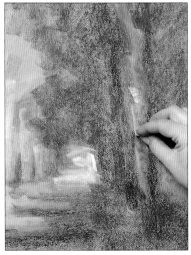

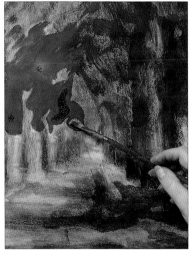

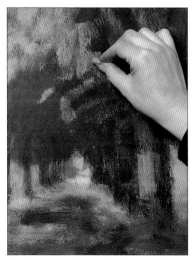

1 *It is safe to use charcoal paper for the turpentine method, since the spirit evaporates and does not cause the paper to buckle. Block in the picture, with side strokes, laying one color over another on the tree trunk to make a soft blend.*

2 *When you are satisfied with the composition and balance of colors, begin the wet brushing, again using a bristle brush but this time dipping it in turpentine. The paper will turn almost black but resumes its normal color as soon as the solvent dries.*

3 *The turpentine makes the pastel greasier. Work into the still-wet paper with dry pastel and you will find that the color spreads easily.*

Charcoal and Pastel

BUILDING UP YOUR SKILLS

You have already learned that charcoal is a good medium for making preliminary drawings, but it can also be used during the painting process. You can use it to reinforce lines, build up areas of tone, or soften colors. Because charcoal and pastel have similar textures, they are ideal partners.

Charcoal line can be particularly effective for figure studies and portraits, or any subject where the emphasis is linear. There is a danger of charcoal dust spreading onto and sullying the pastel colors. It is best to begin with the charcoal, and when you add pastel color, keep the two areas separate – or fix the charcoal first.

If you use charcoal to lay in broad areas of tone, such as dark shadows, you will be applying pastel color on top; whether you fix the charcoal before doing this depends upon the effect you are seeking. If you want the colors to be muted, leave it unfixed, and deliberately allow the pastel color to mix into it. This can be an excellent method for any subject with a somber color key, such as a cityscape at dusk.

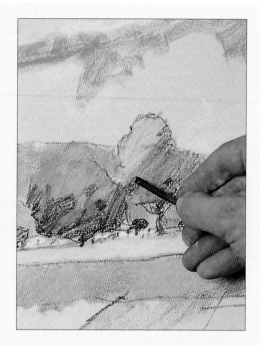

Charcoal is also useful for toning down any area that looks too light or bright. In landscape, for example, you often find that a color used for some feature in the middle distance appears over-assertive. By laying charcoal on top and lightly blending the two, you can subdue the color, turning a bright green or blue into a grayed-down version of the same hue.

CHARCOAL LINE AND TONE

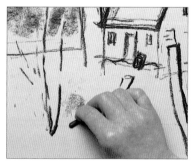

1 *Make a full drawing, using a medium-thickness stick of vine charcoal. Use the point of the stick for the lines, and the side for areas of tone.*

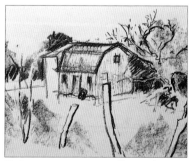

2 *Do not restrict yourself to outlines, as you would with an underdrawing. In this method the charcoal plays a definite part in the picture rather than being covered up with layers of color.*

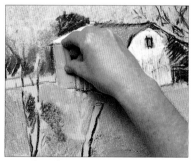

3 *When the drawing is complete, begin to apply pastel color, blocking in the sky and foreground grass. For the brilliant hue of the house wall, you will need to mix colors, so use the side of a stick to drift blue over green.*

ESTABLISHING THE TONAL STRUCTURE

Charcoal was used here, although it is not visible. The sanded paper was tinted with a light-colored pastel mixed with turpentine. A charcoal drawing established the tonal structure of the composition, and pastel color was applied on top. Because the sanded paper grips the charcoal firmly, the dust does not dirty the pastel colors. (Blanco Reflections – Deborah Christensen)

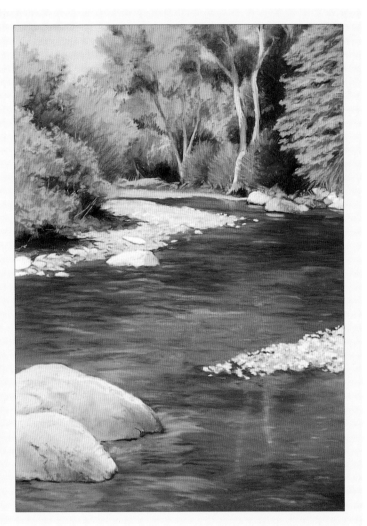

4 *Vary the sky colors by laying a little pale yellow over the blue, and use your fingers to blend them. Be careful not to smudge the house while you do this.*

5 *More color is needed on the house, but the charcoal and pastel mixture there is already thick, so fixing is advisable. Mask the rest of the work with paper and spray lightly.*

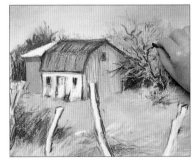

6 *With most of the colors now in place, use the charcoal again to draw into the trees and add detail to the roof and windows of the house. Continue alternating pastel and charcoal until you feel the picture is finished.*

Underpainting

As we have seen, establishing the early stages of a painting, known as blocking in a drawing, are sometimes done with hard pastel, but there is another way of building the "skeleton" of the picture, which is to make an underpainting. You can use either watercolor or acrylic, and in either case you must use paper that will not buckle when wet.

An underpainting can be as simple or as complex as you like. In a landscape it could consist of only two broad areas, blue or gray for sky and browns and greens for land. But you could take it much further and fully establish the tonal structure as well as sketching in the important shapes, such as trees or rocks.

You can also achieve intriguing effects by using contrasting colors for the underpainting. Some artists choose a warm yellow underpainting for an area that is to be cool blue-gray, or lay a deep blue base over an area that is to be red. The ground color showing through the pastel strokes produces an exciting, vibrant effect.

LAYING AN ALLOVER TINT

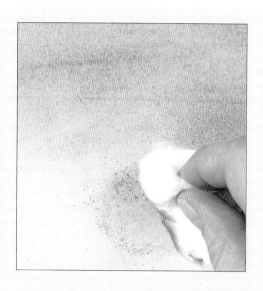

If you like to work on watercolor paper, you will normally need to tint it in advance, because otherwise you will find distracting flecks of white appearing through your pastel strokes. You can color the paper with watercolor or thinned acrylic, using a large, soft brush to lay an even wash of color. Or you can use ground-up pastel color to lay a "dry wash." To do this, peel some of the paper off one of your pastel sticks, or use a broken one. Hold the stick above a saucer and scrape it gently with a knife to make colored dust. Then dip a rag or cotton ball into the powder and rub it across the paper, pushing it well into the grain.

MAKING A VIVID UNDERPAINTING

1 *If the subject is colorful, it makes sense to give it a ground of bright color. Working on watercolor paper, use a broad brush to apply strong washes of watercolor (or acrylic).*

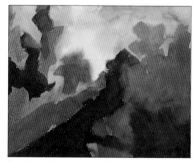

2 *Cover the entire surface with paint, applying darker colors where you want to build up dark tones of pastel. The deep purple here will be allowed to show through the lighter pastel colors for shadows.*

3 *Allow the underpainting to dry thoroughly before working with pastel. Then use short side strokes in various colors to create broken-color effects, suggesting flowers and foliage.*

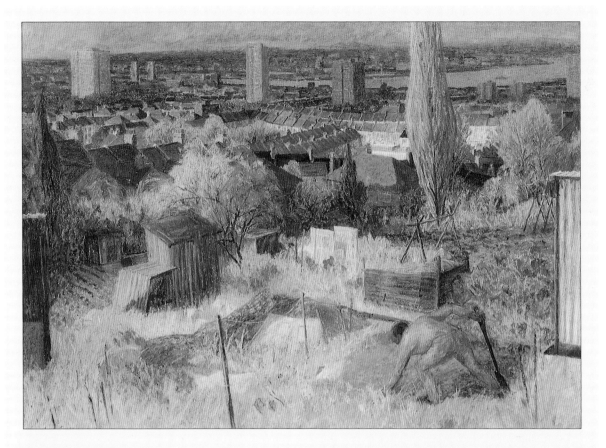

USING BRUSHSTROKES

In this large-scale work on watercolor paper, the underpainting was treated as an integral part of the building-up process. Instead of applying flat watercolor washes, the artist used expressive brushstrokes designed to complement the later pastel marks. In the finished picture it is hard to distinguish one medium from the other. (View Over Allotment – Patrick Cullen)

4 Continue to build up the picture with small strokes. Do not try to cover the underpainting; the essence of this method is to leave parts of the watercolor showing between and beneath the pastel marks.

5 Now use the tip of the pastel to begin refining shapes and introducing small contrasts of color. Notice how the orange underpainting shows through the blue of the sky to give the painting a lively sparkle.

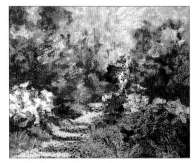

6 Flecks of yellow and orange underpainting enliven the areas of green and enhance the vibrant color effects. The heavy grain of the paper helps by breaking up the pastel strokes to suggest texture – especially evident on the path.

Using Thick Color

In some pastel paintings you can see that the color was so thickly applied that it almost resembles oil paint. Such works are produced by a variety of overlaying methods; they sometimes involve wet brushing and often call for the use of fixative at various stages.

You can lay color thickly on Mi-Teintes paper if you build up gradually from initial light applications, but the best surfaces to use for this kind of work are sanded paper, velour paper, and pastel board, shown opposite.

Sanded paper is something of an acquired taste. If you want to try the effect without spending much money, buy a small sheet of carpenter's sandpaper (fine grade) and see how you get along.

Smooth watercolor paper is also favored by some artists who work with thick color, but because it has little texture to hold the pastel, it will not stand too great a degree of overworking. It is therefore best used in conjunction with a watercolor or acrylic underpainting, which allows you to restrict yourself to one or two layers of heavily applied pastel.

IMPASTO EFFECTS

Impasto means applying paint so thickly that you can see raised edges. In pastel work you can achieve an equivalent result by using the full strength and texture of the pigment in heavy strokes. Mounting sanded paper on a rigid surface enabled this artist to apply maximum pressure. The detail shows that, on the branches, the effect is close to that of oil painting. (Between Showers – Margaret Glass)

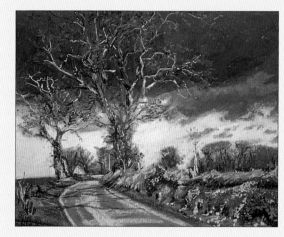

CARPENTER'S SANDPAPER

Not all sanded papers are made from sand – the correct generic term is abrasive papers. Silicon carbide, for example, is a component of papers used for metalwork, the so-called wet-and-dry papers. However, all the pastel painter needs to know about is the different grit grades, of which there are five: very coarse, coarse, medium, fine, and very fine. Medium paper is the roughest you should attempt to use; the best choice to start with would be fine or very fine.

Very fine silicon carbide allows for heavy color and fine lines.

Fine sandpaper is rougher, breaking up the color slightly.

Fine silicon carbide is a little smoother.

Medium-grade sandpaper is too rough for any but broad effects.

SANDED PAPER

 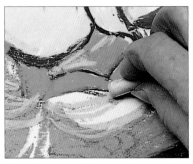 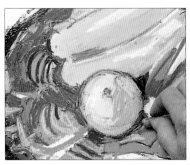

1 *On this paper it is impossible to blend colors in the normal way, so mix colors on the fruit by laying one over another, using positive line strokes. Proceed in the same way on the plate.*

2 *As far as possible, use colors as they come, choosing a selection of blues, greens, and red-browns that will look well together.*

3 *Mix some colors on the dish by overlaying, then strengthen the shadows beneath the fruit. Continue slowly building up the colors until you are satisfied with the result.*

VELOUR PAPER

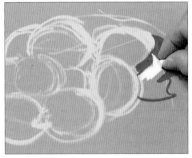 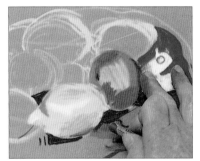 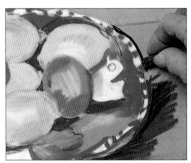

1 *After completing a preliminary drawing in yellow, begin to place blue, then white, carefully around the shapes of the fruit. The velvety nap of the paper grips the pastel firmly.*

2 *The paper allows blending, so when you have applied some color to the fruit, create a soft shadow by rubbing a little dark blue into the white of the plate.*

3 *Complete the dish and fruit. Neaten the edge of the dish by drawing black around it. It is almost impossible to use color lightly on this type of paper, so it encourages a bold approach.*

PASTEL BOARD

 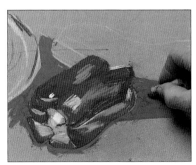 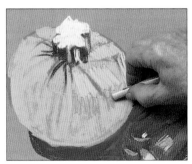

1 *This surface also grips the pastel firmly, but gives a crisper line than velour paper. Try to exploit this, overlaying colors on the red pepper with a series of lines.*

2 *Add further colors to the pepper to build up the forms, then work on the blue tablecloth, pushing the pastel firmly into the board so that it is completely covered.*

3 *Use firm linear strokes to describe the forms of the pumpkin. There is already a considerable buildup of color, but the surface has not become clogged, as it would have on standard pastel paper.*

Laying a Textured Ground

BUILDING UP YOUR SKILLS

The paper you choose for a pastel painting can influence the appearance of the work to a limited extent, but you can exploit texture in a more dramatic way by laying your own textured ground. To do this you need acrylic paint or a substance called acrylic gesso (a combination of chalk, pigment, and plastic binder), along with a heavy watercolor paper or a piece of board, such as mat board. Put on the paint or gesso with a bristle artist's brush or ordinary paintbrush, aiming for a slightly uneven, striated look. When you lay pastel on top of this ground, you will find that the color catches on the small ridges, creating intriguing effects. It takes a little practice to discover how best the method can be used, but this is essentially a try-and-see technique.

PERSONAL EXPERIMENTATION

Working on a homemade textured surface is essentially an experimental technique, and artists evolve their own recipes for grounds. This painting is on masonite, which has been coated first with gesso, then with acrylic paint, and finally with transparent acrylic medium mixed with pumice powder. For the last coat, a paintbrush was used to make diagonal strokes, the effect of which can be seen clearly in the detail. (Apples and Tea – Doug Dawson)

ACRYLIC GESSO GROUND

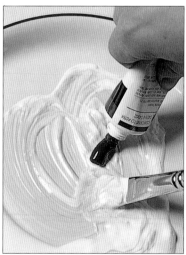

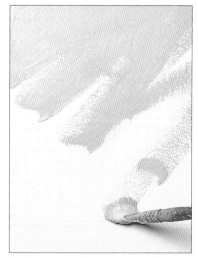

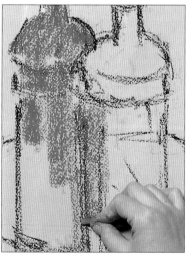

1 *Unless you want to work on a white surface, tint the gesso by mixing it with acrylic paint of a neutral color. This method is quick because there is only one layer to dry. However, you could apply the gesso first and then tint it.*

2 *Using a bristle brush, paint the colored gesso all over a piece of heavy watercolor paper. Aim for an uneven effect, because you want the striated texture of the brushstrokes to show through the pastel.*

3 *Allow the gesso to dry. Make a charcoal drawing and then begin to apply color on the bottles, using bold side strokes and heavy pressure.*

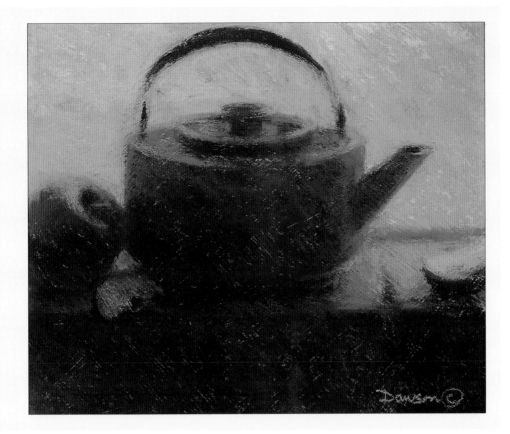

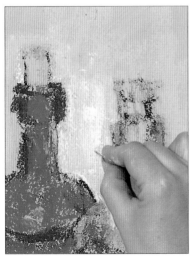

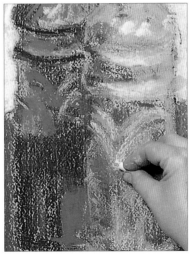

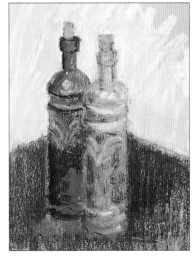

4 *Draw two or three broad strokes of yellow for the corks and begin to work the background around them, using first blue-gray and then white.*

5 *Build up the detail on the bottles with an edge of white pastel. You will not be able to achieve fine lines, because the texture breaks up the strokes, so try for broad effects.*

6 *The underlying texture contributes a lively quality, and although detail is limited, the bottles are convincingly rendered. This method is exciting if you do not fight the texture but go with it.*

Making Corrections

BUILDING UP YOUR SKILLS

People who have not used pastel are sometimes discouraged from trying the medium because they have been told that they can't correct errors. It is true that you can't erase a pastel line as cleanly as a penciled one, but there are ways of making corrections, particularly in the early stages.

If your first marks or your underdrawing go wrong, you can rub down the line to soften it and redraw on top, or flick it with a stiff brush, which will take off much of the pigment. To remove a line more thoroughly, use a kneaded eraser or bread, a traditional and effective cleaner. Don't try an ordinary rubber eraser, since this may damage the paper as well as pushing the particles of pigment deeper into it.

In the later stages you can't erase in the conventional way – and trying may spoil the work – but it is still possible to make corrections by working over any area you are not happy with. It is surprising how radically you can change things in this manner. You obviously can't go on correcting forever, because the buildup of pigment will become too dense, but even if this occurs, all is not lost. Spray the offending area with fixative or damp it down with a wet brush to regain a workable surface. Don't use water on thin pastel paper, however, because it may buckle. Nor is water advisable for sanded paper or pastel board, as it will damage the surface.

If toward the end of a picture you find that there is an area you would like to change, and the pastel is too thick to work over, you can scrape away the top layers of pigment with the flat of a sharp blade and then use a kneaded eraser. This should be a last resort, because you can easily damage the paper unless you work extremely cautiously. You also run the risk of creating dust that spills onto adjacent areas; so either cover the rest of the surface with paper or pick up the dust with the eraser as soon as you have scraped it off.

BRUSH AND COTTON BALL

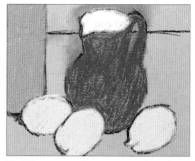

1 *Often you will spot a mistake only after you have blocked in the picture. In this drawing the ellipse at the top of the pitcher is incorrect.*

USING A BLADE

1 *This method is useful for small areas, where the pastel is too thick to work over. It makes a lot of dust, so protect the rest of the picture by placing clean paper around the area to be corrected.*

USING BREAD

Take a piece of soft white bread and squeeze it between your fingers so that it has the consistency of a kneaded eraser. Dab the bread onto the surface to lift off the pastel.

2 *Flick lightly with a bristle brush to remove the top layer of pigment. At this stage the color has not been pushed into the paper, so it comes away easily.*

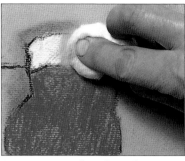

3 *However, to clean the surface sufficiently for reworking, you may need stronger measures, so rub off the remaining color with a cotton ball.*

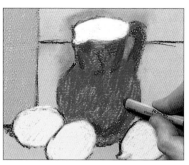

4 *Redraw the ellipse and fill in with white before continuing to work on the body of the pitcher.*

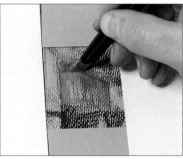

2 *Scrape the pigment off with the side of a sharp knife, making sure to work gently and carefully to remove the color layer by layer.*

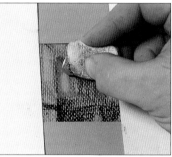

3 *Finally, dab lightly with a kneaded eraser to pick up the pastel dust. Take care not to press hard or you could smear the remaining color.*

4 *Once the pastel dust is removed, the subtle improvement in the painting can be seen. This last-resort technique is worth considering for the later stages of a painting.*

USING A KNEADED ERASER

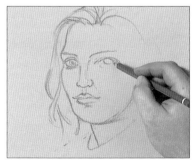

1 *Errors are especially obvious in portraits, so check the underdrawing carefully. Here the eye is too large and out of alignment.*

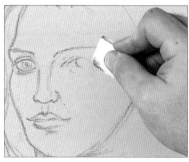

2 *At this stage it is easy to correct with a kneaded eraser. Use it in a dabbing motion along each unwanted line to lift the color off cleanly.*

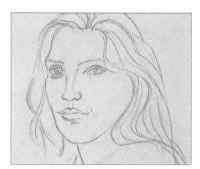

3 *Redraw the incorrect marks, erasing again if necessary. Do your best to make sure that the underdrawing is accurate before you apply color.*

Comparing Methods

No two artists' work is exactly alike. Even when the same medium and basic techniques are used, it is easy to distinguish one person's style from another's, just as you can recognize individual handwriting. The pictures on these four pages, which show two artists painting the same subject, demonstrate this clearly. The differences in their handling of the pastels, and hence the finished results, are striking. There are, however, similarities, apart from the subject matter: both artists used the same colors (the starter palette shown on page 21); both worked on the smoother side of gray Mi-Teintes paper; and both took a selective approach to the subject, omitting certain details.

This editing process, whether in still life, landscape, or figure painting, will be explored in more detail in Chapter 4, but this demonstration provides insight into composing and organizing a picture, and into the way the pastel marks contribute to the result.

Folds in the tablecloth look fussy and spoil the overall shape, so they have been omitted in both paintings.

Neither artist reproduced the pattern on the background cloth, which was too intrusive. Artist Two changed the color, using more yellow than blue.

ORGANIZING THE SUBJECT
This still-life setup was chosen because it provided plenty of different shapes and forms, allowing you to see how the artists have varied their marks.

Using a dark color in the foreground could detract from the overall effect, so both artists lightened it.

DIFFERENT APPROACHES

As you gain experience, you will develop your own "handwriting" and will probably find that you prefer either line or side strokes. Both these artists have established their styles: one uses almost entirely side strokes, and the other works mainly in line. The details (right) show the methods clearly.

Side strokes were made with short lengths of pastel, directions varied, and colors were built up by overlaying. A sharp edge defines pot rim.

Light side strokes in center of pot, but elsewhere line strokes used – horizontal on top for flat plane, and curving beneath, following form.

Thick side strokes were used to build up main form; edge of pastel used for small highlights that define separate seeds.

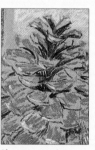

Short, squiggling line strokes with a blunted tip for "leaves," charcoal drawing for dark areas, and dots for highlights.

ARTIST ONE

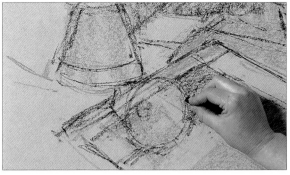

1 The composition is blocked in with gray and then black pastel. The artist does not restrict herself to outlines but begins to establish areas of tone from the outset.

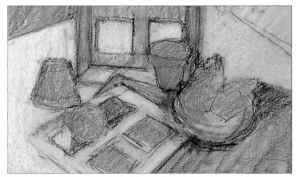

2 The picture is now fully blocked in, with the broad areas of tone and color established. Putting the light color over the darker one on the wooden box produced a subtle color mix.

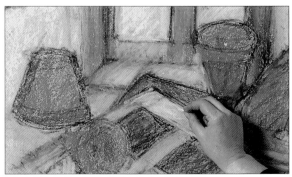

3 The artist builds up colors and tonal contrasts more strongly. She applies white firmly over the earlier colors, using strokes that suggest the texture of the wood.

Continued on page 82 ▷

ARTIST TWO

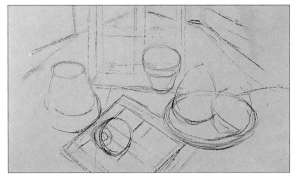

1 A difference in approach is immediately obvious. This artist used charcoal to make a light outline drawing and then started to place the bright colors of the pots.

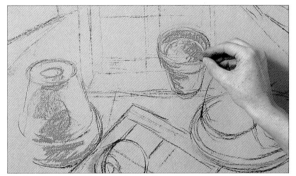

2 In contrast, this artist keeps the colors pure at this stage, applying orange lightly within her drawn lines. She intends to leave much of the paper bare, and therefore colors only the center of the front pot.

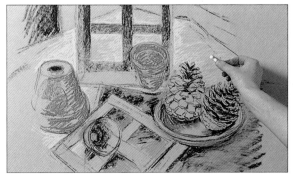

3 This artist leaves the wood in the foreground until later. She has filled in the green area, and now works on the yellow cloth. It was important to consider the balance of these two major colors and the orange pots at an early stage.

Continued on page 82 ▷

ARTIST ONE *(cont.)*

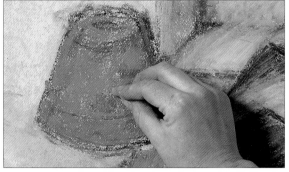

4 *Side strokes of dark brown were laid over the original lightly applied orange to build up the form of the pot. More orange is now added to soften the effect.*

5 *To achieve the dark green foreground, the artist combines colors in successive layers. Having used dark blue, black, and olive green for this area, she now applies a brighter green with the side of the pastel stick.*

6 *Compare the two artists' treatment of the pinecones. Here detail is avoided, but firm, curving side strokes give an excellent impression of the forms. Highlights will be added in the final stages; see them in the finished picture.*

ARTIST TWO *(cont.)*

4 *With color applied to all areas – except where the paper is to show – the artist begins to work on details. Delicate flicks with an edge of white pastel create highlights on the pinecone.*

5 *Throughout the painting, charcoal and pastel were combined. There is charcoal drawing on the pinecones and on the pots. Here it is used again for dots suggesting the corner nails on the top of the box.*

6 *Most of the background is bare paper, with some lightly scribbled marks of yellow suggesting reflections from the tablecloth. This area is given greater definition with linear strokes of white loosely crosshatched over the yellow.*

7 *The artist omitted such details as the folds of the tablecloth because she wanted to stress the strong shapes. She chose a horizontal format (see page 100), cropping the top of the upright box to concentrate attention on the objects. The color has been applied thickly, but the strokes do not all follow the same direction, and this variety prevents the picture from looking static.*

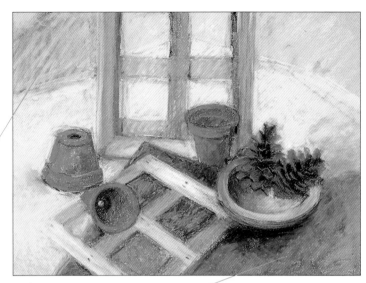

ARTIST ONE

Diagonal strokes contrast with long, upright ones on sides of box. Diagonal marks are also used for central bar of box, relating the two areas.

Deep green built up thickly with overlaid side strokes contrast with pale shapes of yellow cloth, wood, and bowl. Varied direction of strokes avoids dullness.

Background is mainly gray paper, but a few light side strokes of pale blue and yellow link with the foreground colors.

Green is lighter, with gray paper showing, and touches of charcoal suggesting shadows. Lively, slanting hatched and crosshatched strokes provide interest.

7 *The effect here is airier and more delicate, with large areas of the paper left bare, or showing between crisscross strokes. The picture has also been composed differently; this artist wanted to include the pots on the top of the box to provide a balance for those in the foreground, so she decided on a squarer format. In this rendering, the objects are more important than the shapes made by the green and yellow cloths.*

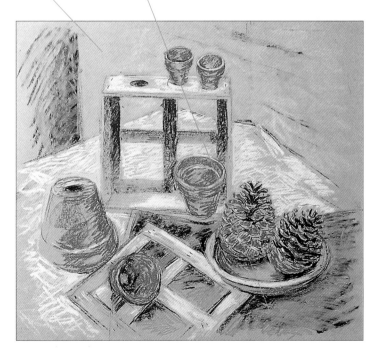

ARTIST TWO

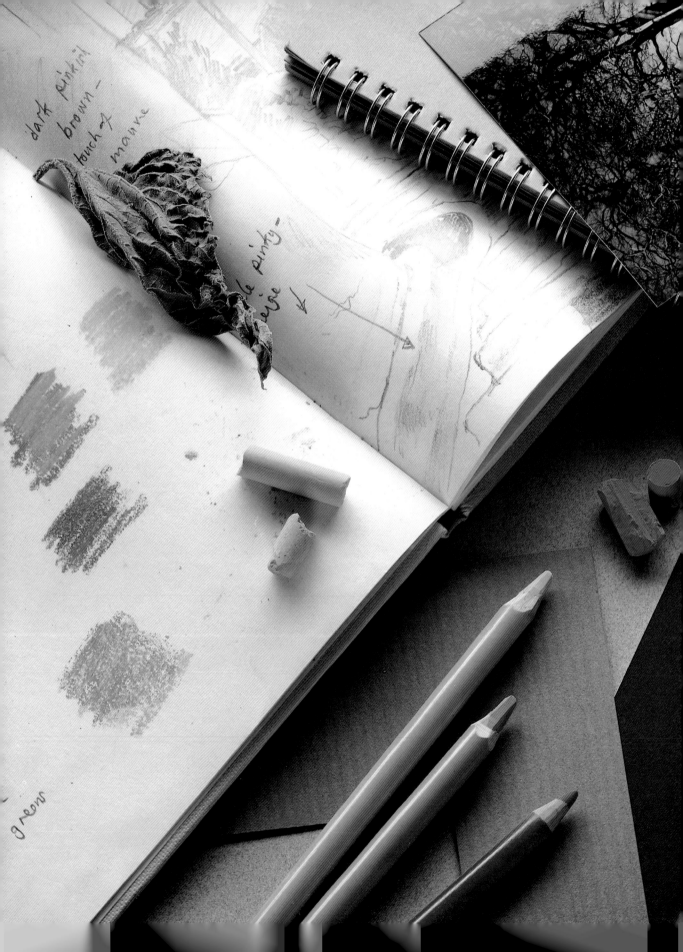

4

Basics of Picture Making

Composing the Picture

Now that you have practiced handling pastels, you can begin to think about the process of organizing – or composing – your painting. There are few hard and fast rules for composition, but there are some helpful general pointers to bear in mind.

Wherever possible, avoid symmetry. If you are painting a landscape that features a large tree and you place it right in the middle of the paper, it will dominate the picture. The viewer's eye will go straight to it, ignoring other elements that you may have taken great pains over.

Such a picture will ultimately fail because it lacks a sense of movement. A painting in which the eye is led into and around the subject is more exciting and satisfying because the viewer is taking part in the picture.

So how do you create this sense of movement? Curved or diagonal lines are often used as a compositional device, because the eye will naturally follow them. In a landscape, these lines could be provided by a path or river running from foreground to middle distance, or by the furrows of a plowed field. In a still life, you could arrange drapery so that a series of folds travels from the front of the tabletop to the group of objects.

CREATING RELATIONSHIPS

Another general rule about composition is that there must be a relationship between the various parts of the picture. This relationship can be one of color, of shape, of technique, or of all three. As you work, always think about the painting as a whole, and try to set up a series of visual links.

Landscapes, for example, are often less than successful because the two main areas – sky and land – are not "tied together" sufficiently. Try making a color link by taking a little of the blue you have used for the sky into the shadows and into areas of foliage.

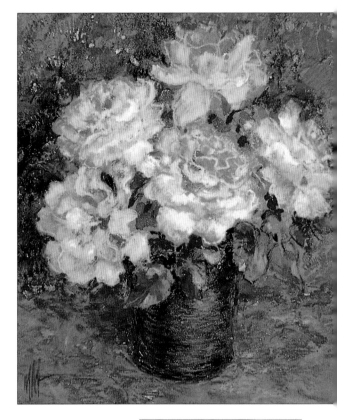

BREAKING THE SYMMETRY

Floral subjects have a built-in tendency toward symmetry; it is natural to want to place the vase in the middle of the picture so that you can fit all the flowers in. You can do this safely as long as you arrange the flowers themselves in such a way that the symmetry is broken. Here the bottoms of the blooms make an upward-sloping diagonal, and the flower at the top is not placed centrally. (Yellow Rose Texture – Maureen Jordan)

Always look for the main shapes. Here the group of flowers makes a geometric shape that counterpoints the cylinder of the vase.

Continued on page 88 ▷

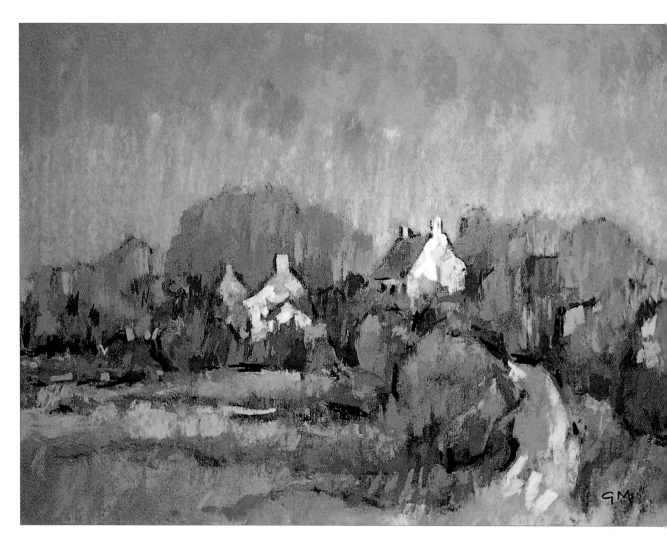

LEAD-IN LINES

Subtle use of the conventional device of a road draws our gaze toward the central group of houses, which forms the focal point. Color is also important to the composition; the eye is led by the brilliant patches of acid green repeated from the foreground trees to the foliage in front of the houses. (Cottages at St. Jacques, Brittany – Geoff Marsters)

The eye is led toward the focal point by the path, horizontal on left, curving treetops, and vertical marks used for sky and trees.

Repeating colors is a sure-fire way of unifying your composition, and you can do the same thing with shapes. In landscape this calls for greater inventiveness, but you will sometimes note a similarity between, say, a cloud formation and a tree, and you can exaggerate the resemblance. In a still life, repeating shapes is easy, because you can set up your group with this in mind, choosing forms that share a natural relationship.

Unity of technique is just as important. Don't use a flat blend in one area and positive line strokes in another. If you have done this, soften the line strokes with a little light blending, or apply some line strokes over the blended areas, to remove the disjointed effect.

BALANCE AND CONTRAST

Although you can unify the composition by repeating shapes and colors, there is a danger that the picture may become dull through over-repetition. A painting needs an element of contrast, whether of shape, color, or tone (light and dark). In a landscape, the rounded, fluffy shapes of clouds could be the perfect foil for spiky trees. In a still

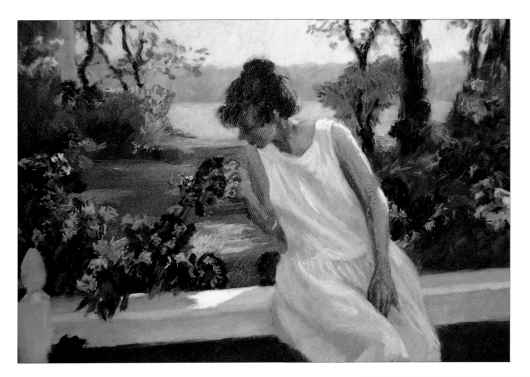

COMPOSING WITH SHAPES
The most obvious feature of this painting is its richness and unity of color. The brilliant turquoise of the water is echoed by other vivid blues on the dress and railing. But the composition is equally important and skillful, with verticals and horizontals balancing the diagonal shape made by the figure. (Time for Roses – Rosalie Nadeau)

The figure marks a strong diagonal, thrusting from foreground to sky. This is balanced by the opposing diagonal of the railing, and intersects the horizontal shadows and waterline.

life, a tall bottle could contrast with the circles made by plates and bowls.

Color contrasts need to be handled with care: too much or too many can destroy the very unity you have worked to establish. They are useful, however, when there is a predominant color in your painting, such as green in a landscape.

Landscape artists often use tiny touches of red or yellow – perhaps flowers in a field or a few brightly clad figures in the middle distance – to enliven large areas of green. Flower painters sometimes deliberately restrict their color range, choosing mainly blue or white flowers, but including one small yellow or red bloom for contrast.

Light-and-dark contrasts are most dramatic when treated as large blocks; tiny dark patches in an otherwise light-toned area look unrealistic and jumpy. Both portraitists and still-life painters sometimes use a very dark background, against which pale skin or brilliantly colored flowers stand out in high relief. A subject beloved of landscape artists is dark winter trees highlighted against an expanse of snow or a pale sky. You will find more about color and tone on pages 90–93.

REDUCING DETAIL

The river draws the eye into the picture and divides the foreground into angular shapes. The interplay of shapes is the artist's theme, and she has emphasized it by avoiding detail. Solid blocks of color have been built up with blending methods so that individual strokes are barely visible. (Autumn Light – *Lois Gold*)

Picture divided into areas of light, middle, and slightly darker tones. Curving shapes of woods and hills contrast with angular shapes in foreground.

Basic Color Principles

On pages 44–47 you learned how to make color mixtures, but this is only one aspect of using color. Once you begin to paint seriously, you will also need to understand some of the characteristics of colors, and discover how they behave when placed in different relationships to one another.

Various adjectives can be applied to colors, such as "vivid," "brilliant," "dull," "muted." These are good descriptive words, and we all know what they mean. But two other terms employed by artists are less readily understood by nonpainters. These are "warm" and "cool."

WARM AND COOL COLORS

The concept of warm and cool colors plays a vital role in painting. The cool colors, which are the blues and any color with a blue content (blue-green, blue-gray, etc.) have a tendency to recede – that is, they appear to draw themselves toward the back of the picture. The warm colors, which are the reds, oranges, and orange-yellows, do the opposite. They are the "pushy" colors, advancing to the front of the image.

These properties of colors help you to create the illusion of three-dimensional space. If you use cool colors in the background – for distant hills in a landscape – and warm ones for the fore-ground, your painting will have depth.

But it isn't a matter of choosing any blue, because all colors have warm and cool versions. Some blues are purplish, veering very slightly toward red, and are therefore warmer than those with a greenish tinge such as turquoise. The crimson reds have a blue bias, and are thus cooler than the orangey reds, such as cadmium red, while a yellow that inclines toward orange – cadmium yellow is an example – is warmer than the acid lemon yellows. This may sound compli-cated, but you will quickly learn to distinguish relative color "temperatures."

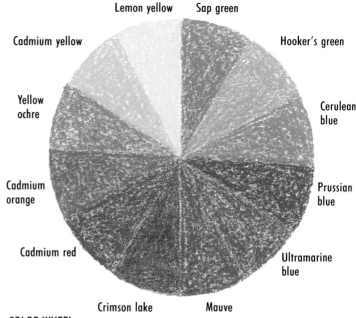

Lemon yellow — Sap green — Cadmium yellow — Hooker's green — Yellow ochre — Cerulean blue — Cadmium orange — Prussian blue — Cadmium red — Ultramarine blue — Crimson lake — Mauve

COLOR WHEEL

The wheel on the right shows a theoretical color wheel; the one above shows actual pigment colors that you can buy. This is the most useful kind, as it helps you to get to know the relative "temperatures" of the colors you are using in your paintings. Notice that the cool colors are grouped on one side and the warm ones on the other.

Yellow — Green — Orange — Blue — Red — Purple

WARM AND COOL PRIMARIES

Although red and yellow are described as warm, and blue as cool, there are variations in temperature within each hue. Here the three primary colors are shown with the warmer version on the left and the cooler one at the right.

WARM | COOL

Cadmium red | Crimson lake

Cadmium yellow | Lemon yellow

Ultramarine blue | Cerulean blue

COLOR RELATIONSHIPS

The temperature of a color is also influenced by neighboring colors. Have you ever chosen a house paint color from a small swatch, painted a wall with it, and found afterward that it looks entirely different? This is an important painting lesson — no color exists in isolation. The color appears to have changed because you are now seeing it in the context of accompanying colors — of carpets, drapes, and so on.

The same applies to painting with pastels, which will look warmer, cooler, brighter, or more muted according to adjacent hues. If you put a bright red or orange against a gray background, for example, it will have more impact than it would if it were placed on yellow or another red. Sometimes a color will have too much impact. For example, a blue chosen for the distant hills in a landscape will not recede properly, even though it is a cool color, unless the foreground colors are more vivid and substantially warmer.

Bear the idea of these color relationships in mind as you work, and you will quickly learn

COLORS WORKING TOGETHER

These samples show how colors look different according to those that surround them. In the top three blocks the orange stands out well against the more neutral gray, and also against the black, which provides a contrast of value. In the central block, it makes less impact than the surrounding red. The cerulean blue looks vivid against the gray-green but less so against the orange-red and the deeper blue.

Orange on gray

Orange on poppy red

Orange on black

Cerulean blue on blue-gray

Cerulean blue on cadmium tangerine

Cerulean blue on cobalt blue

BACKGROUND COLORS

The blues used for the distance push the background away, giving a strong sense of space. The artist has chosen a relatively warm blue, but it is still much cooler than the russets and red-browns adopted for the central group of trees and the foliage in the immediate foreground. (Frosty Morning — Alan Oliver)

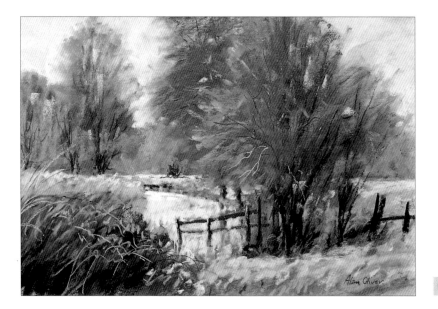

91

how to play off one color against another and set up the kind of exciting contrasts that make painting such a rewarding activity.

A particularly striking contrast occurs between complementary colors. These are the hues found opposite one another on a color wheel – orange and blue, red and green, yellow and violet. Juxtaposed, they appear to vibrate, as each color enhances the other. Most artists exploit complementary contrasts, using violet shadows on a yellow building, for example, or touches of red among greens in a landscape.

All those grays, browns, and beiges that are often hard to give a name to are also a powerful ally in setting up contrasts, as they help you to make the brighter colors sparkle. But choose these colors carefully, because none of them is really neutral. They all have a slight color bias – a gray can be greenish, bluish, or tend toward violet. You could bring in a touch of complementary contrast by setting bright red against a greenish gray, yellow against violet-gray, or green against reddish-brown.

LIGHT AND DARK

Another kind of contrast has to do with value, which simply means the lightness or darkness of any color. All paintings should have some contrast between light and dark, since without it they look flat and uninteresting.

It is important to analyze your subject in terms of light and dark. This is not as easy as it sounds, because our eyes register color before value. It is helpful to squint your eyes, which dulls the color and blots out detail. Try this, looking out of a window. You may see that a tree whose leaves you know to be a pale green is in fact darker than a wall behind it, and almost certainly darker than the sky.

Value has an equally essential role in modeling form. An apple looks round and solid because the light that falls on it produces highlights and a gradation from medium to dark tones. You will not make it look solid unless you can identify both the values and the colors involved.

NEUTRAL COLORS

These are just a few from the large range of so-called neutral colors produced by pastel manufacturers. However, they all have a definite color bias and must be used with care, since they could look quite bright in a painting with a muted color scheme.

Raw umber

Green-gray

Blue-gray

Purple-gray

Warm gray

USING NEUTRALS

Most of the colors in this delicate painting could be described as neutral, but because the most vivid colors – those of the roses – are not strong in terms of either hue or value, the grays, green-grays, and rich browns are perceived as having more color than they might in another setting. (Pink Roses – Maureen Jordan)

NEUTRALS IN CONTEXT

There are only three genuinely neutral colors: black, white, and gray made from a mixture of these two. A color with any kind of bias will be affected by surrounding colors, and these "swatches" show how two grays behave in different circumstances.

Against red and orange, gray-green appears neutral.

Surrounded by a genuinely neutral gray, made from black and white, gray-green becomes positive.

Purplish gray is much less vivid than blue and pink.

Similarly, the purplish bias of this gray shows up as color against genuinely neutral gray.

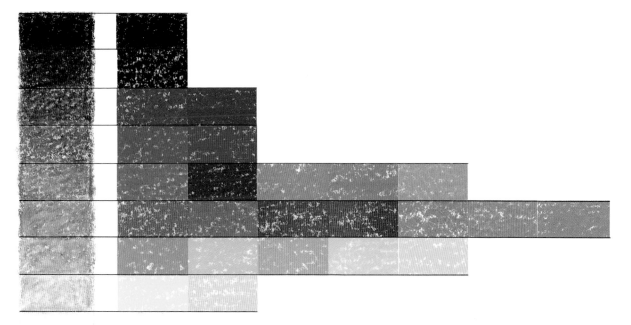

JUDGING VALUE

If you are using the recommended starter palette, become familiar with the value of all the colors by making a chart like this one. Prepare a "gray scale" with seven shades of gray, then draw up a grid and place a swatch of each color where it seems to fit in terms of value. This will help you to assess the values in your subject.

Working from Life

A STARTING POINT

Having set up her group, the artist first looks through an adjustable viewfinder to decide on the composition and shape of the picture. She stands because she wants to look down on the still life rather than viewing it at eye level, which made it look less interesting. A good reason for standing is that it encourages you to move back from your work and assess it.

BASICS OF PICTURE MAKING

Now that you know the theory of picture making, it is time to plunge in and start practicing. So where will you look for your inspiration? You could begin by working from a photograph (discussed on the next pages), but most art teachers will agree that the most valuable early experience lies in painting directly from the real world.

There is a good reason for this. Painting is a translating activity. You are creating an illusion of the three-dimensional world on the two dimensions of a piece of paper, and you have to work out how best to do this. A photograph has already reduced the world to two dimensions, which might seem to make life easier but in fact does not always do so. The camera may not carry out this initial "translation" in a way that you as an artist might, so it robs you of creative options.

The subject you choose for your first attempts is up to you. If you like landscapes, look for a quiet spot where you won't be disturbed by the comments of passers-by. You could try a portrait if a friend or family member is willing to pose, but be warned that this is one of the most difficult areas of painting. A still-life or flower piece would be a good alternative, because you can work undisturbed at your own speed.

When you begin, remember what you have learned about color and composition, and bear in mind that the picture you are making is not just a copy of something in the real world; it has its own independent existence. For example, if you have chosen a portrait and don't achieve a likeness, the painting may still be a good picture. If you are depicting a landscape, don't feel you have to put in every element you can see. As the artist, you dictate what goes into the picture, so if there is an ugly fence or a tree that seems misplaced, you can leave it out.

It can be helpful to make your preliminary drawing while looking through the viewfinder (see panel, right). If you do this, hold it to one side of the drawing board with one hand and draw with the other.

The board is at a slight angle for the preliminary drawing, but for assessment purposes it is best to adjust it to an upright position, as otherwise you will be seeing your work in false perspective.

When you are working from life, the first decisions you must make are what viewpoint to take and how much of the scene you will include. A homemade viewfinder is a great help. Simply cut a rectangular window about 4½" × 6", in a piece of cardboard, or for an adjustable rectangle, use two "L" shapes joined together with paper clips. Use your viewfinder to frame the subject as you would with a *camera. It is surprising how much the composition can be improved by a sideways shift, or a slight lowering or raising of your position. If you have made yourself an adjustable "L"-shaped viewfinder you can also choose the best format for the subject; you may find that a square shape or a long thin rectangle works well.*

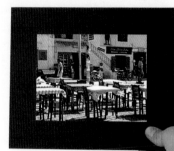

The viewfinder is held near the eye, showing as much of the scene as you would normally see without moving your eyes and head. The composition has good possibilities.

Pushing the viewfinder away slightly isolates the central section. This is less successful, since it loses the awnings and cuts off the body of the figure painted on the wall.

Sliding clamps and screws allow for different sizes of drawing board and different angles.

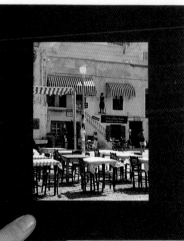

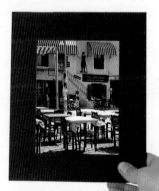

Again, the viewfinder is near the eye, and holding it vertically shows more of the awnings and the wall above. An upright format could work well for this subject.

This works well too. The patch of sunlight on the blue-and-white awnings echoes the sunlit tabletops, and the painted figure forms an intriguing backdrop for the unoccupied chairs and tables.

Using Visual References

Although beginning artists should work directly from a subject whenever possible, there are occasions when this is not practical. You might be planning a painting too large to complete in one session, or you might want to catch a fleeting effect of light in a landscape that has vanished before you have time to commit it to paper. In such cases you should consider working up the painting indoors from visual references collected on the scene.

Many artists do this, finding it gives them more freedom to compose the picture the way they want it. These visual references can be photographs or sketches, but are most often a combination of the two. The camera is an invaluable aid, since it allows you to record a great deal of information very quickly.

But there are problems in using photographs alone. First, the colors are not always true. Film cannot register subtle nuances, so shadows often come out black, and skies an unnatural, uniform bright blue. Second, a photograph ties you to a fixed viewpoint, whereas if you are in front of the subject you can move around to decide on the most favorable angle, and therefore the best composition. So don't restrict yourself to a single photograph; if you have several taken from different viewpoints, you can choose the most suitable or even combine elements from two or three.

It is always advisable to carry a sketchbook as well as a camera, because drawing a scene allows you to express a personal response in a way that taking photographs does not. Sketching commits the subject to memory better too; even if you only jot down a few penciled lines, you will be forced to look in an analytical manner and decide what is most important to your planned picture. There is more about the art of sketching for painting on the following pages.

A quick, light sketch explores compositional possibilities. The curving lamp has been moved to the right in the third sketch and the painting.

Buildings treated in more detail here, in case this reference was needed. However, they have been simplified in the painting.

A bolder, more abstract arrangement of shapes. Foreground trees and tall building and trees on hill are important features of the painting.

WORKING FROM PENCIL SKETCHES

This artist has several sketchbooks filled with drawings, which he looks through for ideas. He combined three pencil drawings for this composition, omitting certain details from each. He sometimes backs up sketches with photographs for color reference, but not in this case, because he wanted a free hand in his choice of colors. (Landscape: Casole d'Elsa – David Cuthbert)

Boats are not easy to draw, so a photograph can contribute more than a sketch. This provided a reference for the fishermen's nets, which have been generalized in the painting.

A useful reminder of the colors of the fishermen's clothing and the shape of the right-hand man's hat. But the composition is poor.

This provides helpful color reference for the sea and boat, but the figures are silhouetted, with no color or detail visible.

Working rapidly with a scribbled pen line, the artist sketched in the figures that will form the main focus of the composition.

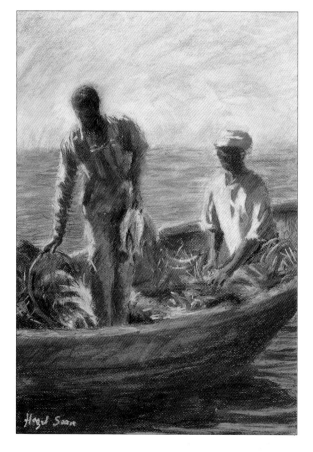

This quick pastel sketch establishes the shape of the boat (lower in the water at the back), and the size relationship of figures to boat.

Again in pastel, she begins to plan a color scheme for the painting. She uses blue paper, since blue and brown are the dominant colors.

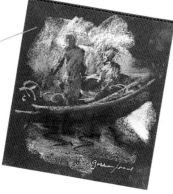

WORKING FROM PHOTOGRAPHS AND SKETCHES

If you work from a single reference, you have no choice of compositions to consider. The artist took several photographs, and having decided to feature the figures in her painting, made several rapid monochrome and color studies. The sketches were more valuable than the photograph of the figures, because they convey a better sense of movement. (Cape Fishermen – Hazel Soan)

Making Your Sketches Work

There are two kinds of sketches: those that are finished art in themselves and those that are intended as a basis for paintings.

Sketching for a painting should be regarded as note-taking, and the type of notes you make will depend on the medium you are using. Pencil is an excellent and highly versatile sketching tool, which can record linear outlines and areas of tone. But of course, it is monochromatic, so you will either have to make a separate color sketch or add written markings to the pencil sketch, a common practice among artists. There is nothing more frustrating than pinning up a series of pencil sketches a week after they were made, only to find them useless because you have no idea what the colors were.

Making accurate color notes involves recognizing colors and describing them meaningfully to yourself. It is no good just writing down "blue" or "green." This will mean nothing to you when you want to use the sketch, but "very dark blue-green" or "pale gray-blue with a hint of mauve" will. Some artists use a familiar reference to aid their memory, for example "creamy coffee," or "Chinese vase blue." Constructing color notes is a highly personal activity.

If you are using pastel as your sketching medium, you can place the emphasis on recording the colors, but you may then find you have insufficient information on shapes and forms.

Look at your sketch critically when you have completed it, and see whether you think you could paint from it. If not, then make another, perhaps in pencil or pastel pencil, concentrating on whatever is missing from the first sketch. It will take practice before you get it right, but once you start working from sketches you will quickly discover what you want from this preliminary information-gathering and the best way to achieve it.

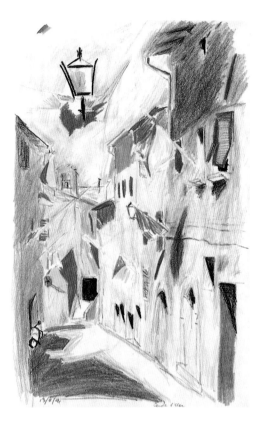

COLORED PENCIL
This is another good medium for making color sketches. As you can see from this study, you can achieve considerable depth of color. Like the oil-pastel sketch below, this could be used as the basis for a finished painting. (Casole d'Elsa – David Cuthbert)

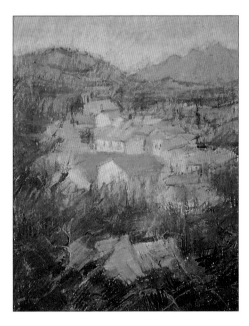

OIL PASTEL
If you like to work up finished paintings from on-the-spot sketches, you might consider buying a small box of oil pastels. These are less messy to use than soft pastels, as they do not produce dust and they require no fixing. (Rooftops, Vaucluse – Joan Elliott Bates)

Soft pencils (4B and 6B) used to block in main shapes and areas of tone.

Extra note needed here to remind artist of the varying edge qualities of the cloud.

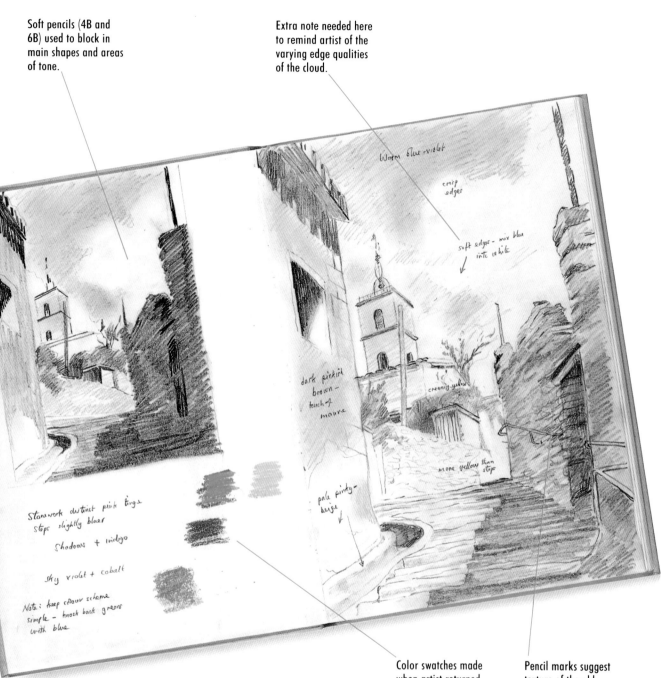

Warm blue-violet

crisp edges

soft edges – mix blue into white

dark pinkish brown – touch of mauve

creamy yellow

more yellow than steps

pale pinky - beige

Stonework distinct pink tinge
steps slightly bluer
Shadows + indigo
Sky violet + cobalt
Note: keep colour scheme
simple – knock back greens
with blue

Color swatches made when artist returned from sketching trip, with scene still fresh in her mind.

Pencil marks suggest texture of the old stone wall.

COLOR AND TONE NOTES

Pencil sketches can provide adequate visual reference, provided that you make notes about colors, as the artist did here. She also backed up the full-page sketch with a smaller one exploring the distribution of tones. The dark wall on the right and the shadow on the steps are an exciting aspect of the subject. (St. Laurent-de-Cerdans – Hazel Harrison)

Exploring the Options

There are decisions to be made at every stage of a painting. As you paint, consider how best to exploit your pastel marks and how much detail to include. Assess your painting to check and adjust the balance of tones and colors. Many of these decisions become instinctive, but there are other, more conscious choices to make before you begin to paint.

Planning a painting is a process of exploring options. The first concerns format. Your painting could be a horizontal rectangle, a vertical one, or a square. The second concerns composition. How will you place the subject on the paper, and how much of it will you show? And finally, which color paper will you choose? To guide you through the possibilities, these four pages show how a professional artist approaches such choices. She has made some quick sketches to help her decide on format and composition, and has then painted the same scene on two different shades of paper to discover how the ground color influences the overall color scheme.

A vertical format shows more sky. This provides light area to balance the path.

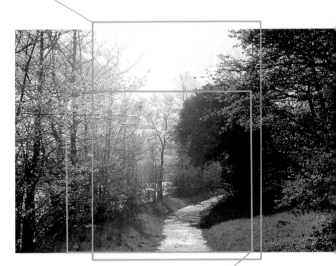

TRYING THINGS OUT

When you are working from a photograph, don't automatically adopt the same format. Explore possibilities by masking different areas with four strips of paper. If you are painting on the spot, use a viewfinder (see p. 95).

A horizontal format centers the path. Could make squarer, thus losing some of left and right sides.

THUMBNAIL SKETCHES

Pencil or charcoal sketches like these are another way of planning your composition. They take longer than masking a photograph, but give you more opportunity to rearrange shapes and organize the tonal structure.

A vertical format could work well, allowing the artist to exploit the trees' upward sweep.

A square shape sacrifices the vertical sweep of the left-hand trees but makes more of the large right-hand tree.

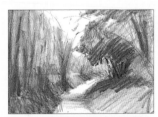

More sky is visible in a horizontal format; the foreground was cropped to accentuate the shadow of the right-hand tree. This sketch was chosen as the basis for the final painting.

Brown paper

Medium brown is easy to work on. Neutral and therefore unobtrusive, it allows light and dark colors to show up well. Brown paper is good for landscapes, because it provides a natural setting for the greens. Nature is rich in both these colors, so flecks of paper will blend with the pastel.

Blue paper

This is also a popular choice for landscapes. Touches of blue are often apparent in green foliage, and shadows frequently have a bluish tinge, so areas of paper can be left uncovered to enhance the overall effect. However, blue is a stronger color than brown, and this can affect your judgment in the early stages of a picture. Neutral colors, for example, may initially look duller against the blue.

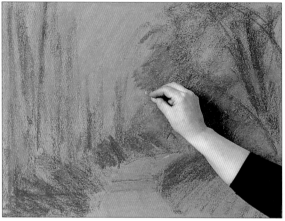

1 The artist likes to build up her colors with a layering technique. She wants to give the sky and the path a warm tinge, so after making a charcoal underdrawing, she begins with an orange-brown pastel.

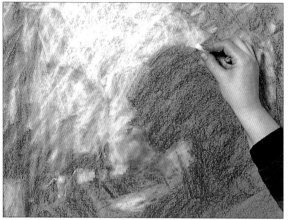

1 Because this paper is a dark, positive color, the artist chooses a light pastel for the sky. She needs to block in the light tones early on, or the painting might become too low-key.

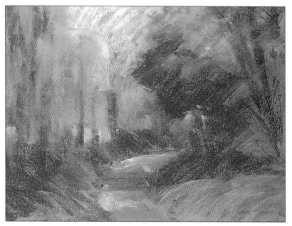

2 Before beginning to assess and adjust tones and colors, the artist covered the entire paper rapidly. The painting is now blocked in, with a definite tonal structure.

Continued on page 102 ▷

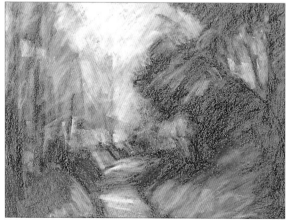

2 Here you can see how the paper color influenced both the choice of colors and the way of working. The covering of pastel is lighter than in the other picture, with more of the ground color coming through to contribute to the effect.

Continued on page 102 ▷

BROWN PAPER *(cont.)*

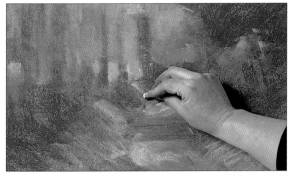

3 *The artist develops the colors gradually, moving from one area of the picture to another. Here side strokes of light green are mixed into the earlier colors and the charcoal drawing to produce a semi-blend.*

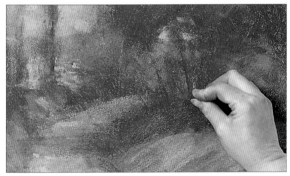

4 *The picture is a broad impression, meaning that detail was not added, but here a little definition is needed. The painting was sprayed with fixative, and a sharp edge of black pastel is used to draw the tree trunk and branches.*

5 *The painting is nearly finished, but some final adjustments and details are needed. The sky was lightened, with drifts of yellow suggesting foliage against the light, and a few twigs are drawn with delicate strokes of the pastel edge.*

BLUE PAPER *(cont.)*

3 *Colors respond to the changing needs of the painting rather than depicting the subject literally. This red-brown adds warmth to the tree and contrasts well with the blue paper.*

4 *Because some blue paper will be left showing, the strokes in this painting are placed farther apart, making them more distinct. Here the pastel is applied thickly, but on the path above the artist's hand the paper is visible between strokes.*

5 *Although the specks of blue paper are effective in places, they could detract from this solid dark area. The artist uses her fingers to push the colors firmly into the grain of the paper.*

BROWN PAPER

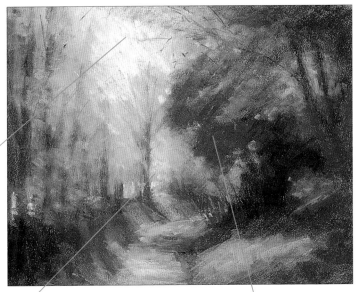

6 *The two paintings have strong similarities, because both are by the same artist, but there are important variations. The colors are warmer in this version, because the brown paper set the color "key." The compositions are different also: here the artist cropped some of the foreground and plays more with the light and shade on the right of the path.*

Diagonal strokes echo those on the tree but follow the opposite direction, setting up a feeling of rhythm.

Small area of white draws the eye into the composition.

Tree is treated broadly to prevent it from dominating the composition.

BLUE PAPER

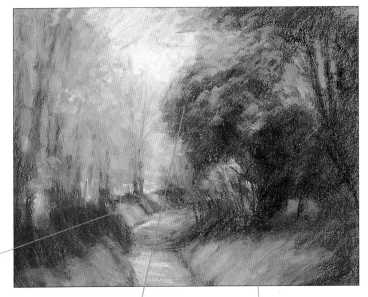

6 *When you work on a colored paper, you need to be assertive in your use of color. Hence the tonal contrasts are stronger in this painting than in the brown version. This resulted in greater detail and definition. The large tree, for example, gives a clearer suggestion of texture and individual forms. Here, the right-hand foreground is less important than the forceful curve of the path.*

Shadow and patch of sunlight reinforce the curve of the path along which the viewer's eye travels.

More detail, tonal contrasts, and suggestion of texture draw the eye, making the tree the focal point.

Pattern of light and shade are played down, so as not to distract from the focal point.

5

Picture Making

Still Life

Still life allows the artist to take control. You can paint any item around the home that appeals to you and arrange it as you please. And still life helps you to develop your skills, because you can take as long as you like to complete your work. There is no hurrying to catch your subject before the light changes or because your model needs a rest. Most artists turn their hands to still life at some point in their careers, and many specialize in this field of painting because it is exciting and rewarding.

TYPES OF STILL LIFE

A still life can be any group of inanimate objects, from bottles or fruit on a tabletop to a pair of shoes in the corner of a room; and it can be as simple or as complex as you like. But there are two distinct types of still life: the organized group, and the "found" subject. In the first, you choose items that you like to paint and arrange them to form an interesting composition.

A "found" subject is something you happen to see, such as clothes in a closet, a plant on a windowsill, or an open book left on a chair. This classification also embraces paintings of interiors, which are still lifes with a visible setting. Throughout the history of art there have been many beautifully depicted interiors.

The 17th- and 18th-century Dutch painters, such as Pieter de Hooch, produced tranquil, highly detailed interiors. In the early 20th century, Pierre

"FOUND" SUBJECTS

This group was essentially happened upon and adjusted to improve the composition. There is, however, a carefully planned color theme based on the contrast between warm red-browns and turquoise-blue walls. The artist muted and "blued" the green of the plant so that it does not conflict with this. (Reflections — Sandra Burshell)

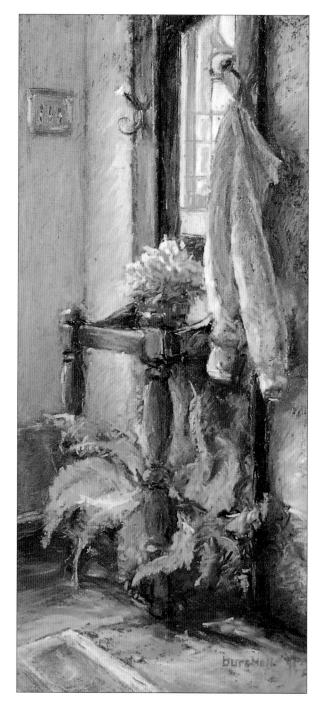

EFFECTS OF LIGHT

Putting a window in your painting gives you an excellent opportunity to experiment with the effects of light. Here the sunshine pouring into the room creates patterns and pools of light and adds an extra dimension to the composition. The window itself was treated loosely, so that the viewer is not distracted by the view beyond. (East Window – Margaret Glass)

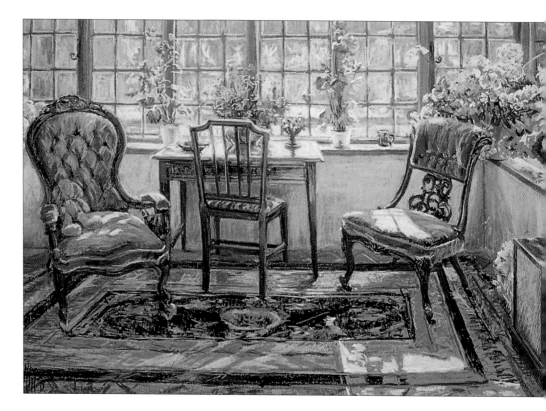

Bonnard and Gwen John portrayed the rooms in which they worked. Their paintings are more impressionistic than those of the Dutch artists, showing perhaps a mantelpiece with objects, a corner of the room, or a chair by a window.

When you find a subject, you are free to alter its composition; in an interior, for example, you could move furniture and ornaments. But the essence of the found group is spontaneity, so don't make it look too well-ordered.

CHOOSING THE GROUP

A still life usually has a theme, giving the impression that the objects belong naturally together. In a found group a theme will already exist, but in a deliberate arrangement you will need to select items that combine comfortably.

A popular still-life theme is the culinary one – a group of fruits, vegetables, or other food, perhaps combined with dishes, cutlery, or kitchen utensils. Texture can also be a theme, with components such as glass, metal, and fabrics selected for their surface qualities. Or you could make color the main theme, choosing a collection of blue objects but including a yellow or red one for

Continued on page 108 ▷

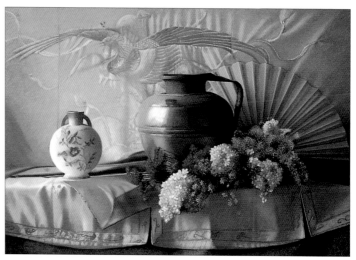

ECHOING SHAPES

This group was set up with care; the objects were chosen to present an array of delicate colors and rich textures, which the artist exploited with smooth blends. The painting is unified by color but also by repeated shapes. The roundness of the small vase echoes that of the brass pitcher; the wings of the bird continue the curve of the fan; and the dried flowers make a curve in the opposite direction. (Brass and Dry Flowers – Barbara Willis)

contrast. Contrast is always important in painting, so avoid items that are all the same shape or color to get an interesting result. If you decide to paint a bowl of fruit, for example, see if you can introduce something angular as a counterpoint to the rounded shapes. This linear touch could be provided by the back and front of the table-top, or you could include a book or napkin.

ARRANGING THE GROUP

Artists who specialize in still life spend a considerable time setting up their groups, and you must be prepared to do the same. This is the first step toward composing the picture. There are no definite rules about arrangement, but bear in mind that even an organized group should look as natural as possible. Also, you need to establish spatial relationships that tie the different elements together visually.

Once you have made a preliminary choice of objects, assemble them, then move them around until the group coheres. If the composition looks cluttered, edit your original choice. Novices tend to overcrowd their still lifes. Let certain objects

Continued on page 110 ▷

THE NATURAL LOOK

This seemingly natural group was deliberately arranged, and the composition thoughtfully planned. It is based on a triangle, with the pitcher at the apex and the spoon, bread roll, and newspaper forming the sides. (Morning Shadow – *Sandra Burshell*)

EXPLORING ARRANGEMENTS

You should avoid introducing too many colors, because they will tend to cancel one another out and the painting will lack coherence. Have some contrasts, though, of color and shape; in all these arrangements the oranges and yellows offset the deep blues, and the tall bottles make a good background for the predominant circles and curves. It is a good idea to start with more objects than you think you will need and gradually eliminate items as you try out different arrangements.

Over-cluttered, and glass bottle color insufficiently strong. Pitcher facing outward draws eye out of picture. Pattern on ginger jar fights tablecloth.

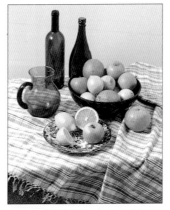

Much better. The pitcher now takes the eye in. Fruit in foreground balances that in bowl, and folds of tablecloth give movement.

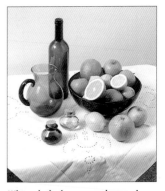

White cloth shows up colors and creates attractive blue shadows from glass. Could be toned down in painting to avoid stark contrast.

CREATING MOVEMENT

Even though still-life objects are inanimate, they should not look static. Technique gives this picture a vigorous feeling. The loose scribbled marks enliven flat areas, such as the foreground tabletop. (Soup Tureen, Fruit and Flowers — Maria Pinschof)

FAMILIAR OBJECTS

This artist arranged an evocative group in a formal pyramidal composition. Her smooth and precise technique, unusual in pastel work, allowed her to describe each item in photographic detail. (Dear Friends — Barbara Willis)

LIGHTING A STILL LIFE

Light plays a vital role in all painting. One of the attractions of still life painting is that, because you are in control of your subject, you can play around with various lighting effects rather than taking the light "as you find it." The pictures here show some of the interesting possibilities.

Backlighting can be very effective. It darkens the colors of the objects and reduces detail while casting strong shadows directly in front of them.

Here a low light from the side has been used, casting intriguingly shaped shadows and creating highlights.

Light from directly in front is usually less successful, because the shadows are behind the objects and thus contribute less to the composition.

overlap, and position some nearer the back of the table than others. Watch out for spaces between them; if one component is too far from another, it will become isolated and destroy the group relationship.

When you begin to feel that the arrangement is working, look at it through a viewfinder, as shown on page 95, to check whether it will fit properly into your picture area; if not, make some final adjustments until you are happy with the appearance of the group.

COMPOSING THE PAINTING

You may think that you have finalized the composition once you have arranged the group, but this is only the beginning. Before you start to paint, you must figure out what viewpoint to take, what shape the painting is to be, and how you will place the subject on the paper. The viewfinder is helpful again here. You may find that it reveals

possibilities you had not previously considered, such as observing the group from above or below.

A high viewpoint, such as you have when you work standing up, is often effective for an arrangement that includes dishes or bowls, because it allows you to see more of the circles, introducing a pattern element. A low viewpoint from a seated position can work well for a group of tall objects, such as bottles.

If your still life is set on a tabletop, try looking at it from one side so that you see the corner of the table, rather than square-on, which gives you a hard horizontal line in the foreground. It is usually best to avoid horizontals, as they block the eye rather than leading it into the picture, creating a static effect. A device often adopted to break the line of the table edge is a piece of drapery hanging over the front and sweeping around the objects, making a series of curves and diagonal lines from foreground to background.

HIGH VIEWPOINT

A strong pattern derives partly from the way the fruit is arranged and partly from the high viewpoint. This enhances shapes because forms are less apparent, and it separates the objects from the flat plane on which they are resting. The artist emphasized the separation by omitting any shadows beneath the fruit, so that they look as though they are flying upward. (Fruit Still Life — Catherine Nicodemo)

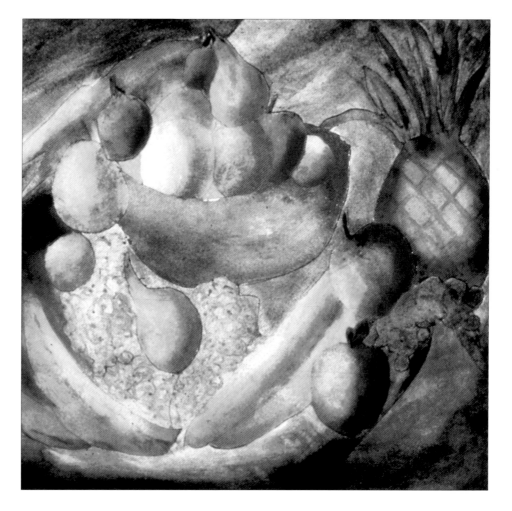

You can spend time arranging a still life only to find that it loses its appeal when you return to your easel. This is because you have shifted your viewpoint, which radically changes the visual relationship of the objects. So before you begin to paint, look at the group through a viewfinder from your painting position, and if it still does not jell, move your easel, or work from a standing position so that you can look down on the subject.

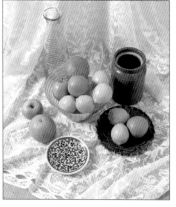

High viewpoint (standing position). Most suitable for flat objects, and works well for dishes and fruit. But foreshortening of bottle and jar looks uncomfortable.

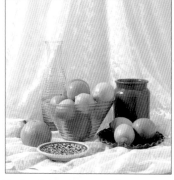

Eye-level viewpoint is good, stressing diagonal side of bowl, tall glass bottle, and upward-sweeping folds of drapery. Also creates an oval ellipse of the plate in the foreground.

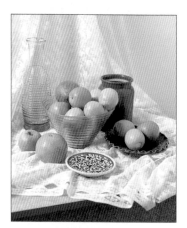

Viewing from left makes drapery into interesting shape and causes bowl to overlap brown jar. Gives a pleasing impression of movement.

USING SHADOWS

The shapes made by shadows can play as powerful a role in a painting as the objects themselves. Here a group of children's toys was the starting point for an almost abstract arrangement of geometric shapes and vivid colors. The artist evolved his own method to achieve the extraordinary depth of color, working on wet paper (stretched to prevent it from buckling) and building up from dark to light. The pastels hardened as they dried, so no fixative was needed. (Staying After School – Darrell Fusaro)

Painting Fruit

PICTURE
MAKING

The rich colors of fruit are nature's gift to still-life painters, and since fruit is readily available, you will never be at a loss for a subject. You can add more interest to an arrangement by cutting some of the fruit, as the artist did here. This provides a contrast of shapes and textures as well as giving a fuller picture of the fruit. When you set up the group, keep in mind that the background plays an important part in defining the fruit. For example, to make light-toned but vivid colors stand out well, a dark background usually works best.

Composing the picture •

Balancing colors and tones •

Using lively pastel marks •

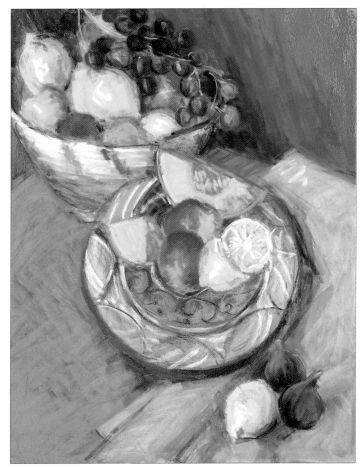

A dark background makes the yellow and red fruit stand out.

The pointed shape of the cut melon overlaps the bowl, creating a relationship between the two.

The lemon in the foreground ensures that yellow is repeated throughout the composition.

Compare the finished painting with the photograph. You can see that the artist's interpretation is more exciting. To increase the impact of the picture, she used a rich blue for the background to emphasize the colors of the fruit. She also played down the patterns on the tablecloth and plate so that the fruit is the focus of attention. (Fruit in Season – Debra Manifold)

1 The artist is working on pastel board, because it allows her to build up the colors thickly. She makes her preliminary drawing with compressed charcoal, keeping the drawing fluid.

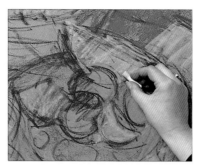

2 The artist begins to work over the charcoal, using the edge of the pastel stick to make hatching strokes.

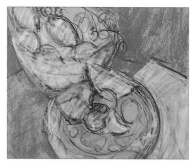

3 It is important to identify the color theme of the painting at an early stage, or the colors may become disunited. Here the major theme is the blue-yellow contrast, so the artist places these colors before bringing in the reds and neutrals.

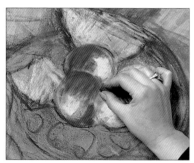

4 She builds up the forms and individual characteristics of the fruit, laying rich red over the yellow in the same broad hatching technique. Color links are created by repeating this red both on and behind the dish.

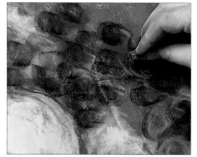

5 The grapes do not play a dominant part in the composition, so she treats them lightly, making curving side strokes with a short length of black pastel. Thought is given to how the marks will add to the overall effect.

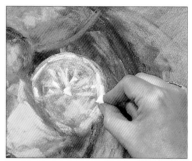

6 It is surprising how accurately an object can be rendered with very little detail. These lines made with a broken edge of white pastel are all that is needed for a convincing cut lemon.

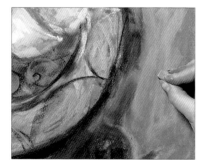

7 The artist decided to modify the foreground drapery, which was too blue, so she adds a layer of gray-green. She suggests folds in the drapery by drawing strokes going in several different directions.

8 The brocade cloth is treated in a similarly generalized way. The bold diagonal strokes are kept open so that the earlier blue shows through. This creates a lively color interaction as well as adding surface interest.

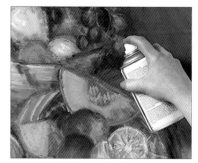

9 The texture of pastel board permits a heavy buildup of color, so it is seldom necessary to fix the work between stages. However, it is wise to spray on fixative when the picture is completed, before protecting it with tissue or tracing paper for storage.

Painting Patterns

PICTURE MAKING

A richly patterned carpet or tablecloth can spark the idea for a painting. But dealing with intricate and vivid patterns can be tricky. First, you must observe the effects of perspective closely in order to get the pattern right. Second, you need to keep all the borders clean and sharp, making sure that one color does not seep into another. Don't overdo the pattern element; try to balance it with plain areas.

Observing the effects of perspective •
Keeping the colors clean •
Removing unwanted details •

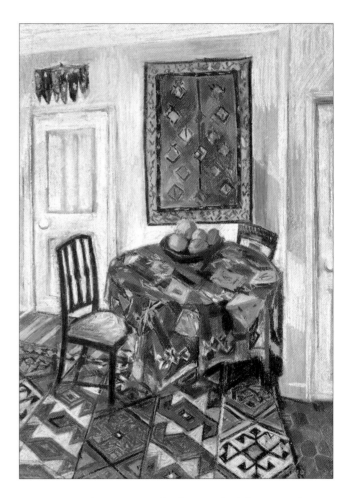

Doortop ornaments, lampshade, and door knobs clutter and weaken the composition. Door knob changed to white in painting.

Door moldings, hardly visible in the photograph, need to be enhanced to make the background less starkly white.

The pattern was worked in separate areas of color with minimal overlaying to keep it crisp.

A dark shadow under the table separates the tablecloth from the rug. Artist lengthened the tablecloth and reduced the shadow to link the two areas.

As you can see if you compare the photograph of the scene with the painting, judicious selection and rejection created a stronger composition. The most important change was to tilt the perspective to show more of the tabletop and rug. The doors and the upright of the wall on the right now provide a good balance for the wall hanging. (Interior with Patterned Carpet — Pip Carpenter)

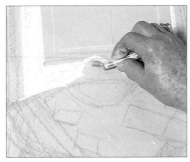

1 A medium-blue hard pastel was used for the initial drawing. The artist now begins to fill in each area separately. She is working on the rough side of Mi-Teintes paper, because its texture will hold the pastel well.

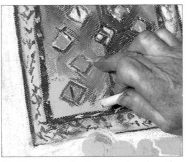

2 The touch of color was placed on the orange as a guide so that she can pick up the same color on the wall hanging. She works on this next, blending the light orange into the red to create a soft-textured effect.

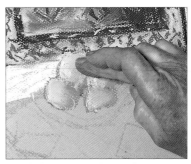

3 Thick color is applied to the oranges and blended with the finger. The artist works from top to bottom of the picture, starting with the central area, so that she does not have to rest her hand on completed work.

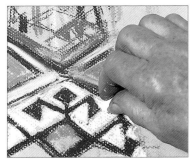

4 On the tablecloth, colors are applied over one another where soft effects are needed but otherwise kept separate as much as possible. Unity of color is preserved by repeating the deep blue of the bowl on parts of the pattern.

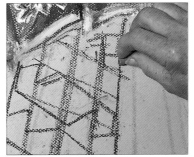

5 After completing the tablecloth, the artist works on the carpet, reinforcing and correcting her original drawing to get the complex perspective right.

6 The pattern is filled in area by area. It is not normally good practice to work piecemeal, but these intricate shapes and rich colors demand a slow and deliberate approach.

7 The black pattern is applied first, and white is taken carefully around the edges. This area is in the foreground, so any mistakes would be obvious.

8 The red stripes on the rug below the door are slightly exaggerated to make a color link with the patterned carpet. Compare them in the photograph and in the finished picture.

9 The door and most of the wall were left until last so that the artist could judge how much color and detail were needed. A piece of paper is used as a mask to ensure straight edges.

Different approaches

There are two main schools of still-life painters: those who set up elaborate arrangements containing many objects and those who prefer simple groups. The Dutch painters of the 17th and 18th centuries, who established still life as a painting subject, belonged to the first category. The French Impressionists, concerned with being true to what they saw, chose humble subjects, such as a plate, knife, and loaf of bread on a table. Both approaches are valid, but if you want to follow the Dutch example, you will need a good selection of objects, so start collecting suitable fabrics, china, and glassware.

Subject and arrangement are complex. Mantelpiece creates a frame within a frame.

Front lighting from above shows up objects in detail. It casts back of cupboard into shade so that bowl stands out.

Careful arrangement of spoons and other objects highlights artificiality of composition. Also introduces a touch of mystery: who is coming to eat the cake?

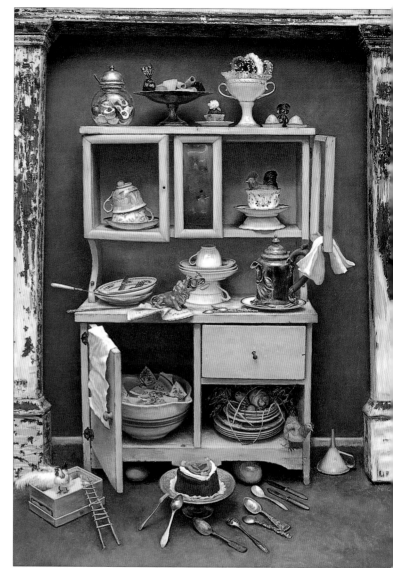

COMPLEX GROUPINGS

These two paintings differ in lighting and technique as well as in subject matter. Hard front lighting, casting the minimum of shadow, illuminates each object, which the artist drew in minute detail. She began with pastel pencils and hard pastels, then combined these with soft pastels to build up smoothly blended surfaces in which no pastel marks are visible. (Yellow Cabinet with Cups and Saucers – Deborah Deichler)

SIMPLICITY

In contrast to the deliberate arrangement opposite, these objects seem to belong on the windowsill, and the technique is much freer. The primary theme of the picture is light, which comes from behind the group so that the shadows play a vital role in the composition. Both the window and the framed photograph are suggested rather than portrayed literally, to prevent them from dominating the picture. (The Blue Vase — Margaret Glass)

Pattern on curtain is important, as it links where light strikes with that on vase, but the artist avoided detail and tonal contrast.

Loose strokes of light pastel over darker colors suggest window, with nature beyond, but treatment is impressionistic.

Light and shadow create diagonal stripes, which counterpoint verticals and horizontals of window frame.

Pattern is played down so that vase has a strong, simple shape.

Flowers

Flowers are among the best-loved subjects in painting, and their vivid colors and fragile texture are ideally suited to pastels. Are there some colors in your starter palette that you have never had a chance to use? Well, a flower painting may provide just the opportunity for bringing brilliant red, orange, and purple into play, and perhaps even for expanding your palette. Some suggestions for additional colors are given on page 123.

Of course, not all flowers are bright; some have delicate hues. But pastel is equally suitable for these. The only aspect that pastel handles less well than other media is detail – you couldn't use it for the precise botanical studies of single blooms that some watercolorists make. Pastel demands a broader, bolder approach, so when you begin a picture, keep it simple. Establish the main shapes and colors first. You can add touches of crisp detail in the later stages.

Flowers can be painted outdoors in their natural habitat, but the term "flower painting" is usually used to describe an indoor arrangement of cut flowers in a vase. This is a branch of the still-life genre, and has the same advantages. You can choose the flowers you want, place them in a vase that complements them, and control the details of the composition.

The only slight problem is that flowers do move – not to the same extent as people, of course, but in the course of a day blooms can drop their petals and buds may unfurl, changing the appearance of your group. You therefore have to work faster than you would with an inanimate still life, which you could paint for several days.

ARRANGING AN INDOOR GROUP

Arranging flowers for a painting differs from making a floral display. In general, it is best to aim for simplicity and a natural look rather than

Continued on page 120 ▷

SETTING UP A FLORAL GROUP

You can make a lovely painting out of a very simple subject such as a bunch of wildflowers in a jar, or one rose in a small bowl, but if you decide on a mixed group, take some time over arranging it, as this is the first step in composing your picture. Try to achieve a harmony of colors, or restrict yourself to one or two colors, and try out several different vases to see which one sets off the flowers best. The photographs here may give you some ideas.

This arrangement of white lilies has strength and simplicity, and the straight-sided vase is a good choice. To paint it, you might need to introduce some color variation into the background to prevent it from looking dull.

This is a nicely balanced, natural-looking arrangement, with the squat, heavy-glass vase complementing the flowers well and contrasting with the round table.

Complementary colors – yellow and violet – have been used to striking effect in this group. It is cleverly arranged, with the spray of foliage making a sweeping curve that breaks up the top edge of the vase and adds foreground interest.

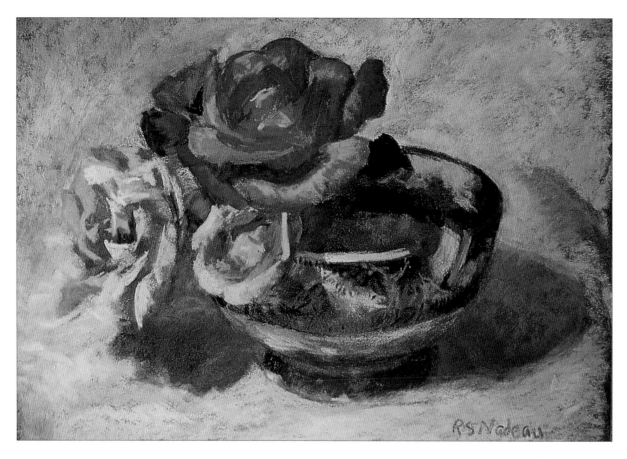

KEEPING IT SIMPLE

*Roses have strong shapes that invite individual treatment – a single rose can be the subject of a picture. But take care over the composition; this group gives the impression of simplicity but was artfully planned. The round shape and glowing colors of the bowl balance those of the flowers, and the blue shadows provide contrast. (*Chipped Bowl with Roses *– Rosalie Nadeau)*

WORKING BROADLY

*To capture flowers, it can help to work in color immediately, without making a preliminary drawing, as was done here. The artist vitalized the picture by building it up in a series of lines flowing in the direction of the vase and flowers, and using scribbles in foreground and background. (*Zinnias in Vase *– Maria Pinschof)*

119

the formal, symmetrical florists' style, which can appear static in a painting. Let some of the flowers droop over the edge of the vase, and don't have all the blooms facing forward as though they were posing for a photograph. You will have a greater variety of shapes if some are turned away.

Do not overdo contrasts of color. The most successful flower paintings either have one dominant hue, with perhaps a touch of a complementary color for contrast (say, a bouquet of blue flowers with one small orange one), or a range of harmonizing colors, such as blues, mauves, and pinks. Too many colors will make the picture look disjointed and jumpy.

When you have arranged the flowers, look through a viewfinder and see if the composition needs improvement. You may notice that you have a lot of blank space in the front of the picture beside the vase. This can happen with groups that make too tall a shape to fill the standard rectangular paper format. You can solve the problem by introducing another element beside the vase, such as a glass, bowl, or one or two pieces of fruit. An even simpler solution is to break off one of the blooms and place it by the vase, or to wait until some petals have dropped and leave them there, which looks completely natural.

CROPPING

Arranging the flowers is the first step toward composing the picture, but adjustments will be needed when you begin to paint. You can enhance a tall or wide arrangement by cropping — that is, by letting one or two blooms go out of the picture at the top or sides. This avoids the uncomfortable impression of everything being squeezed in to fit the paper.

BACKGROUNDS

In the majority of flower paintings, the background is left as an area of undefined space, with some slight variation of color suggesting the play of light and shade. But this does not mean that backgrounds are unimportant. They play a vital role in the picture, and you must consider which color or tone will complement the flowers. Avoid too much contrast between background and flowers, and bring in touches of the flower or vase color to create a visual link.

Another option you might explore is setting

Continued on page 122 ▷

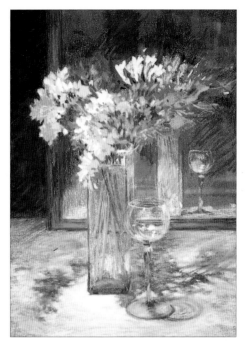

FILLING IN THE SPACES
The artist solved the problem of a tall display by bringing in some still-life objects — the wineglass and mirror — as well as making a feature of the foreground shadow. The mirror plays a double role, reflecting the glass and vase to create interest at the right of the picture and providing a background vertical that echoes the side of the vase. (Reflections I — Maureen Jordan)

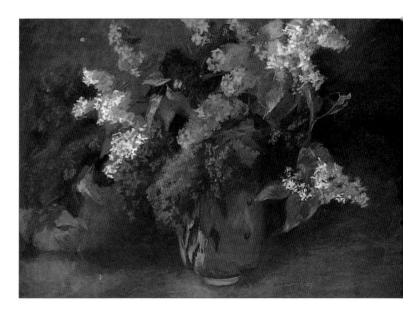

LETTING THE FLOWERS BREATHE
The flowers stretch beyond the picture at the top and right side. This makes them look more natural, because it suggests that they have a life outside the boundaries of the painting. The artist deliberately restricted her color scheme to harmonious purples and blues, with white providing tonal contrast. (Color Purple – Rosalie Nadeau)

When you first look at a multi-petaled flower, such as a dahlia or chrysanthemum, it seems complex, with many different planes and surfaces. But there are basic shapes in flowers: most are circles, bell shapes, or cones. Some are a combination; the daffodil, for example, is a bell shape set in a circle. Try to identify these shapes, and notice how they are affected by perspective. A sunflower (circle) seen at an angle becomes an ellipse, and if you draw this accurately you will have no trouble placing the petals around it.

A sunflower seen from the front forms two circles, an inner one for the center of the flower and an outer one for the petals. Sometimes there will be more than one layer of petals.

Viewed from a three-quarter angle, the central circle becomes an ellipse and may hide some or all of the petals on the far side.

The trumpet of a daffodil is bell-shaped, but from the front you will still see two circles: the nearest edge of the trumpet and the halo of surrounding petals.

From a side view or three-quarter view, the bell shape can be seen clearly, and the halo of outer petals forms an ellipse.

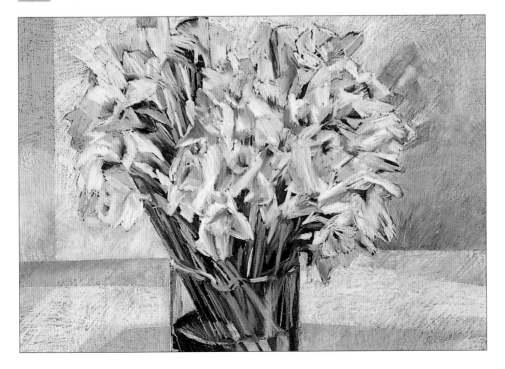

BACKGROUND INTEREST

The background is part of the picture and must be related to the foreground; if you are using positive strokes rather than smooth blends for the flowers, continue them into the background, as the artist did here. She used a dark paper, which shows between strokes to emphasize them and also creates an outline effect on the flowers. (Narcissi – Pip Carpenter)

up your group on a windowsill. This would give you a framework of vertical and horizontal lines, which can work well, as the straight lines contrast with the rounded shapes of flowers and the flowing curves of stems and leaves. You might suggest the view through the window with a touch of green or blue, but avoid detail or too much contrast, since this could detract from the main subject, or focal point.

NATURAL HABITAT

Paintings of flowers growing in a yard, park, woodland, or open countryside come under the category of landscape. Although you can choose the best viewpoint, you cannot control your subject. But you can organize the composition and decide how much you will put into your picture. Will you, for example, portray the flowers as broad masses of color, or focus on one or two blooms?

The latter approach would work well for large, dramatic flowers, such as roses, magnolias, or sunflowers, which have strong shapes. It would be less suitable for flowers that make their impact en masse, such as bluebells in a wood or daisies in a field. Massed flowers can be treated broadly, but you want to make them recognizable, so look carefully at their colors and growth habits, which are clues to their identity. In a painting of a bluebell wood, for example, you need little detail – as long as the color is right and you give the impression of dense growth, there will be no doubt about what flowers they are.

COLOR THEMES

A pitfall when painting flowers outdoors is the presence of too much color. The rich medley that some gardeners love can appear disorganized in a picture. Look for a dominant color or a striking contrast, then play down the other colors so that they do not compete.

A good contrast is that between complementary colors. A bed of orange marigolds, for example, would be enhanced by introducing touches of blue, perhaps by exaggerating a background feature, such as blue-tinged foliage. Yellow flowers can be set against patches of mauve, or vice versa. The red-green complementary pair is a ready-made choice, since red flowers have green leaves.

ORGANIZING THE SUBJECT *(right)*
Subjects like this are not easy to handle. The area of empty grass contrasts with the busy display as well as placing it in space, and the flowers were organized so that the pale flowers on the right and the red ones in the middle create lines leading the eye toward the dominant blue blooms. (Three Phlox in Red – Rosalie Nadeau)

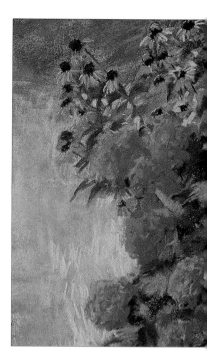

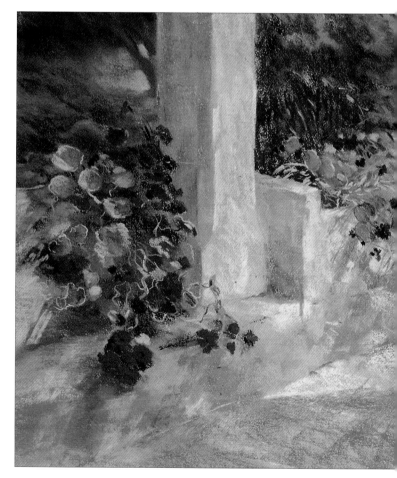

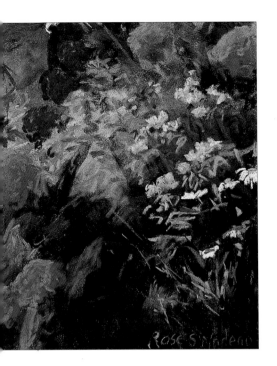

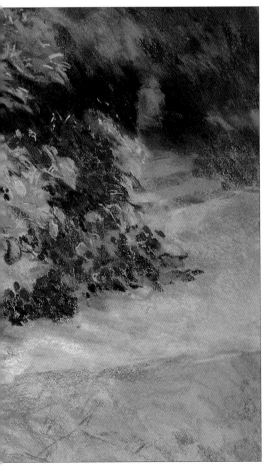

COMPLEMENTARY COLORS *(left)*
Nature is rich in "opposite," or complementary, colors, especially red and green, and the artist exploited these in her painting. To balance the plant colors and create foreground interest, she used a touch of yellow-blue as a contrast for the stone of the patio. (Sunlit Patio — Jackie Simmonds)

SUGGESTED NEW COLORS

You will need to add to your starter palette if you intend to specialize in flower painting, because many of the vivid oranges, brilliant pinks, and purples are impossible to achieve by mixing other colors. If you are painting blue flowers, see page 137 for a further selection of blues.

REDS AND PINKS

Vermilion hue
No. 6

Vermilion hue
No. 2

Rose madder
No. 6

Rose madder
No. 2

PURPLES AND VIOLETS

Pansy-violet
No. 8

Pansy-violet
No. 3

Purple
No. 4

Purple
No. 8

Mauve
No. 3

YELLOWS AND ORANGES

Lemon-yellow
No. 2

Cadmium yellow
No. 6

Yellow-green
No. 3

Cadmium orange
No. 6

Cadmium orange
No. 4

Violet and White Flowers

PICTURE MAKING

In flower painting, a definite color theme provides a harmony in keeping with the subject. Depending on the color chosen, it can also create dramatic impact — in a group of brilliant red and purple flowers, for example. In this painting, however, the effect is restful. The dominant color is violet, and the artist has emphasized it in two ways: first by using white flowers as a contrast, and second by taking blue-violets into the shadows to convey overall harmony. She chose the flowers and containers and carefully set up the group, looking at various arrangements through a viewfinder and making sketches before beginning the painting.

Emphasizing a dominant color •
Organizing the subject •
Building up colors •

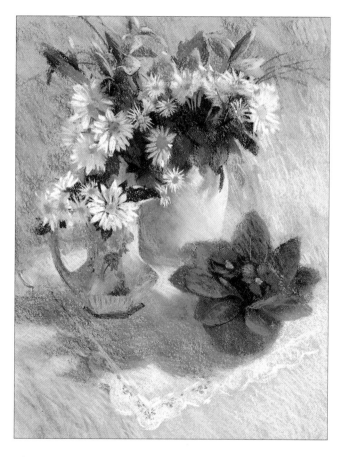

The background is colorless, so artist has brought in blues to harmonize with the violets. She has also omitted the hard line of the table back.

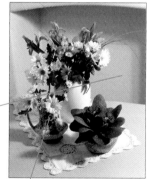

Patches of light are subdued in painting to stress shape. Subtle colors are built up by overlaying strokes.

If you compare the painting with the photograph, you will see that some of the detail was suppressed, and the pattern on the small vase only faintly suggested. To keep a light effect, the artist also reduced the contrasts of tone, although there are enough dark areas to make the white flowers stand out. Most striking of all is her use of pastel, with subtle strokes laid over one another to give an impression of shimmering light. (Daisies and Irises — Jackie Simmonds)

1 Working on the smooth side of blue-gray Mi-Teintes paper, the artist started with a light charcoal drawing in which she indicated the main areas of tone and suggested the flower shapes. She fixes this before using pastel.

2 Her method is to look for dark areas first, which she blocks in with side strokes. She blends colors in the early stages so that she can draw over them later, and here blue is applied over a lightly blended area of gray.

3 With the distribution of dark tones providing a structure, work begins on the lightest ones. For this area of tablecloth in front of the blue shadow, she uses line strokes, widely spaced so that the gray paper shows through.

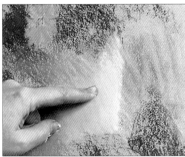

4 The rounded form of the tall white vase is built up by applying several colors over one another and blending with a finger. This will be left as a blend, and not drawn over, to imitate the smooth surface.

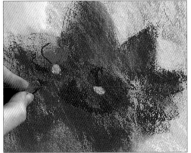

5 The small bowl of violets is not the focal point of the composition, and the artist does not want it to stand out too strongly, so she avoids too much detail.

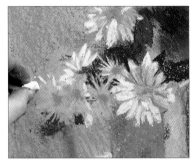

6 Earlier on the daisies were blocked in as simplified shapes so that the artist could establish the relationship of flower heads to stems and leaves. Now she defines each petal, using firm strokes of white over blue-gray.

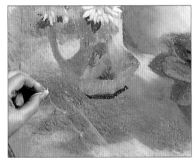

7 The center of interest is the small vase of flowers, and to help emphasize it the artist used a pink not seen elsewhere in the painting. To play down the foreground, she treats the tablecloth lightly, adding just a suggestion of edge.

8 She continues to add detail and definition, working from one area of the picture to another, and now draws in the leaves. These fine lines, crossing the diagonal strokes used for the background, contribute to the rhythmic flow of the composition.

9 During the course of the day, some of the flowers began to open, and the leaves of the violet changed position, necessitating redrawing. This could be done because the pastel had been applied fairly lightly – too heavy a buildup would have made it impossible.

Floral still life

Flowers are often combined with other objects in an arranged and orchestrated group. Such arrangements allow you to bring in color contrasts and experiment with different shapes, creating a more elaborate composition than you can with flowers alone. But be careful not to overdo the contrasts, and choose objects that have some relationship to the flowers so that the picture does not look disjointed.

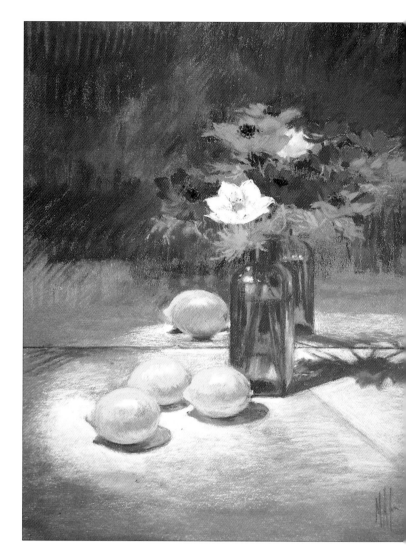

COLOR CONTRASTS

Flowers and fruit have a natural relationship, so they are often used together. Here lemons were chosen because they provide contrast for the deep, rich blues and purples. Note how the artist draws attention to them through lighting; they sit in a pool of light, enclosed by a curving shadow. (Lemons in the Spotlight – Maureen Jordan)

Strong tonal contrast provided by the white flower against a dark background draws the eye to focal point.

A lemon overlapping the vase creates a spatial relationship and emphasizes a contrast of shapes.

The dark tone of the background makes flowers stand out, but colors pick up colors in the flowers and vase.

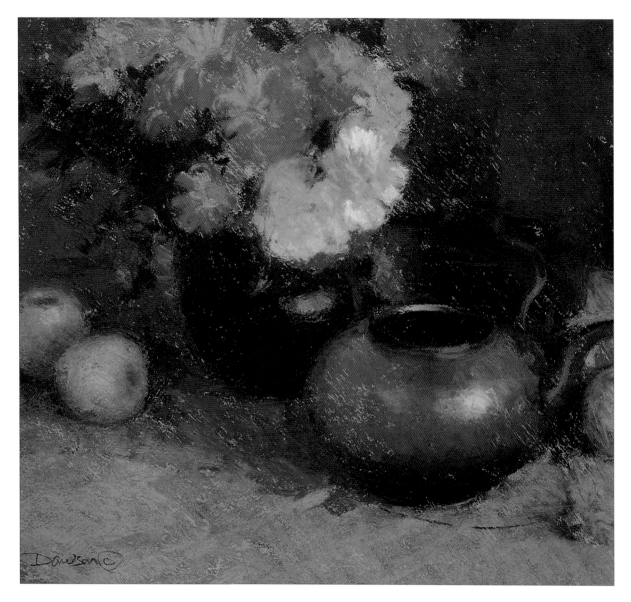

RELATED COLOR

*This painting has an obvious pink-red color theme. The flower colors are echoed in the copper kettle, and touches of warm red-brown appear on the apples. This same red-brown was used to tint the paper, and the artist left patches of background color showing through, particularly in the foreground. (*The Table by the Window *– Doug Dawson)*

Surface of the kettle reflects the flower colors; warm red-browns harmonize with the rich pinks of the flowers.

Patches of warm background color showing through gray-green link the foreground to the flowers and kettle.

Area of blue makes the handle and rim of the kettle stand out; it also echoes the dark leaves at left.

BACKGROUND FLOWERS

Often flowers are the center of interest in a floral still life, but here they form a decorative background for the blue pots. There is an overall floral theme, as the blue flowers are echoed by the printed ones on the foreground cloth. The glass pots are framed and enclosed by flowers. (Still Life with Frosted Blue Glass – Jackie Simmonds)

This pot is worked more lightly than the central ones so it does not distract the eye.

Brown paper acts as the background color for the pink flowers; it is left showing between strokes of white and pale blue.

Pink flowers provide an essential color contrast for the predominant blues.

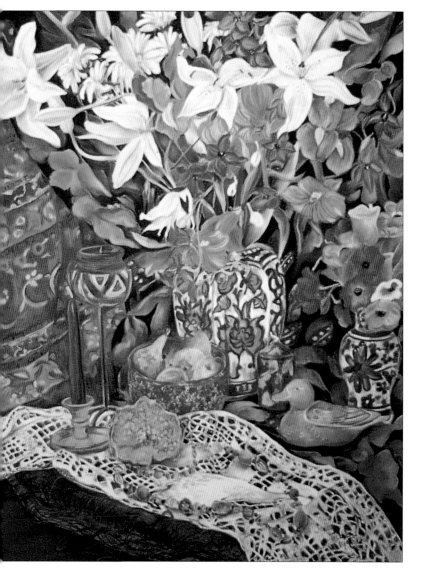

PATTERN

There is an innate pattern in floral subjects, which is stressed here by treating the flowers almost as flat shapes and bringing in a selection of other strongly patterned objects. This painting is interesting in that it has no obvious focal point; instead the artist wove the shapes and colors into a tapestrylike effect across the picture surface. (Flowers and Duck – Jenny Webb)

Crisply rendered pattern and strong tonal contrasts balance the white flowers.

A minimum of tonal modeling was used, so that flowers read as light-on-dark shapes.

The lace runner is carefully arranged to create the dark shape in the foreground; tonal contrasts are important throughout the picture.

129

Landscape

PICTURE MAKING

Landscape is a popular painting subject, and it is easy to see why. We all enjoy walking or driving through the countryside, admiring the effects of changing light, the shapes of mountains, and the colors of spring or fall foliage. It is natural to want to record some of these sensations.

But sadly, another reason for the popularity of landscape among beginning artists is that it is seen as an easy option, which it is not. Although it may not demand as high a standard of drawing as, say, portraiture, successful landscape painting does require careful organization.

VIEWPOINT AND COMPOSITION

In a still life or indoor flower painting, much of the composition is arranged before you begin to paint. Obviously you can't rearrange landscape features in the same way, so you must compose from what you have in front of you.

The first decision is what viewpoint you will take. Use the viewfinder shown on page 95 to frame your subject in different ways. Try the effect of holding it at varying distances from your eyes. Holding it out at arm's length, for example, will push the scene farther away. You will quickly see that you have a good many choices without even changing your own position.

You may want to move around as well, in order to consider whether to take a high or a low viewpoint. This is important, because it affects how much you can see of the landscape. If you are sitting on the ground in a field of long grass, you will have a fine view of individual stalks; but if you stand, you will see over the field toward the distance. So you may find that it is better to work standing than seated.

A low viewpoint, however, can be ideal for some subjects, such as mountain scenes where there is a relatively flat foreground and the main

Continued on page 132 ▷

STRESSING PATTERNS

The viewpoint is high, looking down into the swirling water. At a lower viewpoint you would not see the curve of the river or the patterns created by the foaming eddies, which are the main subject of this painting. Pattern is always more obvious when viewed from a distance or from above, because the forms become flattened. If you stand on a hill overlooking fields, you will see a patchwork of shapes and colors rather than the undulations of the land. (Torrential Stream – C. Murtha Henkel)

LANDSCAPE

CREATING DRAMA

Here the viewpoint is low. The artist looks up at the trees, which seem to explode into the sky like fireworks. The drama was increased by setting the dark triangle of trees and hill against a pale but glowing sky that occupies a large part of the picture space. Notice how the sky color is repeated on the tree trunks and branches, illuminated by the sun at top left. (Cypress – Kitty Wallis)

CHOOSING A VIEWPOINT

Choosing the spot from which to paint is the first step in composing a landscape, particularly one that contains a dominant feature, such as a tree. If you walk around your subject, you will probably find several good angles, so you can paint more than one picture of the same scene. Any of the photographs shown here could form the basis of a composition.

View from path below the trees provides strong curving shapes in the foreground and outlines the trees against the sky. More wind cloud would create a sense of movement.

Close-up view from the path focuses attention on the sunlit trunks and crisp shadows. Dull foreground would benefit from lively pastel marks.

This view highlights the twisting branches of the left-hand group of trees. The tall tree at front provides a strong vertical, and there is a good contrast of lights and darks.

View from above the trees shows overall shape of group as well as individual trees. Glimpse of village and hills gives a feeling of space.

interest is the distant mountains. These will look taller and more dramatic the lower down you are.

Once you have chosen your viewpoint, the next step is deciding how to place the subject on the paper, so review the guidelines on composition given on pages 86 to 89. Don't put a dominant feature in the center of the picture, and never place the horizon in the middle. This divides the picture into two distinct areas of sky and land, destroying the unity of the composition.

Skies play a vital role in landscape painting, so use them in a positive way, not just as a backdrop. You may decide to make the sky your leading player, giving it two-thirds of the picture space. This is especially effective for flat landscapes, because it increases the sense of space.

FOREGROUNDS

Landscape paintings are often spoiled by a weak or too dominant foreground. It can be difficult to decide what to do with this area of the painting. When a small shrub or some other feature is close to you, there is often a temptation to treat it in greater detail than the rest of the picture, but that could be a mistake. An overly detailed foreground can act as a block, drawing the viewer's eye to that area alone. You can often see this effect in photographs, where the foreground details are in sharper focus than the middle and far distance.

Continued on page 134 ▷

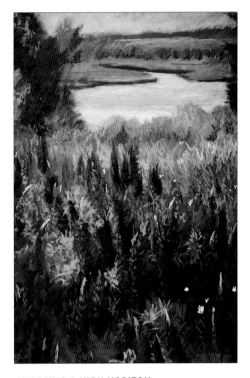

CHOOSING A HIGH HORIZON

An unusually high horizon has been chosen for this painting because the sky is of less importance than the flowers and the lake. Some sky had to be included, however, in order to explain the color of the water, which always reflects the sky. (Love Peonies – Rosalie Nadeau)

PLACING THE HORIZON

In a flat landscape, or a seascape, a distinct horizon line separates earth from sky. You must decide where to put this, and how much space to allocate to each area. The sketches here show two treatments of the same subject. Do not put the horizon in the middle, because that creates a disjointed effect.

By cutting down the sky area, the artist was able to emphasize the curves of the fields and the foreground grasses.

Careless photography often results in a centrally placed horizon, as in this case. Do not make this mistake in the painting.

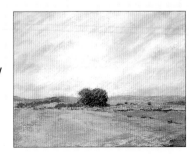

The expanse of sky gives a sense of space, but enough land was included to "anchor" the sky and create a relationship between the two areas.

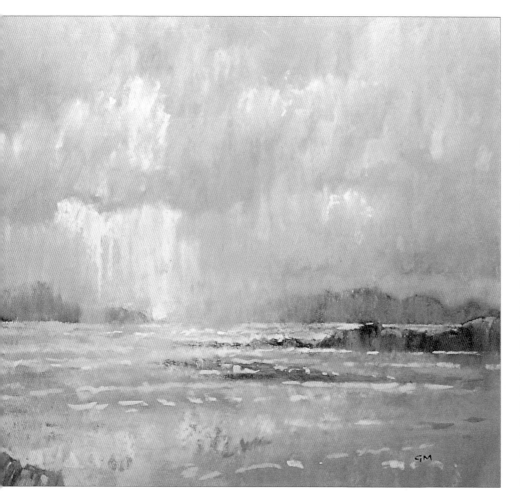

MAKING THE MOST OF SKIES *(left)*
The flat plane of the sea is often less interesting than the sky, so it makes sense to place the horizon low, letting the sky dominate. Here it occupies two-thirds of the picture space. The artist built up the glowing colors with layer upon layer of pastel in downward strokes, which suggest the weather conditions – showers alternating with sunshine. (Towards Ardnamurchan – Geoff Marsters)

FOREGROUND SHADOWS *(right)*
Shadows can play a vital role in composition; they often provide that essential touch of foreground interest, as they do here. Foreground shadow must not become too dominant. The artist worked lightly, leaving patches of bare paper between strokes of dark green to achieve a lively color mix. (Summer Morning – Alan Oliver)

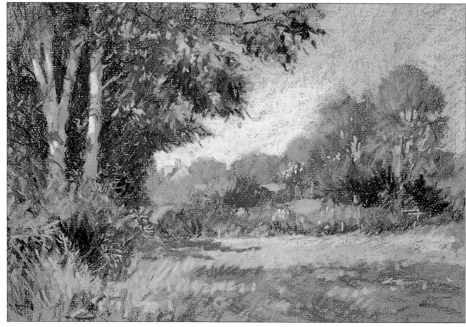

133

Foregrounds are an important part of the picture space, because they are an introduction to the scene, but try to see them in terms of the overall picture, not as a series of features that must be faithfully reproduced. A painting needs to have some foreground interest, but if the center of interest is in the middle of the picture – perhaps a group of trees that you want to emphasize – avoid putting too much into the foreground. You might introduce a touch of tonal contrast by means of a shadow cast by another tree or bush outside the picture area, or you can simply suggest detail by the way you use your pastel marks. A few decisive strokes or squiggles can give the impression of grasses, small stones, flowers, or the undulations of uneven ground.

Sometimes a foreground feature will be the most exciting aspect of the scene, so that it calls for more precise treatment. In this case you will need to set up links between foreground and middle distance to lead the eye from one part of the picture to another. A bright yellow flower could be echoed with touches of the same color farther back. Or you can make visual links through the use of your pastel marks, repeating the strong lines of a foreground feature in the middle distance or in the sky.

CREATING SPACE

You have already seen how warm and cool colors can help give your paintings a feeling of depth, but there are other means as well. The most powerful is linear perspective. You may think that as long as you avoid painting buildings you won't have to deal with this, but the rules of perspective apply to everything.

We will be looking at how perspective affects straight lines later on, but as far as landscape painting goes, the essential rule is that things appear smaller the farther away they are – the law of diminishing size. This may sound obvious, but it is surprising how we can sometimes ignore the evidence of our own eyes. Because you know that a range of mountains is high, you can fail to appreciate how little of the picture space it will occupy. By making the mountains too tall you will effectively pull the background forward, destroying the illusion of space. The best way to check the effects of perspective is to measure one thing against another. Do this by holding up a

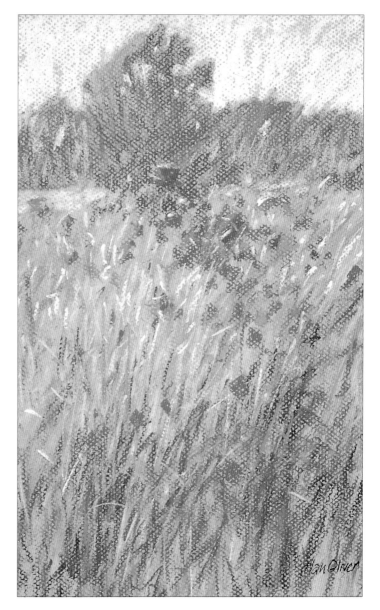

DOMINANT FOREGROUND

The foreground is the main subject of this picture. The artist chose a low viewpoint, from which the stems and flowers seem to push skyward. Their upward sweep is emphasized by the inclusion of the tall trees and by the direction of the pastel marks. The marks veer to the right in the foreground and to the left in part of the background, enlivening the composition.
(Poppies – Alan Oliver)

Continued on page 136 ▷

LEADING THE EYE

The foreground should lead the viewer into the scene, and this can be done partly by pastel marks. The diagonal marks on the left and the curve on the right of this painting lead us to the dark line of shadow and upward via the vertical straight edge of the tree. Our eye then follows the lines of trees and is led downward again with the vertical strokes of grasses, so that we travel around the picture. (Winter, Andalusia — James Crittenden)

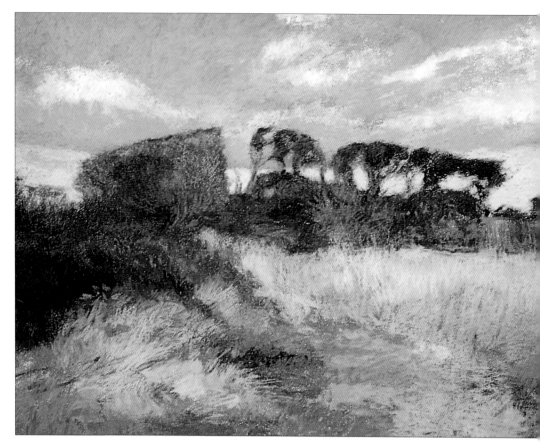

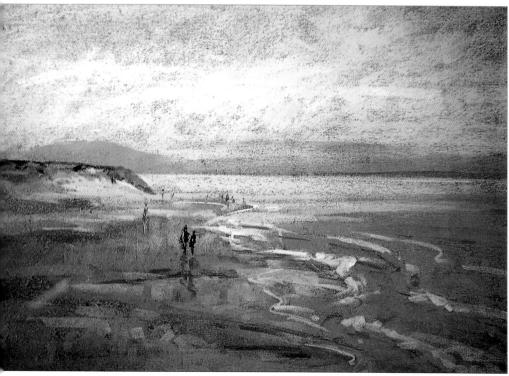

DIMINISHING SIZE

The artist made subtle use of perspective by bringing the curves of the waves closer together as they recede. But it is the tiny figures at the far end of the beach that really suggest its depth and give a sense of distance; they are hardly more than dots and dashes in comparison with those in the middle ground. (September Evening — Aubrey Phillips)

pencil in front of you and sliding your thumb up and down it. You may be amazed to see how tiny a far-off tree is in relation to a field in front of it.

Skies are affected by perspective, too. Clouds seem smaller and closer together above a distant horizon than when they are directly overhead. It helps to think of the sky as a flat bowl inverted over the earth.

Whether it is cloudy or clear, the sky will always appear paler on the horizon. This effect is caused by another sort of perspective: aerial, or atmospheric, perspective. Tiny particles of dust and moisture in the atmosphere create a kind of veil in nature, causing colors to become progressively cooler and lighter in tone as they recede from you. Contrasts also diminish, until you can barely distinguish them. If you observe the effect of both types of perspective correctly, your work will have the space and depth that are vital to good landscape painting.

WALKING INTO THE SCENE

The artist created space by using cooler, paler colors for the distant hills, and by the sharp perspective of the path running from foreground to middle distance. But equally important is the way in which the path appeals to the imagination – it invites us to explore the landscape for ourselves. (The Ridgeway, South Malvern Hills – David Prentice)

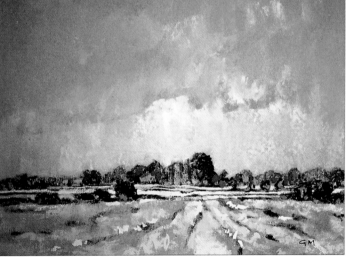

SPACE THROUGH PERSPECTIVE

Perspective makes receding parallel lines appear to draw closer together until they finally meet. In landscapes such lines are unlikely to be perfectly straight, but they still converge in the distance, and observing this effect correctly will help you create the illusion of space. In this picture, the lines emphasize the depth of the field and also depict the irregularities of the ground. (Fen Landscape – Geoff Marsters)

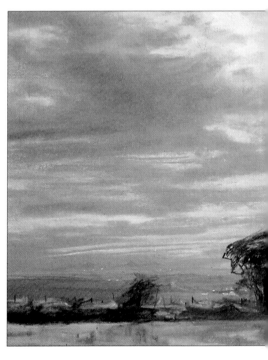

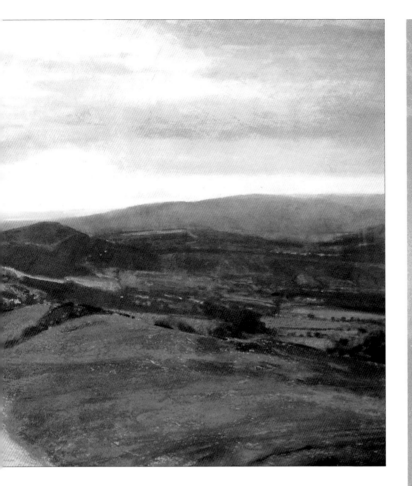

The predominant color in most landscapes is green, so although you already have five greens in the starter palette, plus one gray-green, you will certainly need more. A larger selection of blues will give you more flexibility over skies, and some additional browns and grays will be useful for trees, winter fields, cloud colors, and distant features, such as hills.

GREENS

Viridian
No. 6

Grass-green
No. 1

Lizard-green
No. 7

Terre verte
No. 5

BLUES

Cobalt blue
No. 4

Cobalt blue
No. 2

Cerulean blue
No. 0

Indigo
No. 6

Indigo
No. 3

BROWNS AND GRAYS

Burnt umber
No. 4

Burnt umber
No. 1

Burnt sienna
No. 0

Green-gray
No. 1

Blue-gray
No. 2

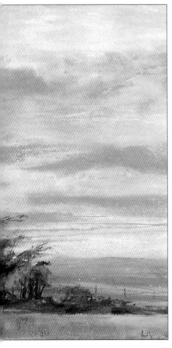

CLOUD PERSPECTIVE

There is a grand impression of space in this landscape, partly due to the use of aerial perspective – the background tones are light compared with the central tree – and partly to the careful observation of the clouds. The largest cloud is at the top of the sky, with the horizontal bands of cloud becoming closer near the horizon.
(Hawthorn, Cornwall – Lionel Aggett)

Skies and Seascapes

PICTURE MAKING

Many artists have gazed at the fascinating formations and colors of clouds and wished they could capture them in paint or pastel. The trouble is that clouds are always on the move. They change their shape, disperse and re-form, and colors alter through the day according to the position of the sun, which means that you have to work fast if you are painting on the spot. One answer is to follow the example of this artist, and develop the painting from a combination of sketches and photographs. Try not to rely on photographs alone, because they cannot do justice to the subtleties of color; instead, make color notes as described on page 98.

Building up colors •

Emphasizing space •

Setting up color echoes •

The sky, although a brilliant blue, is dark in tone. The artist indicated this with heavy charcoal shading.

The small figure increases the sense of space; landscape painters often place a figure or group in the middle distance.

In the charcoal sketch, the artist made no attempt to record detail, but established the composition and made notes about tones and colors. Once the main colors are in place, she can elaborate them, bringing in such lively touches as the blues in the foreground. These are important, because they echo the sky color, creating color links that unify the composition. (Breezy Day, Minsmere Beach – Margaret Glass)

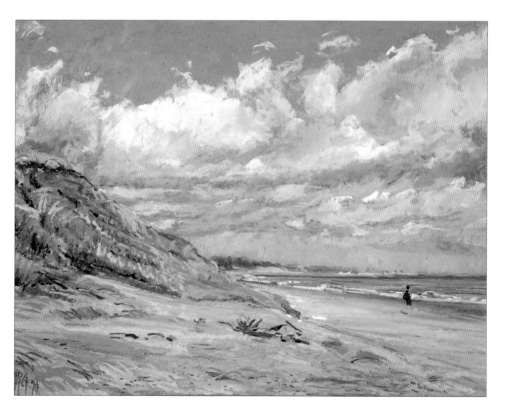

1 *Working on a warm brown-ochre sandpaper, the artist began with sketchy pastel lines and now works on the sky. This deep blue is the dominant color, and once it is in place she will be able to assess the colors for the land.*

2 *The artist indicated the full range of colors and tones in the sky before working on the foreground. She needs strong tones to balance those of the clouds, and uses brown, orange, and now gray, making firm marks.*

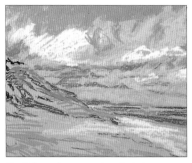

3 *Color echoes are already being set up: the blue of the sky appears also in the foreground, and some of the browns and ochres of the land are repeated in the clouds.*

4 *You cannot be tentative when working on this kind of paper. The artist makes bold dabs, squiggles, and inventive marks in a variety of colors. This area of the picture needs to stand out strongly in order to balance the sky.*

5 *The clouds are softened by applying one color over another. This method mixes the colors to produce a blended effect but does not remove pigment.*

6 *By moving continually from one area of the picture to another, the artist can make comparisons. She softens the colors on the dunes, again by overlaying, but is careful to preserve the individual pastel marks.*

7 *Sandpaper grips the pigment firmly, but surface dust is removed with a dry, stiff-haired paintbrush. Brushing is needed because too much color was built up to work over, and the artist wants to lay a solid area of white on the cloud top.*

8 *The colors of the sky on a distant horizon are subtle and can be tricky to handle. The artist uses a mixture of colors: a cool blue-green with a warm mauve-blue on top. The first color comes through slightly, creating a three-dimensional effect.*

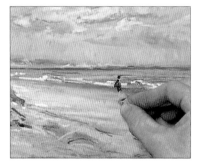

9 *The final touch – the figure – is drawn delicately with the pastel tip. This had to be left until last, since it would have been impossible to work around it. Tiny flecks of white, suggesting a collar, link the figure with the white edges of the waves.*

Hilly Landscapes

PICTURE MAKING

Many artists work entirely from life, but others prefer to paint away from the scene, because this offers them greater freedom to alter components and colors. This exciting painting was based on a pencil sketch made on the spot, and although the artist also referred to photographs taken at the same time, the colors result from his personal approach. He made no attempt to reproduce an image directly from a photograph.

Using expressive pastel marks •

Working from a sketch •

Judging tones and colors •

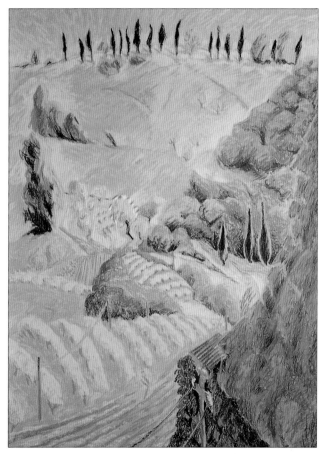

Shape and size of silhouetted trees were recorded with precision.

Direction and intensity of light is indicated by dark pencil marks on the left and below.

Texture and shapes of trees are loosely scribbled.

The sketch (left) was made with a painting in mind, so the basic composition was planned in front of the subject. The artist also adopted a similar technique of semiscribbled lines for both sketch and finished picture (above). There is no blending apart from the overlaying of colors. The painting is on the smoother side of a warm ochre Mi-Teintes paper. (Tuscan Scene – David Cuthbert)

1 *The artist makes an underdrawing in hard pastels, first in mauve and then in a contrasting light blue. This establishes fluidity of color from the outset and allows him to introduce changes as the work develops.*

2 *He begins to build up colors, starting with the sky and moving down to the hills. Here, crosshatching with curving strokes is used to describe the undulations of the land.*

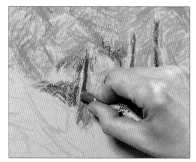

3 *To set up the tonal structure of the painting, the darkest areas, such as these cypress trees, must be placed at an early stage. Firm strokes of deep green are laid over the earlier blues.*

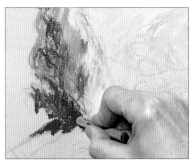

4 *This tree is the dominant shape on the left of the picture, balancing the right-hand group. Strong tonal contrasts and a rich variety of colors are used, with swirling strokes that build up the forms.*

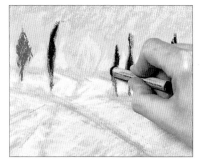

5 *Moving from one area of the picture to another, the artist assesses the tones and colors of the distant trees against those in the middle ground. He finds that they need to be darkened and given more positive shapes.*

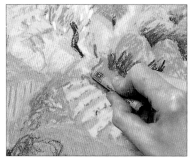

6 *To define the edge of the vividly striped field, the pastel is applied firmly and thickly. This detail reveals the effect of the varied colors and busy marks, with the paper showing through the greens to create sparkle.*

7 *The application of dark green is the first step in developing the immediate foreground. Leaving the foreground until last can make it easier to judge the strength of tone and color needed, as well as the degree of detail.*

8 *The artist decides to lighten the foreground foliage to lessen the division between this area and the middle ground. There is a considerable buildup of pastel, so the new color merges with the earlier ones.*

9 *The effect was too soft to pull the foreground into focus, so the picture was sprayed with fixative, and more fine scribbled lines are then added with the edge of a black pastel stick.*

Painting light

A landscape is more than just trees, fields, and hills — you must also take account of the prevailing light, because it dictates the colors and tones. The difference between a sunny and an overcast day is obvious, but the light also changes according to the time of day and the season. If you are painting on location, don't work longer than about two hours, or the entire color scheme will alter.

Trees very light in tone, though darker than distant mountains; colors subtly modulated.

Variety of colors in this area are mainly worked over white so as to lighten them.

Strongest tone and color always in foreground, but contrasts still slight.

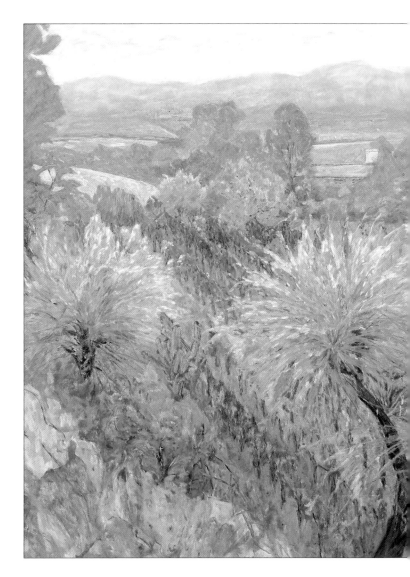

EARLY MORNING LIGHT

At this time of day the light is at its gentlest. Tonal contrasts are slight and colors less vivid. By working in a high tonal "key" – that is, in predominantly pale colors – the artist conveys the cool luminosity of the early morning. (Two Willows – Patrick Cullen)

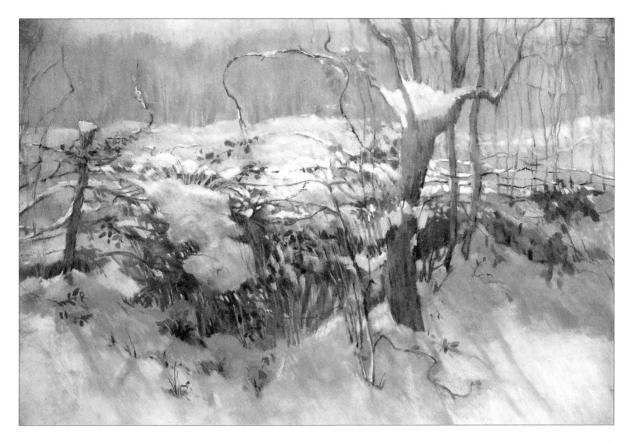

WINTER LIGHT

Although you sometimes see strong blue skies in winter, the light is usually more diffuse than in summer, and the shadows softer, with a blue bias caused by reflection from the sky. Here the delicate blue-grays and mauves are enhanced by contrast with the warm red-browns of the hedgerow and dead leaves. (Winter Hedgerow — Jackie Simmonds)

Contrasts of tone slight in distance; colors lightly applied and blended to soften lines.

A little yellow makes area stand out from more distant snow to create depth.

Pale yellow over blue-gray warms the snow color; snow seldom appears pure white.

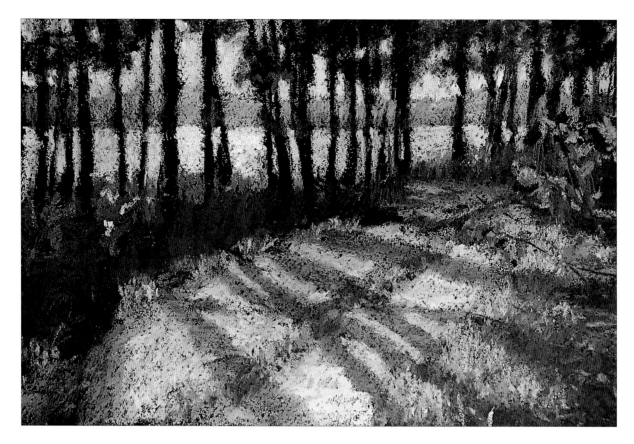

EVENING SUNLIGHT

*The sun creates shadows, which present
compositional possibilities. Evening light is often
best, making shadows longer and colors richer.
This wonderful impression of sunset colors uses
mauve and yellow complementary contrasts to
enhance the effect of the diagonal shadows
leading to the dark verticals of the trees. To set
the tonal key for the painting, the artist made the
unusual choice of black paper, working up from
the darkest to the lightest colors. (Cove at Dusk
— Rosalie Nadeau)*

Setting sun illuminates
the water and
silhouettes the trees.

Bright highlights
and patches of vivid
color where sun
strikes foliage.

Flecks of black paper
show, toning colors
down slightly.

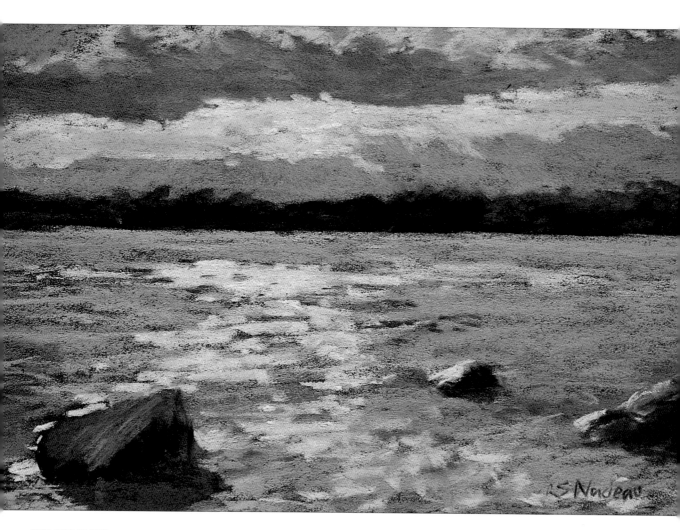

SUN AND CLOUD

Unpredictable days when sun alternates with cloud produce the most exciting lights. One part of the scene will be brightly lit, and another dramatically dark, or small clouds will cast intriguingly shaped shadows on an otherwise luminous scene. The effect of sun emerging from clouds to sparkle on the water is captured in this painting. (Cove Cloud Break — Rosalie Nadeau)

Distant hills in shadow create dark shape that balances cloud above.

Triangular shape leads eye toward sparkling water and provides contrast of tone.

Rosy hue at bottom of sky repeated in foreground water with light overlay of color.

Portraits and Figures

When the camera was invented, there was alarm and despondency among artists and art lovers. How would portrait painters earn a living when the camera could produce perfect likenesses in a fraction of the time? "Art is dead," people said. But it was not. Painted portraits have continued to coexist with photographs, and artists still find the human face and figure among the most exciting and challenging of subjects.

And challenging they are, because in this branch of painting you cannot get away with poor drawing and inaccurate observation. Errors such as wrongly proportioned bodies are immediately noticeable, because the subject is so familiar.

HUMAN PROPORTIONS

Accuracy in drawing and painting is mainly a matter of practice – of training yourself to see your subject in an analytical way. But it does help to have a few guidelines to fall back on, so that if your picture looks wrong you can figure out why. Human faces and bodies vary widely – that is what makes them so interesting – but there are some basic rules about human proportions.

The body is about seven and a half heads high – the head is used by artists as the unit of measurement. If a person is standing with arms hanging free, the fingertips reach to about mid-thigh, and the body's halfway point is at the crotch.

Another error is to make hands and feet too small; nearly all beginners do this. Feet have to support the entire weight of the body, so they need to be relatively large – the length of the foot is about the same as the height of the head. Hands are working tools that need strength. An outstretched hand will cover the face.

There are standard proportions for faces also. The bottom of the eye sockets is the midpoint of the head, and the eyes are about one eye's distance from each other.

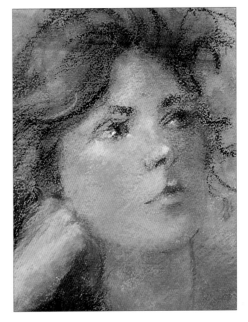

PORTRAITS

You may feel that all this is irrelevant to the central business of portraiture, that of achieving a likeness. But it is much easier to assess individual features if you know the norm.

There is unfortunately no recipe for attaining a likeness. Some people have the knack, but most of us have to rely on careful observation and a good deal of trial and error. Ask yourself first what shape of face the sitter has: is it long and narrow, rounded, or angular with prominent bones? Try to identify the skin coloring. Skin is, of course, affected by lighting conditions, but you can nearly always recognize a basic color, which may be pinkish, ivory, coffee, or deep purplish brown – to name just some of the possibilities. Once you have established this basic color you can begin to look for the colors of the shadows and highlights that define the shapes.

Shape of face and skin tone give you a good start, after which you can concentrate on features,

FORM AND COLOR
The key to the overall skin color here is seen in the lighter area, particularly on the forehead. But the artist used a wide range of colors, mixing them in repeated layers of soft hatching. The choice of blues and greens for the shadow areas enabled her to build up forms without heavy shading. (The Eyes Have It – Dorothy Barta)

Continued on page 148 ▷

Few people conform completely to the standard, but the rule about the proportion of head to body is nevertheless a useful guide, as it helps you avoid obvious errors, such as "pinhead" figures. If you are drawing a standing figure like this one, mark in the head first, measure it, and then make marks down to the feet.

The forehead and crown make up more of the total head area than you might imagine. Beginners often place eyes too high: remember that the bottom of the eyes is the midpoint, and mark this in before you treat the features in detail.

In a profile view, the curve of the head is less pronounced, so the guidelines from ear to eyes and bottom of nose can be almost straight. Do not underestimate the space taken up by the back of the head.

The perspective effect in a three-quarter view makes the features appear to bunch together, curving around the egg shape of the head. To get the placing of the eyes right, draw guidelines curving around the head from the top and bottom of the ear.

asking yourself similar questions – eyes small? eyes slanting? mouth wide? nose long and narrow? and the like – as you build up the image.

SETTING THE POSE

Some portraits focus on the head, with the body cropped off just below the base of the neck. These are known as head-and-shoulders. A half-length portrait includes the top part of the body and the hands, while a full-length is the entire figure, seated or standing.

Whichever category you choose, don't rush into the painting without giving serious consideration to the way you pose the sitter. Aim for a natural, relaxed look, even in a head-and-shoulders portrait, where you won't see much of the body. If you decide on a half- or full-length, find a chair or couch in which the sitter both looks and feels at ease. Bear in mind that posing for a portrait is tiring, so ask your subject's advice on the most comfortable position. You will often find that this contributes to the likeness, since people have characteristic postures that they fall into naturally.

You might even chose an outdoor setting, which creates a more natural and spontaneous impression. This would be suitable for a painting
Continued on page 150 ▷

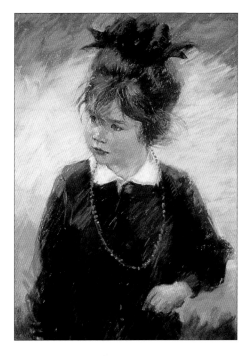

PAINTING CHILDREN

By choosing a half-length portrait, the artist was able to stress the contrast between the dark dress and the delicate colors of the skin. The outdoor setting is a good choice, because it makes the pose look natural. (Kate – Kay Polk)

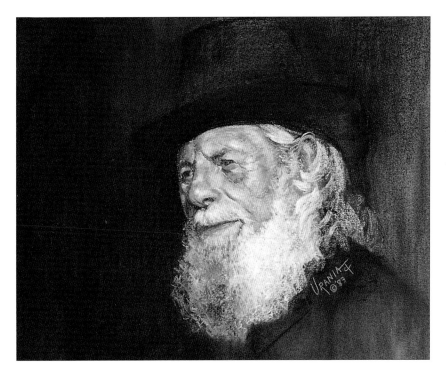

PLACING THE HEAD

In a head-and-shoulders portrait it is important to consider how to place the head and from what angle to paint. This artist has chosen a conventional three-quarter view, but in a horizontal format, with the background occupying a large part of the picture. This was because she wanted to draw attention to the head through a dramatic contrast of tone, which she has further emphasized by allowing the hat and clothes almost to merge into the background. (The Circuit Judge – Urania Christy Tarbet)

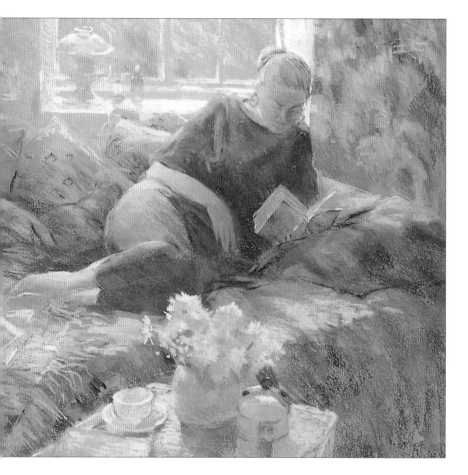

THE FIGURE IN A SETTING

If you focus on the face, you can generalize the background, even leaving it as bare paper; but when you portray a whole figure, the setting can be an important part of the picture. Here the artist has sensitively orchestrated the colors and all the elements of the composition. Placing her model in a relaxed pose in front of a window has allowed her to explore the effects of light and color rather than making a deliberate figure study. (3 P.M. – Jackie Simmonds)

FORESHORTENING

The perspective effect known as foreshortening distorts proportions, so here you must discard rules about the length of legs, size of feet, and so on, and learn to trust your eyes. The parts of the body nearest to you appear larger, so in a reclining figure either the head or the feet will be disproportionately large, depending on which end you are viewing from.

Legs seen from the front appear shorter and wider, and now occupy less space than the top part of the body. Pointing feet are also foreshortened.

The whole body is foreshortened, with the legs and feet much larger than the top part of the body, and the hands large in relation to the head.

Here the normal rules of proportion apply, with the legs about the same length as the top part of the body.

of a child, or you might show an avid gardener resting in a deck chair surrounded by his or her horticultural creations.

Clothes, too, can help convey a feeling of the person, so it is not usually good to dress your sitters in their Sunday best, but rather have them wear their everyday attire. You can take this idea further and include in the painting some objects that hint at the sitter's interests. This is a device often used by portrait painters – an artist is shown holding paintbrushes, or a writer with a pile of books on a table nearby.

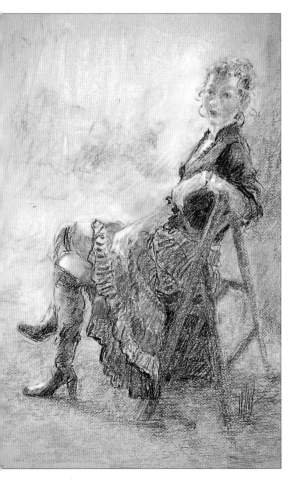

FOCUS ON CLOTHES
Clothes can encapsulate a character or mood so successfully that they become the main subject of a picture. This zestful study emphasizes the flounced skirt and long boots. (Charlotte – Maureen Jordan)

PEOPLE IN CONTEXT
Even if you only want to treat the human figure as an additional element in a landscape or urban scene, you should try to make each one look individual. You need not be concerned with features in such cases, but observe the general shapes and postures of people, and the attributes that mark their differences. Watch how they move as they go about their routine activities, and look out for any typical gesture that will suggest what a person is doing.

Quick sketches and photographs are helpful here. Outdoor scenes containing moving figures must usually be composed and painted indoors for obvious reasons, so it is essential to have a store of visual reference. If you do work from photographs, however, try not to get bogged down in detail. Convey a feeling of movement by the way you use your pastels. Often just a few well-placed lines or some dots and dashes of color are enough to suggest figures.

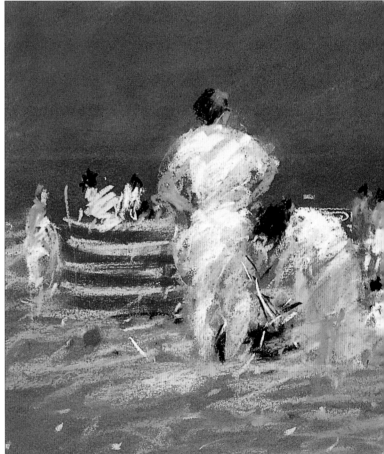

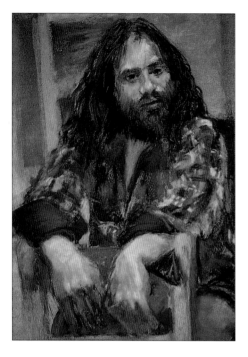

INCLUDING HANDS

Hands can sometimes convey as much about people as faces do, which is why they are often included in portraits, but they should not be allowed to dominate. This painting is cleverly organized so that our eyes focus first on the hands, but then travel upward to the face via the wrist and the red band on the arm. (Jaymie – Rosalie Nadeau)

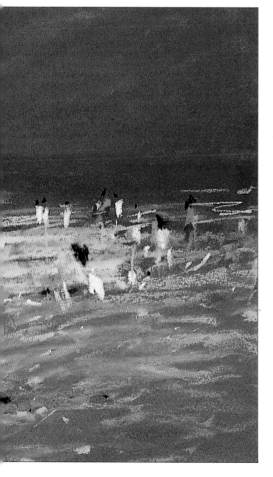

SHAPES AND POSTURES

None of these figures is treated in detail, and the more distant ones are just decisive flicks of pastel. They carry perfect conviction, however, because the artist has observed the shapes of their postures so well. The figure bending over the stroller, for example, is suggested with a few diagonal lines. Bold, lively pastel marks bring a strong sense of movement to the scene. (A Norfolk Beach – Alan Oliver)

SUGGESTED NEW COLORS

You would not find it easy to describe pale or medium-tone skin with only the colors in the starter palette; so for portraits or figure studies you will need a greater range of light neutral colors with a pink or yellow bias, together with cool blues and grays for shadows. For darker skins and for hair, extra browns are recommended.

PINKS AND PINK-BROWNS

Madder brown
No. 0

Cadmium red
No. 1

Rose madder
No. 0

Purple-brown
No. 1

YELLOWS AND YELLOW-BROWNS

Yellow ochre
No. 2

Yellow ochre
No. 0

Naples yellow
No. 0

Burnt sienna
No. 2

Burnt sienna
No. 0

BROWNS, GRAYS, AND LIGHT BLUES

Vandyke brown
No. 8

Sepia
No. 5

Burnt umber
No. 1

Cool gray
No. 4

Green-gray
No. 1

Cobalt blue
No. 0

Head-and-Shoulders Portrait

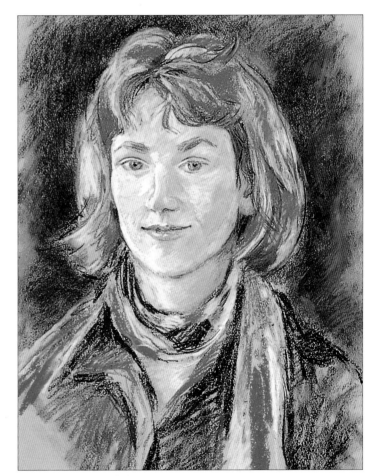

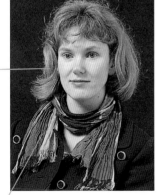

project 6

Setting up a pose •

Painting skin •

Creating a sense of life •

PICTURE MAKING

A portrait focusing on the face is probably the simplest, because you don't have to cope with the complex forms of the full figure, or with hands – a notorious stumbling block. But because such compositions have only one element for the viewer to focus on, mistakes such as wrongly placed features will be glaring, so take care with the initial drawing. To avoid the dull, staring passport-photograph look, paint your sitter from a slight angle, and when you set up the pose, try to make the person feel and look comfortable. Don't be afraid to rearrange clothes and hair. In the portrait here, the rhythmic curves of hair and scarf play an important part.

Hair gives movement to an essentially static subject.

Scarf provides tonal contrast and continues the rhythm of the hair.

The painting shows how to achieve an effect by making small alterations. The line of the scarf was changed to make a strong vertical on the right of the picture, leading up to the face; in addition, it hides the hard line of the shoulder on the other side. The model is gazing into space, but in the painting she looks directly at the viewer, and this suggests a relationship between her and us, so that she becomes a living person whom we might know. (Victoria – Ros Cuthbert)

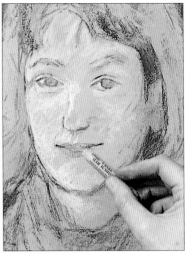

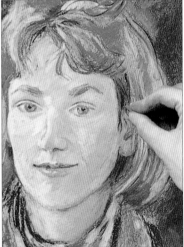

1 *Working on the smoother side of gray Mi-Teintes paper, the artist begins with a careful drawing in charcoal. She wants to avoid making corrections later, so she checks the proportions before applying color.*

2 *The skin colors are pale and subtle. To set a key for judging these, the artist first puts in the bright background and some of the darker tones, such as this shadowed area of hair.*

3 *The medium gray of the paper also provides a contrast to the choice of skin colors. These are mainly pinks and white, lightly applied so that they are modified by the paper color. More pink is added to the lips with the edge of the stick.*

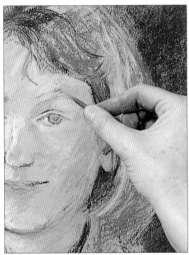

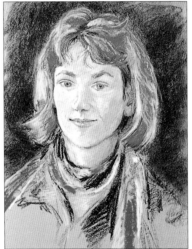

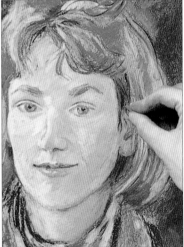

4 *The face begins to take form, aided by work on the shadows in a blue-gray slightly darker than the paper. Light brown pastel is used to make delicate line strokes for the eyebrows.*

5 *The painting has reached the stage where the artist can consider finishing touches and minor changes. Clothes are so far only suggested. She decides to bring in some bright turquoise to balance the vivid background, as can be seen in the finished picture, opposite.*

6 *Because the pastel was used delicately, any major corrections are now inadvisable; but colors can be subtly altered. The ear was too pink, so charcoal is used to tone down the color. Again, you can see the effect in the finished picture.*

Figures in Landscape

PICTURE MAKING

Our fellow human beings, singly or in groups, in action or repose, are probably the subject we encounter most often. But people are tricky to draw, and landscape can have a more immediate emotional appeal. However, if you set your figures in a town or a landscape, you will have the best of both worlds, and you will probably find that groups are easier to manage than a portrait or closeup figure study. Accuracy of drawing matters less than general atmosphere, good composition, and well-balanced colors. If you work from photographs, try to interpret rather than copy. Here the photograph provided a reference for the figures and also for some of the colors, but the artist made a pencil sketch from it and used that as his "working drawing" (see Step 1).

Interpreting a photograph •

Reserving the paper color •

Omitting unhelpful detail •

Fussy detail distracts eye from figure group, so is omitted in painting.

The central figure is a pivot, linking the others, so it is emphasized in the painting with stronger color.

Foreground area was simplified to focus attention on figures.

Whereas the photograph is a jumble of colors and tones, the artist sets up a series of color links that unify the painting. Parts of the paper are left uncovered, so that its warm gray recurs throughout the picture, and pastel colors are repeated from one area to another. The pink on the underside of the umbrella can be seen again on the central figure and on the woman's coat. (Harbour Fish Stall, France — Alan Oliver)

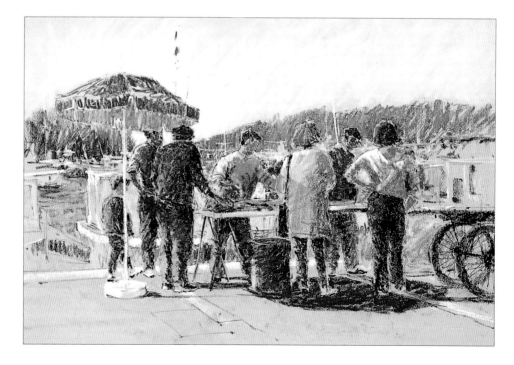

1 *The artist often works from pencil drawings such as this, usually with color notes. In this case he has omitted the written notes, as the photograph provides adequate color reference.*

2 *Having made an outline drawing with black conté crayon, which he likes because it does not smudge, he starts to lay on colors, starting with the darker ones, but keeping the marks light.*

3 *To help assess the colors for the seller, the artist began with the dominant shape, the umbrella, and now uses a similar pink. This links the two so the figure stands out from the background.*

4 *The sky is an integral part of the picture. Strong diagonal side strokes continue the sense of movement of the figures and suggest a windy day.*

5 *Because the strokes were kept open, colors can be overlaid without clogging the paper. The color of the hills is warmed by the addition of purple.*

6 *The artist begins to work on the highlights, using a short length of pastel for maximum control. Fixative is then applied to allow further work, but the finished picture is not fixed, because the artist finds that this dulls the colors.*

7 *Light pinkish brown was added to the foreground, leaving much of the gray paper showing as a second color. Detail here would detract from the figures, but some color was needed, along with a suggestion of perspective lines.*

8 *The central mast being drawn is important to the composition. It echoes the vertical of the umbrella pole and emphasizes the upward thrust of the figures. The masts also play a descriptive role, telling the viewer that this is a harbor scene.*

9 *For the final touches of definition, conté crayon is again used, as for the initial drawing. This gives a very fine line and can be applied over pastel, providing the color is not too thick. The flagstones in the foreground (see finished picture) were also drawn with conté.*

Figures in action

Whether engaged in sports or performing everyday tasks, people in action make an exciting painting subject, but a challenging one. Especially if you work from photographs, remember to use the techniques that give an impression of movement: strong linear strokes or scribbled marks are better than soft blends. And back up photographic reference with information; become familiar with the way the body behaves when it is in motion by observing people and making quick sketches whenever you can.

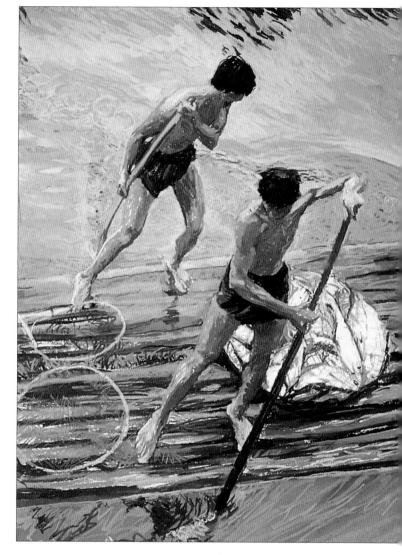

Heavily applied, decisive strokes communicate tension of an arm taking the weight of a pole.

Movement of water is conveyed by varied side strokes and lightly scribbled circles.

Firm linear diagonals and scribbles of black and white where the pole breaks surface of the water.

DIRECTIONAL STROKES

The artist was prompted by the relationship between the movement of the bodies and that of the water, and expressed this rhythmic flow through her pastel marks. The strokes on the figures follow the direction of their movement, emphasizing the diagonal thrust, while inventively varied marks suggest the shifting of the water. (Fishing, Banyan Lake – Kitty Wallis)

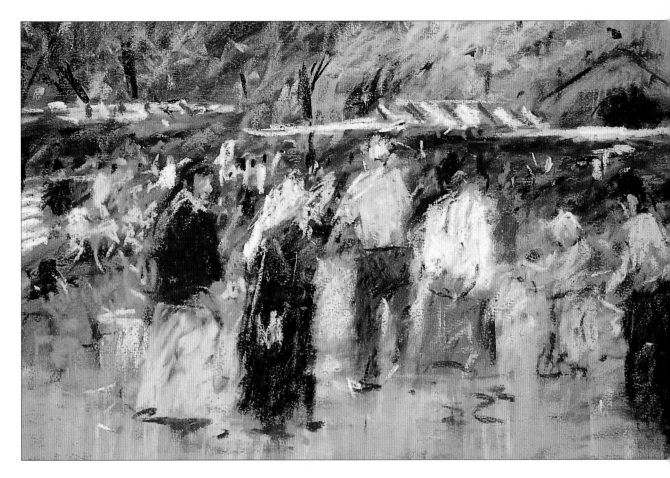

IMPRESSIONISM

By keeping detail to a minimum, the artist created a powerful impression of market bustle. The figures are sketched rather than drawn, with rapidly applied side strokes from a short length of pastel. The feeling of movement is continued into the background. (A French Market — Alan Oliver)

Varied, crisscrossing strokes suggest dappled light and echo the marks used for figures.

Short, jabbed strokes and scribbled marks hint at background figures and activity.

No detail on this figure, yet overall shape and posture are clearly conveyed.

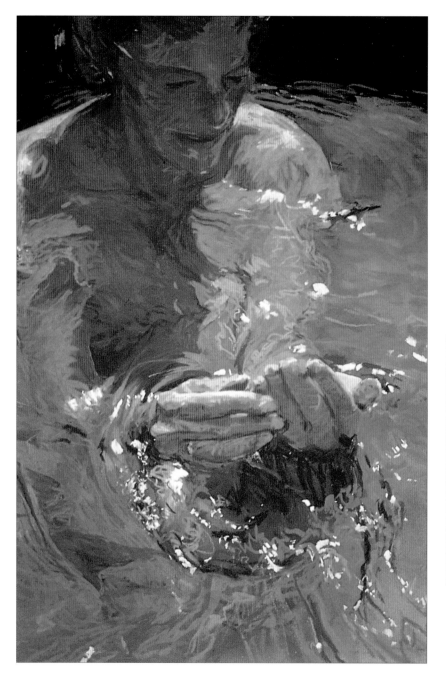

Figure looks solid, but varied marks prevent a static look.

Linear marks and squiggles overlay more flatly applied color of underpainting to convey movement.

Deep blue of water reflects onto hands, producing an exciting color effect.

INTERACTIONS

This artist particularly likes exploring the interaction of figures and water. She contrasted the solid bulk of the head and shoulders with the delicate, complex shapes where ripples of water distort the chest and arms. She achieved her rich colors by working over an acrylic underpainting on specially prepared sandpaper. (Hot Tub No. 11 — Kitty Wallis)

TELLING A STORY

There should always be some relationship between the figures in a group. You can achieve this through technical devices, such as letting one figure overlap another. But you can also make the picture "tell a story," as the artist has done here, introducing humor – and even a touch of caricature – by exaggerating the movements of the figures and their shapes. (Double Decaf Low Fat Latte – Carole Katchen)

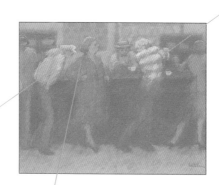

Height of figure and length of legs exaggerates movement of body.

Posture gives impression of involvement. Both leaning figures enclose woman in red, the picture's focal point.

Tilt of head and arms akimbo suggest argument between the woman and man.

Buildings

PICTURE MAKING

If you live in a town or city, you will probably have spotted many promising painting subjects but perhaps felt nervous about tackling them because of their complexity and wealth of detail. But cities can be treated in much the same way as landscapes by suppressing details that are not relevant to your composition and concentrating on color and atmosphere.

SHAPES AND PROPORTIONS

It is easy to get bogged down in detail, so begin by analyzing the main shapes of the buildings and their proportions. Both are vital, because they give the buildings their individual character.

Ask yourself whether the height of a building is greater than its width, whether the windows are close together or far apart, large or small in relation to the wall area, and how much space the roof occupies in the whole structure. Remember that some buildings have been designed by architects according to rules of proportion, while others, such as farm outbuildings, may have been put together simply from local materials. Buildings conform to regional traditions and have recognizable style. Give your paintings a "sense of place" by recording such features.

TOWNS AND CITIES

City districts also have their own distinctive flavor, so pay attention to the predominant building material and the way in which the buildings are arranged. Some towns have wide, straight streets with regimented rows of houses; in others, streets

Continued on page 162 ▷

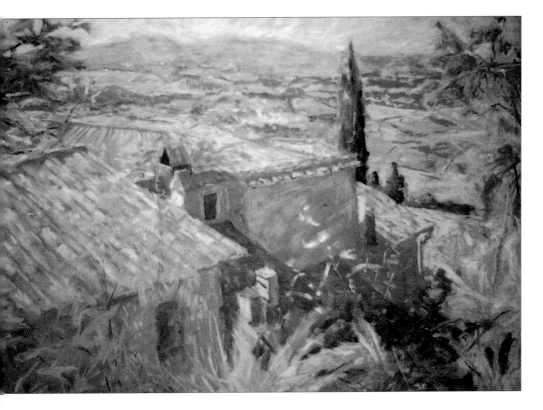

BUILDINGS AS LANDSCAPE

As is often the case with old buildings, these seem to grow naturally out of the land, just as the trees do, and the artist treated them in the same way. He has given a good impression of place; the tiled roofs and thick walls are typical of the Italian countryside. (Rooftops, San Donnino – Patrick Cullen)

ARCHITECTURAL STYLE

Although the building has little detail, its general proportions and the shapes of the windows are sufficient to communicate its style and identify it immediately to anyone familiar with the town. The artist's main theme is light and color, and he conveyed the rich hues of a sunlit fall day by using the same vivid palette for the trees and the building. This prevents the building from becoming too dominant. (St. John's College Gate, Cambridge – Geoff Marsters)

are narrow, and buildings vary. Create the feeling of urban bustle by including people, cars, and typical "street furniture," such as lampposts, railings, signs, and benches.

Alternatively, you can depict a convincing townscape from a high viewpoint, such as an upstairs window. This allows you to see the entire layout of the place, and can provide an exciting composition, with rooftops forming patterns. If you live in an apartment with a good view, you are fortunate, and if not there are often public buildings that provide suitable vistas.

If your subject is a single building, such as your own house, you will want to create a likeness, so make sure that the shape and proportions are accurate. But consider viewpoint and lighting as well, because they will affect your composition. It is not always wise to paint a building from directly in front; a three-quarter view conveys greater solidity as well as looking more interesting. Sunlight provides shadows that help to define the structures and give tonal contrast.

If you chose a building as a subject, it is

Continued on page 164 ▷

INCLUDING FIGURES

You will usually want to include one or two figures in an urban scene, but people instantly attract the eye because we identify with them, so they can dominate the composition. The artist avoided this risk by treating the group of girls very broadly, and setting up strong tonal contrasts on the building and statue behind, so that this area becomes the focal point. (Summer Evening, St. Martin's Place — *Margaret Glass)*

WINDOW VIEWS

A window provided the artist with a high viewpoint, allowing him to emphasize the almost abstract patterns made by walls and rooftops set at varying angles. Although he suggested the texture of the buildings, using scumbles and overlaid color, together with sweeping strokes for the roofs, he minimized detail to ensure the satisfying arrangement of shapes and colors. (Valensole – Patrick Cullen)

VIEWPOINT AND LIGHTING

This subject might look unexciting seen from the front and under a gray sky. Here, however, the sunlight brings the colors to life and creates a good shadow that, together with the three-quarter viewpoint, gives solidity to the structures. The artist unified the composition by using the same red-browns on foreground trees and roof. (Forget-me-not, Buttercup – Rosalie Nadeau)

because you respond to it – you admire its proportions or the way it nestles into the landscape. An old building might attract you by the texture of its peeling paint or weathered wood. Try to identify the building's special features, and see if you can find ways of pointing them up. A house set in an expanse of country, for example, would call for a distant view, expressing the interaction of man-made and natural features, or perhaps hinting at the isolated lives of the inhabitants.

PERSPECTIVE

Whether your subject is one building or an urban panorama, you will have to come to grips with the basic rules of perspective. But these are not really alarming, and once you have mastered them you will find them helpful.

In the landscape section on page 134 you saw how things appear smaller the farther away they are. This is the starting point of all perspective. If you look at a tabletop from the front, you will notice that the sides seem to angle inward, making the back shorter than the front. This is because all parallel lines receding from you seem to converge, becoming closer together until they meet at a point known as the vanishing point.

The vanishing point is located on an imaginary line called the horizon, a word often used loosely to describe the division between land and sky or sea and sky, but in perspective it has a more precise meaning. The horizon line is your own eye level, so it changes according to where you are, becoming higher when you are standing and lower when you sit. It is important to understand this, because the horizon dictates the angle at which the converging parallel lines slope.

Your angle of viewing also affects the way the parallel lines behave, because the vanishing point is opposite you. If you stand in the middle of a railroad track, it will be directly in the center, but if you move to one side, it will move to a different point on the horizon line.

Similarly, if you look at a building from an angle, so that each side forms a separate plane, there will be two vanishing points, one for each plane. A complex grouping of buildings set at haphazard angles to one another will have many different vanishing points; but provided you remember that each one is situated at your own eye level, you won't go far wrong.

PLOTTING PERSPECTIVE LINES

When making your preliminary drawing, sketch in the horizon line, then draw one of the receding horizontal lines – you could begin with a roofline or the tops of windows. Take this line down to the horizon (H) and mark where the two lines meet. This is your first vanishing point (VP). All the lines parallel with this will meet at the same place.

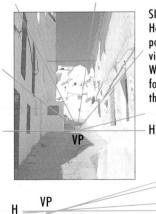

SINGLE VANISHING POINT
Here there is only one vanishing point for the buildings, because the viewpoint is the middle of the street. While the houses are built on level foundations, the road runs uphill, so the vanishing point is above the horizon.

ATMOSPHERE

This building has the atmospheric feeling common to many old deserted barns and farmhouses. The artist exploited this by using predominantly dark tones and muted colors, with the sharply drawn trees and grasses giving dramatic emphasis. She conveyed the impression of weather-worn wood by dragging white pastel over the darker colors just enough to catch on the grain of the textured canvas. (Illuminated Barn – C. Murtha Henkel)

TWO VANISHING POINTS
You can see two separate planes of this building, and each one has its own vanishing point, but at the same level – the horizon line.

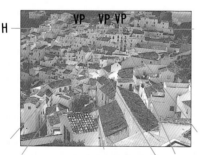

MULTIPLE VANISHING POINTS
For a subject like this, with buildings set at odd angles to one another, you cannot mark in each vanishing point. But do mark the horizon, and plot the perspective of the foreground buildings.

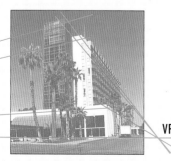

SUGGESTED NEW COLORS

Compared to such subjects as flowers, buildings are muted in color, so you will want to extend your range of neutral browns and grays. But brickwork or tiled roofs can be colorful, particularly when the sun is shining on them, so have some extra red-browns, pinks, and yellows on hand as well.

GRAYS

Blue-gray No. 2

Blue-gray No. 0

Cool gray No. 6

Indigo No. 1

RED-BROWNS AND PINKS

Red-gray No. 4

Red-gray No. 2

Indian red No. 6

Indian red No. 4

Cadmium red No. 1

Cadmium tangerine No. 1

YELLOWS AND BROWNS

Yellow ochre No. 4

Raw sienna No. 6

Raw sienna No. 1

Naples yellow No. 2

Mediterranean Village

PICTURE MAKING

The whitewashed houses, clear blue sky, and deep shadows provide an attractive subject. The artist visited this village on a family vacation, and because time was limited, she developed the painting afterward from a photograph. She departed from her visual reference in a number of ways, using the photograph to structure the composition and to help with details, but relying more on her memories of the colors and general atmosphere of the scene.

Masking for clean edges •

Including a figure •

Heightening colors •

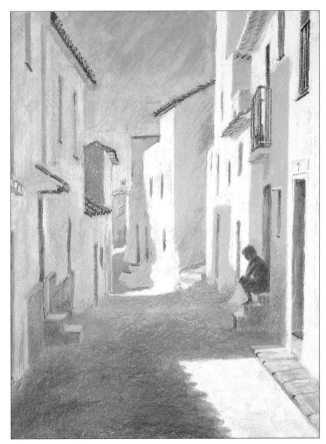

Straight, clean edges are important. The artist used masking tape as an aid.

This shadow was darkened and warmed in the painting, to heighten contrast with the sunny side of the building.

Silhouetted figure merges into the surrounding tones, so in the painting, the wall is made lighter than the woman.

There is always a good deal of blue in the shadows on white buildings, and because the artist wanted to play this up, she chose a contrasting pale orange-brown paper. Blending was used for the sky and some of the shadows, but most of the painting was built up with light hatching strokes that allow colors to show through one another. This effect is especially noticeable in the foreground shadow and on the figure. (Casares, Andalusia — Hazel Soan)

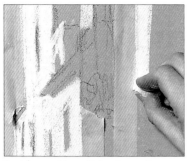

1 After making a light charcoal drawing, the artist starts on the white buildings. The pastel is applied thickly here, and masking tape is used to keep the edges straight.

2 The masking tape is removed, leaving a crisp edge. Notice that the pastel is not uniformly thick. To the left of the tape is an area where the paper shows through, suggesting the crumbling texture of the wall.

3 Because there is so much white in this painting, it was important to place the lightest tones first. With the white wall in place, it is easier to determine the color for this shadow, created with strokes of red-brown over blue-gray.

4 The faint charcoal outline of the figure is strengthened with blue pastel ready to be filled with a mixture of this and other colors.

5 Small details are often left until the final stages of a painting, but this area of strong color is important to the composition and color scheme, so the artist establishes it before continuing with the walls.

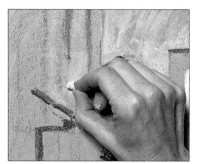

6 Tones and colors are continually assessed. There was insufficient tonal contrast between the orange of the windows and the blue first laid down for the wall, so the blue is lightened with side strokes of white.

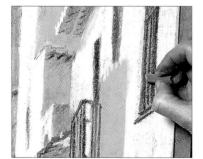

7 The wall on the right is complete. Linear details are now put in with the point of the pastel. Care is taken to avoid smudging the whites and the delicate blue-gray of the shadows.

8 Shadows can easily dull through overblending. A variety of colors were laid over one another but were not blended, and the area is finally darkened and enriched with light side strokes of purple.

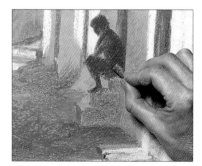

9 The figure is important but should not stand out too strongly, so it is treated almost as a silhouette; red-brown worked into the earlier blue-gray gives it a suggestion of form. The colors are similar to those of the shadows, which unifies the composition.

167

Painting details

If your subject is a building of fine proportions or interesting shape, you may want to show all of it, but you can often make an equally attractive picture from an architectural detail, such as a door, balcony, or wall with carved stonework. This can be easier than handling the intricacies of perspective over a large scale, but you need to take care with composition and lighting. Don't place your chosen feature in the middle of the picture, and try to work on a sunny day so that there are shadows to provide good contrasts of tone.

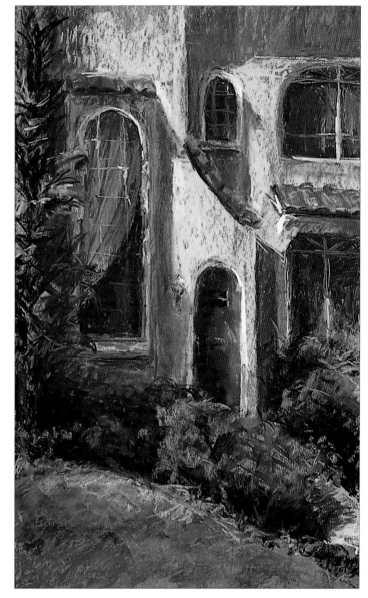

Pointed shapes and diagonal lines lead the eye to this focal area; dark shadow above helps it to stand out.

Suggestion of curtain and of window bars prevents the window from looking empty and "blind."

Curving diagonal draws the eye into the picture and echoes the curve above central door.

CONTRASTING SHAPES

The artist made a pleasing arrangement of tones, colors, and shapes – tall curves and firm diagonals and verticals. The low evening sunlight gives a rosy glow to the walls and casts shadows that strengthen the forms. (East Livingston Place, Old Metairie – Sandra Burshell)

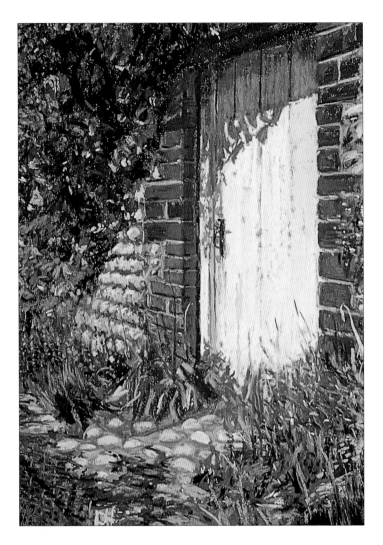

PATTERN AND TEXTURE

The initial impact of this painting also derives from the organization of shapes and tones, with the dominant rectangle of the door balanced by the triangle of light stonework on the left and the curves of the cobbles below. But there is much additional interest in the patterns and textures of brick, wood, and stone, contrasting with the freer forms of foliage and grasses. (The Yellow Door – Margaret Glass)

Shadows create a visual link between door and foliage, and soften shape of the door.

Solid pastel for smooth cobblestones; this contrasts with linear marks for grasses.

Long, downward strokes follow direction of the wood; patches of unpainted paper suggest texture.

Caring for Your Work

Unless you take steps to protect your work, it can easily become smeared, and the paper damaged. The best protection is provided by a frame and glass, but framing all your pictures would be expensive. A surface such as pastel board or sandpaper, which grips the pastel firmly, needs no fixing, but spray other work with fixative and let it dry thoroughly before putting it away. Pastels must be stored flat, not upright, to avoid damaging the edges of the paper. You can stack a good many paintings on top of one another, but they must be separated by tracing paper to prevent color transfer. Tracing paper is preferable to tissue paper, because it is heavier. The protective sheet should be fixed to the pastel paper, using any of the methods shown below, so that it does not move when you are looking through your work.

Pastels must be framed under glass to guard against accidental smearing and to protect them from damp and dust. The painting must never touch the glass. If you are having your work mounted professionally, ask the framer to insert a thick mat or small pieces of wood, known as slips, between the painting and the glass.

When framing work, the pastel must not touch the glass. If it does, moisture caused by condensation will make blotches on the picture surface.

USING A MAT

You can make a thick mat by gluing two pieces of mat board together and cutting to size. For a more decorative effect, cut one piece slightly smaller than the other, so that the edge of the bottom piece shows. Use identical or contrasting colors.

USING SLIPS

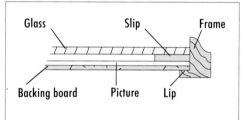

You can separate the glass from the picture by placing a thin piece of wood in the lip (the L-shaped groove on the inside edge of the frame molding). You need a frame with a deep lip.

TAPE AND TRACING PAPER

Cover the picture with tracing paper, fold about 1 inch over the back, and fasten down with masking tape.

MASKING TAPE HINGE

Or align the edges of tracing paper and picture, stick the tape onto the tracing paper, then fold over onto the back. You will need wider tape for this.

ATTACHING TO BOARD

This method ensures that the picture is kept flat. Fasten it to a piece of mat board larger than the painting, then cover with tracing paper and place tape along the top.

PORTFOLIOS

Keeping your pastels in a portfolio protects them from dampness and dust. The best type opens out flat, making it easier to look through your work periodically. Do not store the portfolio upright, as this could damage the edges of your work and cause pastel dust to drift downward.

Making a mat for your picture gives you a chance to reassess it, and you will sometimes find you can improve the composition simply by the way you place the mat.

If you have worked right to the edges of the paper, you will have to sacrifice a little of the picture – the edges must be covered by the mat and attached to it – but you can crop much more drastically than this. If you have placed the horizon too near the center, for example, you might lose some of the sky or foreground. Cut two "L" shapes as shown, and move them around on the picture to examine different options. You can use thick paper for this, or pieces of your mat board.

If you decide on a cropped version, cut the mat to these new dimensions, but don't cut pieces off the picture, because you may change your mind.

Picture might benefit from cropping foreground.

Cropping some sky focuses eye on house and foreground.

Central portion of picture makes an uncluttered composition.

The colors chosen for the starter palette on page 21 are from the Daler-Rowney range. If you are unable to obtain these pastels, or prefer a different make, choose the nearest equivalent in your chosen brand. Do not expect the colors to match exactly, as pigments and methods of manufacture vary from one range to another. You will also find differences in the grading

systems. For Rembrandt pastels, the number after the comma denotes the shade. The pure pigment is numbered 5. A higher number, from 7 to 10, indicates a proportion of white added, while colors with lower numbers contain black. Grumbacher use a lettering system. D is the pure color; A is the darkest shade, with added black, and M the lightest, with the most white.

	DALER-ROWNEY	GRUMBACHER	REMBRANDT
	French ultramarine No. 6	Ultramarine blue deep D	506,5 Ultramarine deep
	French ultramarine No. 1	Ultramarine blue deep M	506,9 Ultramarine deep
	Prussian blue No. 3	Prussian blue H	508,7 Prussian blue
	Cerulean blue No. 4	Greenish blue D	570,8 Phthalo blue
	Purple No. 6	Deep violet A	536,5 Violet
	Mauve No. 2	Bluish violet M	548,7 Blue violet
	Crimson lake No. 6	Madder lake D	318,5 Carmine
	Cadmium red No. 6	Cadmium red medium hue D	371,7 Permanent red deep
	Cadmium tangerine No. 4	Permanent red #1D	235,5 Orange
	Yellow ochre No. 6	Light ochre D	227,5 Yellow ochre
	Yellow ochre No. 2	Gold ochre M	227,7 Yellow ochre
	Cadmium yellow No. 4	Cadmium yellow deep hue H	202,7 Deep yellow
	Lemon yellow No. 6	Lemon yellow H	205,5 Lemon yellow
	Olive green No. 8	Olive green A	620,3 Olive green
	Hookers green No. 3	Chrome green light hue D	675,5 Phthalo green
	Hookers green No. 1	Permanent green light M	675,8 Phthalo green
	Sap green No. 5	Olive green H	608,7 Chrome green light
	Lizard green No. 3	Moss green M	608,9 Chrome green light
	Green gray No. 1	Greenish gray M	709,8 Green gray
	Blue gray No. 4	Gray blue D	727,7 Bluish gray
	Cool gray No. 4	Gray blue K	707,8 Mauve gray
	Burnt umber No. 8	Burnt umber A	409,9 Burnt umber
	Raw umber No. 6	Light ochre A	408,9 Raw umber
	Burnt sienna No. 4	Red brown ochre H	411,7 Burnt sienna
	Silver white	White	100,5 White
	Lamp black	Black	704,3 Black

Index

NOTE
Page numbers in *italic*
refer to illustrations

A

abrasive paper *see*
 sanded paper
acrylics 76, *76–7*, 158
Aggett, Lionel:
 Hawthorn, Cornwall
 136–7
assessing work 171,
 171

B

background:
 colors for *91*
 flowers as *128*
 in flower paintings
 120–2, *121*
 paper as *67*
 role in picture *148*
balance 88, *88*
Barta, Dorothy:
 The Eyes Have It 146
 Model in the Studio
 57
Bates, Joan Elliott:
 Rooftops, Vaucluse
 98
blending 8–10, *9*
 large areas 48,
 48–51
 lines over *48–9*
 small areas 52, *52–5*
blocking in 64, *64–5*
body, human:
 proportions 146,
 147
Bonnard, Pierre 106–7
bread: corrections with
 78
brushes *29*
 blending with *50, 54*
 making corrections
 with *78–9*
 removing dust with
 139
 for wet brushing 68
building up painting
 64, *64–5*
buildings:
 architectural details
 168, *168–9*
 palette for *165*
 perspective 164,
 164–5
 sense of place 160,
 160

shapes and
 proportions *160*
Burshell, Sandra:
 East Livingston Place,
 Old Metairie 168
 Morning Shadow 108
 Reflections 106

C

care:
 of pastels 22, *22–3*
 of work 170, *170–1*
Carpenter, Pip:
 Interior with
 Patterned Carpet
 114–15
 Narcissi 121
charcoal:
 for sketch *138*
 subduing colors with
 70, *70–1*
 underdrawing with
 62, *63, 113, 153,*
 167
 use during painting
 70, *70–1*
charcoal paper *24*, 26
 wet brushing 69
children: painting *148*
Christensen, Deborah:
 Blanco Reflections 71
cities 160–2
clouds: perspective
 136, *137*
color chart *20*, 46–7
color wheel *90*, 92
colored pencil:
 sketching with 98–9
colors 20, *21*
 background *91*
 basic principles 90–3
 blending 8–10, *9*
 broken *14*, 58, *58–9*
 for buildings *165*
 characteristics 90
 complementary *46,*
 92
 contrasts 88–9, *92,*
 108, 108
 cool 90
 for flower painting
 123
 for landscapes *137*
 mixing 44–7, *44–5*
 chart *46–7*
 optical 58
 neutral *92–3*
 overlaying 10, *10,*
 53, 60, 60–1

of papers 26, *26–7*
 for portraits and
 figures *151*
 primary 44
 relationships 91–2,
 91
 reviving 60
 secondary 44, *45,* 46
 sketch notes on 98,
 99
 starter palette 20, *21*
 subduing 60, *60*
 tertiary 44–6
 testing *33*
 thick: using 74,
 74–5
 three-dimensional
 effects 90
 unifying
 composition 88,
 107, 154
 values (tints) 19, *19*
 contrasts 89, 92
 judging *93*
 warm 90
composition 86–9,
 86–9
 breaking symmetry
 86, *86*
 contrast 88–9
 creating
 relationships 86–8
 focal point *87*
 landscapes 86–8,
 132
 planning 100
 sense of movement
 86
 still life 108–10,
 108, 109, 110
 unifying 86–8
conté crayon: use *155*
contrast 88–9
 of color 88–9, 92,
 108, *108*
 of shape 88–9, 108,
 108
 of values 89, 92
corrections 78, *78–9*
cotton swabs 52, *53*
Crittenden, James:
 Winter, Andalusia
 135
cropping 120, *120,*
 171
cross-hatching 10, 56,
 57
Cullen, Patrick:
 Rooftops, San
 Donnino 160

Two Willows 142
Valensole 163
View Over Allotment
 73
Window, Valensole
 14
Cuthbert, David:
 Casole d'Elsa 98
 Landscape: Casole
 d'Elsa 96
 Tuscan Scene 140–1
Cuthbert, Ros:
 Victoria 152–3

D

Dawson, Doug:
 Apples and Tea 76–7
 The Table by the
 Window 127
Deichler, Deborah:
 Yellow Cabinet with
 Cups and Saucers
 116
details:
 adding 66, *66*
 reducing 89, *163*
 suppressing *154,*
 160
drawing board 28, *29,*
 94
Dutch painters 106,
 116

E

easels *23,* 28
edges 66, *66–7*
 masking 66, *67,*
 166–7
equipment 28, *28–9*
 outdoor *23,* 28
erasers 28, *28*
 corrections with 78,
 79
evening sunlight *144*

F

feathering 60, *61*
figures 146–50,
 147–51
 in action 156
 gallery *156–9*
 in context 150,
 150–1
 in landscape 150
 project 154,
 154–5
 palette for *151*

proportions 146, *147*
 in urban scene *162*
fixative 28, *29*, 170
floor covering 28, *29*
flowers 118–22, *118–23*
 arranging indoor group 118–20, *118*
 as background *128*
 backgrounds to 120–2, *121*
 breaking symmetry *86*
 color arrangements 120
 cropping picture 120, *120*
 filling picture 120, *120*
 gallery 126–9
 in natural habitat 122, *122–3*
 palette for *123*
 project 124, *124–5*
 simplifying shapes *121*
focal point:
 lead-in lines to *87*
 painting without *129*
foregrounds: in landscape 132–4, *133, 134*
foreshortening *149*
format 100, *100*
"found subjects" 106–7, *106*
framing 170, *170*
French Impressionists 116
fruit: project 112, *112–13*
Fusaro, Darrell: *Staying After School 111*

G

gesso *76–7*
gestural drawing 40, *40–1*
Glass, Margaret:
 Between Showers 74
 The Blue Vase 117
 Breezy Day, Minsmere Beach 138–9
 East Window 107
 Summer Evening, St

Martin's Place 162
 The Yellow Door 169
Gold, Lois:
 Autumn Light 89
 Beach Grasses 51
 Golden Fields 9
 Snapdragons 67

H

hair: palette for *151*
hairspray: as fixative 29
Harrison, Hazel: *St Laurent-de-Cerdans 99*
hatching 56, *57*
Henkel, C. Murtha:
 Illuminated Barn 164–5
 Torrential Stream 130
hills: project 140, *140–1*
Hooch, Pieter de 106
horizon *132, 133*
 vanishing point and 164, *164–5*
horizontal lines: avoiding 110
human proportions 146, *147*

I

impasto effects *74*
Impressionists 116

J

John, Gwen 107
Jordan, Maureen:
 Charlotte 150
 Lemons in the Spotlight 126
 Pink Roses 92
 Reflections I 120
 Yellow Rose Texture 86

K

Katchen, Carole:
 Double Decaf Low Fat Latte 159
knives:
 craft 28
 making corrections with *78–9*

L

la Tour, Maurice-Quentin de 10
landscapes 130–6, *130–7*
 color contrasts 89
 composing picture 86–8, 132
 creating space 134–6, *135, 136–7*
 figures in 150
 foreground 132–4, *133, 134*
 linking with middle distance 134
 gallery *142–5*
 hilly: project 140, *140–1*
 horizon *132, 133*
 leading eye *135*
 measuring relative sizes 134–6
 painting from life 94
 palette for *137*
 paper for 26
 perspective 134–6, *135, 136–7*
 project 154, *154–5*
 unifying composition 86–8
 using broken color 58–9
 viewpoints 130–2, *130, 131*
lead-in lines *87*
life: working from 94, *94–5*
light:
 effects of *107*
 painting 142, *142–5*
lighting:
 back *109*, 117
 of buildings 162, 163
 front *109*, 116
 side *109*
line strokes 8, 34, *34–5*, 56, *56–7*

M

mahlstick *33*
Manifold, Debra: *Fruit in Season 112–13*
Marsters, Geoff:
 Cottages at St Jacques, Brittany 87
 Fen Landscape 136

St John's College Gate, Cambridge 161
 Toward Cambridge, Winter 58–9
 Towards Ardnamurchan 133
Martin, Judy:
 Rottingdean Allotments 15
masking 66, *67, 166–7*
masking tape 29
masonite: painting on 76–7
mats 170, 171
Mediterranean village: project 166, *166–7*
Mi-Teintes paper 24, *24–5*
 buying 26
 laying thick color on 74
 paintings on *115, 125, 140–1, 153*
 wet brushing 68
mirror: in painting *120*
monochrome drawings 56
morning light *142*
movement:
 creating sense of 86
 in still life *108, 109, 111*
 gestural drawing 40, *40–1*

N

Nadeau, Rosalie:
 Chipped Bowl with Roses 119
 Color Purple 120
 Cove Cloud Break 145
 Cove at Dusk 144
 Fiesta Bouquet 53
 Forget-me-not, Buttercup 163
 Jaymie 151
 Laundry Lights 61
 Love Peonies 132
 Three Phlox in Red 122–3
 Time for Roses 88
 Winter Garden 10
Nicodemo, Catherine:
 Fruit Still Life 110

O

oil pastels 18
 sketching with *98*
Oliver, Alan:
 A French Market 157
 Frosty Morning 91
 Harbour Fish Stall, France 154–5
 Hastings Beach 11
 A Norfolk Beach 150–1
 Old Bridge 5
 Poppies 134
 Summer Morning 133
outlines 66, *66–7*
overlaying colors 10, *10*, 53, 60, *60–1*

P

Paine, Ken: *The Journeyman 13*
palette: making 32
paper 14
 for broken color 58
 colored: influence on color scheme *101–3*
 colors 26, *26–7*
 cushioning surface 24
 dark: as background 67
 textures 24, *24–5*
 for thick color 74
pastel board 24, *24*, 170
 broken color on 58
 laying thick color on 75
 pictures on 10, *10, 113*
pastel pencils 18
 underdrawing with 62, *62*
pastels:
 breaking *33*
 care 22, *22–3*
 cleaning 22
 colors 20, *21*
 composition 18
 hard 18, *19*
 blocking in with 64, *64–5*
 holding 34
 soft 18, *18*
 building up with 64, *64–5*
 storage 22, *23, 28*

types 18–20, 18–19
values (tints) 19, 19
working with 32,
 32–3
patterns:
 emphasizing in
 flower painting
 129
 painting: project
 114, 114–15
 viewpoints 130
pencil: sketching with
 98–9
perspective:
 aerial 136, 136–7
 effects on pattern
 114, 114, 115
 foreshortening 149
 linear 134–6, 135
 in urban scenes 164,
 164–5
 vanishing points
 164, 164–5
Phillips, Aubrey:
 September Evening
 135
 Sunset Over Jura 8
photographs:
 interpreting 154
 working from 94,
 96, 97, 100, 150,
 154
Picasso, Pablo 56
Pinschof, Maria:
 Soup Tureen, Fruit
 and Flowers 109
 Zinnias in Vase 119
planning painting 100,
 100–3
pointillism 58–9
Polk, Kay: Kate 148
portable kit 28, 28–9
portfolios 171
portraits 13, 146–50,
 146–51
 achieving likeness
 146–8
 choice of clothes
 150, 150
 color contrasts 89
 correcting 79
 full-length 148
 half-length 148
 head-and-shoulders
 148
 project 152, 152–3
 painting from life 94
 palette for 151
 paper for 26
 poses 148–50, 152
 proportions 146,

147
 settings 148–50,
 149
pouncing 62, 63
Prentice, David: The
 Ridgeway, Malvern
 Hills 136–7
protecting work 170,
 170–1

R
rags 28, 29
 blending with 50
relationships 86–8
Rembrandt paper see
 pastel board
Rohm, Bob: Taos Fall
 68–9

S
sampler 38
sanded paper 24, 24,
 25
 broken color on 58,
 58–9
 charcoal and pastel
 on 71
 grades 74
 laying thick color on
 74, 74–5
 wet brushing on
 68–9
sandpaper 24, 25, 170
 paintings on 139,
 158
 sharpening pastels
 with 33
 underpainted 12, 12
Sansfix paper see pastel
 board
scribble line 56, 56
scumbling 60, 60
seascapes: project
 138–9
shadows:
 in landscape 133
 from object outside
 picture 134
 softening 52
 in still life 109, 111,
 117
shapes:
 balance 88
 contrasts 88–9, 108,
 108
 unifying
 composition 88,
 107
side strokes 8, 8, 37,

36–7
Simmonds, Jackie:
 Daisies and Irises
 124–5
 Spring Light in the
 Sitting Room 13
 Still Life with Frosted
 Blue Glass 128
 Sunlit Patio 122–3
 3 P.M. 149
 Winter Hedgerow
 143
sketches:
 making 98, 98–9
 outline: as first stage
 of painting 155
 thumbnail 100
 working from 96,
 96–7, 150
skies:
 effect of perspective
 on 136, 136–7
 painting 153
 project 138, 138–9
 using broken color
 58–9
skin color 146
 hatching 57
 palette for 151
slips 170
smearing: avoiding 33
snow 58–9
Soan, Hazel:
 Cape Fishermen 97
 Casares, Andalusia
 166–7
Stanton, Jane: Meadows
 in Windley 48–9
still life 106–10, 106–
 11
 arranging group
 108–10, 108, 109
 choosing group
 107–8
 color contrasts 89
 composition 86,
 108–10, 108,
 109, 110
 creating movement
 in 108, 109, 111
 flowers 118–22,
 118–21
 breaking
 symmetry 86
 project 124, 124–5
 "found subjects"
 106–7, 106
 fruit: project 112,
 112–13
 gallery 116–17,
 126–9

lighting 109
 painting patterns:
 project 114, 114–
 15
 types 106–7
 unifying
 composition 88
 storage 22, 23
 for transporting 28
strokes:
 combining 38, 38–9
 line 8, 34, 34–5
 using 56, 56–7
 side 8, 8, 36, 36–7
 varied 11
studio: equipment for
 28, 28–9
styles 12–14
 comparing 80, 80–3
sunlight:
 on buildings, 162,
 163
 with cloud 145
 evening 144
symmetry: breaking
 86, 86

T
Tarbet, Urania Christy:
 The Circuit Judge 148
 Wisteria and Roses
 55
texture:
 laying ground 76,
 76–7
 in painting 54
 provided by paper
 12, 12, 14, 15
 still life theme 107
three-dimensional
 space 90
tortillons 29
 blending with 52, 52
 making 52
townscapes:
 characteristics 160–2
 viewpoints 162, 163
turpentine: wet
 brushing with 69

U
underdrawing 62, 62–3
underpainting 72, 72–3
 acrylic 158
 wet brush 68, 68–9
 working over 12, 12
urban scenes 160–4,
 160–5
 figures in 162

perspective 164,
 164–5
viewpoints 162, 163

V
vanishing points 164,
 164–5
velour paper 24, 25
 laying thick color 75
viewfinder: using 94,
 95, 110, 130
viewpoints:
 for landscape 130–2,
 130, 131
 for still life 110, 110,
 111
 for townscapes 162,
 163
village:
 Mediterranean:
 project 166, 166–7
visual references:
 working from 96,
 96–7

W
Wallis, Kitty:
 Cypress 131
 Fishing, Banyan Lake
 156
 Hot Tub No. 11 158
 Morning Blue 12
water: sun on 145
watercolor paper 24,
 24, 25
 broken color on 58
 laying thick color on
 74
 picture on 15
 tinting 72
 wet brushing 68
watercolors:
 underpainting with
 12, 12, 72, 72–3
Webb, Jenny: Flowers
 and Duck 129
wet brushing 12, 68,
 68–9
Willis, Barbara:
 Brass and Dry
 Flowers 107
 Dear Friends 109
winter light 143
working methods
 12–14
 comparing 80, 80–3
working position 33,
 94

Credits

Quarto would like to thank all the artists who kindly allowed us to publish their work in this book, including the following who provided demonstrations: Jane Hughes, Ros Cuthbert, Rima Bray, Mark Topham, David Cuthbert, Hazel Soan, Pip Carpenter, Judy Martin, Debra Manifold, Jackie Simmonds, Margaret Glass, Alan Oliver.

We would also like to acknowledge the following owners of featured work (key: *a* above, *b* below): 53*b* collection of Judy Perry and Mary Kelly; 61*b* collection of Carol Craig; 106 collection of Mr and Mrs Chester Fleming III, New Orleans; 108*a* collection of Ashley Harris, New Orleans; 109*a* & 119*b* by courtesy of the Heifer Gallery, London; 116 by courtesy of the Maxwell Davidson Gallery, New York, photograph by Rick Echelmeyer; 119*a* collection of Rogene Cordes; 120*b* courtesy of the Left Bank Gallery, Wellfleet, MA; 123*a* collection of Phillip McLoughlin; 132*a* collection of Denis Munroe Dever; 144 collection of Jack Clobridge; 163*b* collection of Pamela Weiler Colling.

The publishers would like to thank Daler-Rowney for supplying the soft pastels used in the demonstrations in this book. In addition we would like to thank Grumbacher, and Royal Sovereign distributors of Talens products for preparing the chart on page 172.

Many of the artists in this book belong to The Pastel Society of America (15 Grammercy Park South New York, NY 10003)